About the author

Ben Willis is a painter who has exhibited regularly since 1972, and has won numerous awards for his work. He is also an author, and is co-author of *The Art of Oriental Embroidery* (1980, Charles Scribner's Sons). He teaches painting and drawing in his town of Elizabeth, New Jersey.

By the same author

The Art of Oriental Embroidery (with Dr. Young Y. Chung) (Charles Scribner's Sons, 1980)

The Tao of Art

The inner meaning of Chinese art and philosophy

Ben Willis

CENTURY

LONDON MELBOURNE AUCKLAND JOHANNESBURG

A Rider book published in the Century Paperbacks series by
Century Hutchinson Ltd, Brookmount House, 62–65 Chandos Place,
Covent Garden, London WC2N 4NW

Century Hutchinson Australia (Pty) Ltd
PO Box 496, 16–22 Church Street, Hawthorn, Melbourne, Victoria 3122,

Century Hutchinson New Zealand Ltd
32–34 View Road, PO Box 40-086, Glenfield, Auckland 10

Century Hutchinson South Africa (Pty) Ltd
PO Box 337, Bergvlei 2012, South Africa

Set by Avocet Marketing Services, Bicester, Oxon.
Printed and bound in Great Britain by
Richard Clay Ltd, Bungay, Suffolk

British Library Cataloguing in Publication Data

Willis, Ben
 The Tao of art : the inner meaning of
 Chinese art and philosophy.
 1. Art, Chinese 2. Taoism, China
 I. Title
 709'.51 N7340

ISBN 0-7126-1568-7

To my mother and the memory of my father

Contents

List of Illustrations

Acknowledgements

I am grateful for the appreciation and encouragement of my family and friends, especially my mother and stepfather, Mr and Mrs William M. Young; Mrs Mary Judka; Martha; and my staunch friend and mentor, Prof. John F. Murphy of Brooklyn College.

I am indebted also to all of the staff at Century Hutchinson Ltd. who made the publication of this book possible, and to my editor, Mr Oliver Caldecott, for his wholehearted co-operation and support.

In the process of writing this book I have quoted from the following authors:

Blakeslee Thomas *The Right Brain:* A New Understanding of The Unconscious Mind and Its Creative Powers. By permission of Anchor/Doubleday, New York © 1980 Anchor/Doubleday

Capra Fritjof *The Tao of Physics* by permission of Gower Publishing, Aldershot ©

Chang Chung-Yuan *Creativity and Taoism* by permission of The Julian Press, a member of the Crown Publishing Group, New York. Copyright © 1963 by Chang Chung-Yuan.

A Note on Romanization

I have avoided the use of the new *pinyin* system of pronunciation suggested by The People's Republic of China for the following reasons:

1 The majority of readers in the general Western public are more familiar with the old system and will find it easier to read.
2 The typography of *pinyin* is printed in English, using many z's and x's, is discordant and confusing to the reader.
3 In my opinion the *pinyin* system is not any closer to correct English pronunciation of Chinese words than the old system, and in many cases is less so.

Thirty spokes unite at the wheel's hub:
It is the centre hole that makes it useful.
Shape clay into a vessel;
It is the space within that makes it useful.
Cut out the doors and windows for a room;
It is the holes which make it useful.
Therefore profit comes from what is there;
Usefulness from what is not there.

Lao Tzu, *Tao Te Ching*, XI

To a mind that is still the whole universe surrenders.

Chuang Tzu, XIII, 1

Introduction

A book on the relationship between art and creativity and the mystical philosophy of Taoism must intend to go beyond the mere bones of historical fact and explore the deeper marrow of meaning. Some consideration of certain historical questions, however, is helpful to understanding.

Chinese civilization was already more than 2000 years old when European civilization was still in its infancy. Arising out of deep roots in folk religion, ritual, ancestral tradition and prehistoric animism, a strong mystical and spiritual tradition of thought had permeated Chinese culture since the earliest days of dynastic history. It was from this long and very ancient foreground that there sprang to life one of the world's first mature cosmologies, a philosophy of existence and spiritual reality that was to form one of the pillars of Chinese culture – Taoism.

By the fourth century BC, or the latter part of the Chou dynasty, Taoism was well established in China. Its development had been closely followed by another, more structured, view of life and society, Confucianism, and both of these currents ran in parallel lines throughout Chinese history, often incurring a hidden rivalry (generated mostly by the Confucians, who saw Taoism as a threat to their position at court), that was wholly unnecessary. Confucius and Lao Tzu, the founder of Taoism, are now believed to have been contemporaries, although Lao Tzu had done his major work while Confucius was still a young man and was probably much older than the latter. Buddhism was a comparative latecomer to China, not arriving there from India until sometime during the second century AD. At their height all three of these philosophies made major contributions to the foundations of Chinese civilization and its continued cohesion, providing the profound intellectual and spiritual stamina that made China great.

The major tenets of Taoism stand on a small book of only 5000 words, the *Tao Te Ching*, (Book of The Way and Its Virtue),

inseparably associated with Lao Tzu in the Chinese mind. Also intimately sustaining and supportive of Taoist thought were the writings of important followers of Lao Tzu, such as Lieh Tzu and the sage Chuang Tzu, who both left important bodies of work. It was Chuang Tzu, born about 200 years after Lao Tzu, who elaborated on and clarified much of the more subtle thought of the *Tao Te Ching*, and added to it his own brilliant insights. Chuang Tzu also made the *Tao Te Ching* more accessible to the modern mind through his directness. Lao Tzu wrote in an allusive, metaphorical style which much more resembled poetry than philosophy. There is in it little dialectic, no appeals to reason, no scholarly exposition, no intellectual display (indeed, Lao Tzu would have found the thought amusing), and yet it very effectively puts across forceful, gripping truths which are often more suggested than spoken, yet which are undeniably lucid to those capable of understanding them. English translations vary widely in a comprehensive grasp of this quality, those which are least effective being those which have been most literal and language-bound. I think Arthur Waley rendered one of the best bringing to it his own keen intelligence and perception. The *Tao Te Ching* is one of the most widely printed books in world history, second only to the Bible.

Taoism advocates a special way of life and is not a religion in the usual Western sense of having faith in or worshipping a particular deity, nor can the Tao be said to be worshipped. Nevertheless, by the first century AD Taoism had expanded into what is called its canonical or religious phase, which was in reality only the effort to put the philosophy into practice in daily life among monks and laymen. Into this new phase came a consolidated resurgence of many of the original folk, ritual and obscure mystical traditions which had been among the forerunners of Taoism and which had never really separated from it.

While the ancient philosophy of Lao Tzu continued to be the base for these more esoteric practices, and transcendental meditation remained inseparable from them, they generated a number of cultural and scientific innovations. Among these were: the attainment of extreme old age in exceptional cases and a conviction of the possibility of immortality; the development and use of astrology and the martial art of Tai Ch'i Chuan; and the discovery of acupuncture and other methods of improving physical and spiritual health. Other experimentation, at times alchemical in nature, had an equally positive outcome, leading to the discovery of gunpowder, to an effective art of herbal medicine and to accurate

sciences of physiology and physiognomy. The most esoteric branches of monastic or religious Taoism eventually found and practised a meditational means of linking mind, body and health to the circulation of inner energy, often with phenomenal results.

The difference between, or the identity of, these two main aspects of Taoism was not always well understood in the West until late in this century, when thinkers like Holmes Welch began to clarify them. Welch saw the philosophy as the primary underpinning of the religious or monastic practices, which is quite correct, but he overlooked their homogeneity and finally dismissed the religion as a kind of distortion of the original philosophy, which is not correct. More recent thought now views these two currents as but sides of the same coin, with ties in both to China's most ancient past. In this book, although I have touched here and there on esoteric Taoism, I have concentrated for the most part on the original philosophy as set forth by Lao Tzu and Chuang Tzu, as well as on the Chinese philosophy of art, which coincides so importantly with it. This approach may ultimately provide a more satisfactory explanation of all that once seemed recondite, occultist or cultic in Taoism, for it is none of these. On the contrary, it is simple, wholesome, spiritual – and natural.

It has become fashionable in some academic circles to doubt Lao Tzu's authorship of the *Tao Te Ching* for reasons known only to the exponents. That the ancient wise man was a real historical personality is not questioned. It is known from the Chinese first-century historian, S'su Ma Chien, and other sources that his real name was Lao Tan (he was surnamed Lao Tzu – Master Lao – by his followers), and that for much of his adult life he lived in Honan Province and held a notable position as Treasurer of the Chou state, which was recorded in the Chou archives of 374 BC. The main objection to his being the author of the *Tao Te Ching* seems to be in chronology – the book did not appear until about 249 BC. Heartened by this irrelevant bit of information, scholars proceeded to weaken its importance by dismissing it as an amalgam of various writers from various periods in the history of Taoism.

To my mind all of this is a rather flimsy and hopelessly nitpicking kind of argument, even if it purports to include historical 'facts', which do not disprove the tradition any more than they prove it, such facts themselves being subject to the question of accuracy. In my opinion the book has the tone, style and consistent voice of a single very intelligent author, and I see no reason to presumptuously question the tradition of Lao Tzu's specific authorship on which the Chinese people so adamantly insist. Certain chapters of the book

may seem out of proper sequence, but to this the confusion of later generations in arrangement and rearrangement can probably be attributed. Books written on bamboo or wooden tablets, as they were in Lao Tzu's time, can easily get out of sequential order or original format, especially when each entry can stand more or less on its own, as in poetry. In addition, the appearance of the *Tao Te Ching* around 249 BC in no way alters the possibility that it could have been written much earlier, or that it may have been hidden privately or lost for any number of years.

According to the given argument of chronology, it would have been impossible for Lao Tzu to have written the *Tao Te Ching* unless he had lived to well over 125 years of age. Everyone knows this is beyond the possible – or is it?

B.W.

Chapter I
The Brush of Wu Chen

Chinese painting typifies the epitome of a unique creative power – the ability to penetrate the veil of form and to express essential reality. The nature of this ability, and the nature of this reality, have a universal, spiritual and mystical meaning which is hidden within what I have called the Tao of art, the spiritual way of creativity and the creative way of spirit.

Not only was the art which arose and evolved in the beautiful China of history unique in this sense, it was also unique in another respect. It was one of the few times in art history in which art became intimately associated with philosophy, even to the point that a large majority of its expressions were influenced by and in turn influenced philosophy. That philosophy was Taoism.

There is a vast difference between the profound connection of art and cosmology in the Far East and the European art which entered the service of the Church, as for example during the Renaissance, a difference in the philosophy of art and the religion it expressed. For where Christian art embodied by and large the history and good works of the life of Christ that reflected doctrinal Church dogma, its actual artistic philosophy was not influenced predominantly by Christianity. As time passed, Western art became increasingly literal and sensual in creed and expression, distanced from both religion and philosophy, rarely having even a nodding acquaintance with the latter, despite the rise of an important school of Western aesthetic philosophers such as Plotinus, Schiller and Hegel.

In historical China the exact opposite was true. Not only did Taoism permanently alter the techniques and outlook of the artists and result in much of their art taking on the complexion of Taoist ideas and principals, but it also influenced their painting theory and their philosophy of art. A whole literature of Chinese aesthetics proves this fortunate alliance repeatedly and conclusively. Even

more uniquely, art itself served as a tuning fork for the application of those principles, and art, in turn, had an influence on Taoist thought as it broadened and evolved. Yet withal, this was a friendship of mutual agreement.

Understanding Chinese art depends, then, on understanding the philosophy on which it rested and which did so much to shape its youth and guide its maturity. This is also true to a lesser extent of Buddhism, particularly Ch'an Buddhism, and of Confucianism as its contrasting side, a worthy if unrelenting opponent. It is important, however, to remain aware that Chinese painting did not owe its origin to any philosophy, but only to the strong support of its remarkable continuity and distinction, that the creativity which was ever inherent in the Chinese genius was the catalyst which lent authority to the philosophy and gave it focus. The benefits were nonetheless reciprocal and mutually confirmatory. Taoism discovered, through the uncanny wisdom of Lao Tzu and other thinkers, certain principles of nature and the universe which relate importantly not only to human creativity but to human development and spiritual knowledge as a whole. The Chinese painters liked what they heard.

Accordingly, Chinese art must be approached from the outset through its deep and abiding ties to nature. Nature was always at the very heart of Chinese painting and nearly its sole preoccupation. Chinese culture has always been close to the land, to the earth, both in its agricultural basis and in a poetic reverence for nature. The terms which aroused a philosophy of nature in art even preceded Taoism and were anciently seated in a prehistoric animism which took on an increasingly universal scope as the historical period got under way.[1] A burgeoning Taoism had also grown out of the same roots and influences, but its mature philosophy far surpassed the simple nature worship of animism as it generated in art a direct intuitional response to nature which took on many mystical and spiritual overtones as both the art and the philosophy progressed. Of the three main categories of Chinese watercolours, bird, flower and landscape compositions, the latter are by far the most predominant, even though the bird and flower pictures also seek to discover a spiritual presence in nature.

Knowing why the Chinese painted so many landscapes it is also helpful to know something of that landscape itself. As imaginary as it sometimes seems, Chinese art was firmly grounded in realism, and the Chinese landscape really does look the way Chinese artists represented it. Tortuously growing rock formations, jagged peaks and precipitous towers of stone and earth thrusting themselves

skyward, massive eroded limestone outcroppings in unusual forms lining the edges of rivers, all are typical. An abundant variety of trees fill this vivid landscape, ranging widely from ancient pines and junipers lashed into distorted, fantastic shapes by the fierce winds of Central Asia or the Pacific monsoons, to the bowing serenity of willows growing on river banks. Flowing hills and mountain ranges, seemingly perpetual, cover an endless sense of space and distance, broken only by striking peaks and strange formations. Heavy mists rise daily from them or from broad placid lakes, vast winding rivers and river valleys, as well as from torrential waterfalls and quickly running streams. There are abundances of fish, of waterfowl, of birds, grasses, flowers; eternal views of fishing villages, rice paddies, farms and farmers, and above all the whispering mystery of green and resilient bamboo groves. China was old long before the world began. It has the look and feel of prehistory, of an earth primeval and untouched, serene and majestic and rich in its ever-changing moods and manifestations. It is a landscape seemingly surreal but actually timeless, a landscape where nature lies close to its heart.

The Chinese were at home in this landscape, seeing in it mystery and meaning, and it is the same mystery and meaning we see in their paintings, for they have brought it very effectively to us. Directly related to this was a quality the painters spoke of as 'mysterious fitness'[2] as inherent in the highest kind of paintings, a quality of self-existence and self-sufficiency which was above any intellectual conception of it. Moreover, it was a quality found in nature and its appearance in art came from the artist's perception of it. It was spoken of in terms of unity and essentiality, as well as by spirit, describing its feeling as the 'great emptiness' which was the Tao, as the 'hidden idea' of a natural scene of form.[3] From this hint of spirit as somehow present in the forms of nature and even in the absence of form, and arising from the description of spiritual reality as a sense of 'emptiness' or extreme tranquillity, came the importance and meaning of space in Chinese painting.

The Chinese artists were masters of what we call negative space, those parts of a painting which are not occupied by any form. To them, 'what is not there'[4] was as important and meaningful in experiencing the beautiful as the forms themselves, for the human soul was satisfied as it perceived the ineffable rightness of an aesthetic perfection, its 'fitness'.

A good example of this 'mystery of emptiness'[5] or space can be found in the watercolour of a twelfth-century master, Ma Yuan of the Sung dynasty, (Fig. 1). Here are the simplest terms of nature and art. A simple fisherman's home on the banks of a river nestles in the

bosom of the composition, and we see him returning home from the right, his day's catch on a stick over his shoulder as he approaches the short, narrow rough-hewn bridge which will take him to his destination. He will pass, in the dim twilight of near evening, between a pair of old sprawling willows which are now bare in autumn, and in the near and far distance mountains rise, first looming like approaching ghosts and then receding farther and farther into an illimitable distance. From the masses of trees behind his home as well as from the river a soft wall of mist spreads and blends together to become the entire middle ground of the painting.

The composition literally floats in an all-pervading sense of peace, of emptiness. The land mass to the right, where the figure walks, is firmly anchored by the twisted willows and the dark tones of the foreground and by the bridge which ties it to the left half of the composition, leading the eye toward the house and thence along the river's winding route. And yet even these forms, though solid and vigorous, seem to float, to drift in a fluid, ethereal current of oneness with their other surroundings, seeming to be somehow pervaded by them by invisible, but palpable, bonds. The mists which arise from the wooded foothills and from the river to shroud the mountains add importantly to this feeling of floating mystery and unity. For they unify the composition and spread back and forth over and throughout it, giving an authoritative realism by their very indefiniteness, as they contrast with and set off the suggested and more solid forms of tree, house, river banks, and finally the richly dark land masses, bridge and willows.

To the superb genius and mastery of this composition we must add Ma Yuan's effortless, flowing technique and style, his grasp of essential relations of contrast, distance and balance. The latter, an inseparable feature of most Chinese art, effectively embodies and gives voice to one of the most dynamic and perceptive aspects of Taoist philosophy, the doctrine of *yin* and *yang*, which we will come to later on. In this painting the *yin-yang* idea of polarity and oppositional balance in nature is certainly symbolized and present in the beautifully balanced placement of the masses, in the relation of the foreground mass to the left bank and middle trees, in the juxtaposition of the near mountains in perfectly balanced relational harmony to the willows and foreground. We also can't avoid paying tribute to Ma Yuan's incomparable brushwork, how well it describes and captures the essence of the sweeping, oppositional thrust of the willows toward sky and river, yet how strongly rooted they are in the earth and in their own individual character.

Above all, it is space which grips us here, space and mystery and

something more, something intangible, indefinite, yet definitely compelling and impressive. Especially significant is the space that, empty and limitless, soars above the mountains and off to the right distance. Is there not something in this painting, something which we do not read into it with our imagination, something which the whole picture contains, expresses, even radiates? Is there not some suggested indefinable presence, a dynamic, electric vitality, a sense of power that literally bursts from it to transcend the boundaries of the picture plane?

To the Taoist painters and aestheticians the visible forms and shapes of nature held their 'hidden idea', and this expressed a visible and individual quality which could be perceived and expressed by art. This quality, called *ch'i yun*, as a quality of form, was also reflected within, in the heart and mind of the artist. In order to release it, in order to establish an approximation with natural expression, the artist had to be natural himself, and liberated. In this way the concept of free, spontaneous brush work came into existence as a criterion of the finest works of art, and artistic discipline came to centre wholly on the essential quality of a form or motif as well as certain qualities inherent in the human being.[6] Without both of these, the picture would have no aesthetic value, no significance. Above and beyond this important view of wholly spontaneous art, *ch'i yun* was 'a spiritual force, imparting life, character and significance to material forms, something that links the works of the individual artist with a cosmic principle',[7] a distinctly Taoist idea. Siren tells us something more of this consonance of artistic creativity with nature and the universe:

> But this is active in the artist before it becomes manifest in his works; it is like an echo from the divine part of his creative genius reverberating in the lines and shapes which he draws with his hand. To call it rhythm, (as was sometimes done) is evidently not correct, quite the contrary, it manifests unconsciously and spreads like a flash over the picture or over some part of it.[8]

Watercolour was the perfect vehicle for spontaneously expressing nature in Chinese art. It was invented in China, along with most of the major techniques that artists use in it today all over the world. Its first beginnings show up in the latter part of the Chou dynasty (1027 – 249 BC), early in Chinese history. Shortly thereafter, by the Five Dynasties period, it was well established and had even developed into special branches, such as the black and white renditions of landscapes and bamboo known as monochrome ink painting. The

Chinese written language, with its infinite variety of cursive brush strokes and the special skills required for learning them had probably contributed strongly, if not to the invention of the ink painting techniques, at least to some of the virtuoso expertise of the painters with the Chinese brush. The rich Chinese ink, the devoted craftsmanship of the makers of a variety of handmade rice papers, and the use of a smooth raw silk especially for painting and calligraphy, all formed the base for splendid technical conditions and for watercolour masterpieces, and the medium became the most popular and predominant one of Chinese art throughout history.

The Chinese painters in fact loved watercolour – its fluidity, its freedom, its freshness, its latitude for spontaneity provided them with the means they sought for their ideas and their perceptions of nature. Such artistic requirements coincided ever more closely with Taoist insights into reality, and eventually took on a spiritual and ritual significance.[9] For although the technical preparation for painting was optimal, something far more important came into consideration as indivisible from true creativity – the inner concentration and spiritual character of the artist.

The rise of ink painting, by the Northern Sung period, had led also to increased thought on the meaning and method of art.[10] A whole literature of aesthetics developed in which artists and other cultured men such as scholars and poets not only painted but also wrote about art. A speciality of this distinguished group was the association of poetry and calligraphy with a particular branch of landscape art – bamboo painting.

Bamboo became a favourite subject of professional artists[11] as well as the scholar-poets who wrote about it, and nearly every notable painter at one time or another painted the lyrical bamboo of the Chinese garden and landscape. The elegance and nobility of these graceful plants, their flexible, yielding pliability and their uncommon strength, their habit of vigorous growth and vital regeneration, their ability to bend and move with the fiercest storms and winds, and their enduring fresh greenness in winter became closely symbolic of qualities admired in the scholar-gentleman and of the Taoist spirit of nature and *yin-yang*. More than this, bamboo became a most economical means of study and meditation on the source and meaning of Tao, a vehicle for perceiving the fundamental reality of life which the artists could intuitively sense in nature. More than a symbol, bamboo painting was a concentrated way to effectively express penetrating artistic insights, and the painters made full use of its natural beauty.

Such a painter was Li K'an of the Yuan dynasty, who was to join

a list of prominent Yuan masters such as Ni Tsan, Huang Kung-Wang and the irrepressible Wu Chen, all of whom included the enigmatic and lively bamboo in their landscapes. The sophisticated elegance of the bamboo as well as of Li K'an's style are reflected in his painting *Bamboo*, found in Figure 2. A quiet mystique arises from this painting, which concentrates all of its attention on a single graceful cluster of bamboo so that no other distraction can interfere with the mysterious essence it contains, and so that we can experience and savour it fully.

How many times have we seen such a configuration of leaves and natural shapes flowing together, and how many times observed the same ineffable identity about them? Thousands of times – countless times. It is this which here we see and find so striking, for it is the very feeling, the very tone and spirit of nature which this painting evokes within itself and within us. An identity, a feeling, a sense of curious 'mysterious' rightness, of veracity, yes; and something else, again, a sense of being, of spirit. Of course it is the character of the plant we experience, and the masterful way the artist has so completely captured it, but why does its character seem so fresh and enduring no matter where we find it, and so reminiscent of some greater reality?

The bamboo springs from the ground, alive, fresh, fans its own poetic symmetry to right and left. The artist has observed its balance, its unity, and has balanced his composition with the large, complex mass of leaves bending to the left by the simpler, straighter thrust of a smaller stalk mass on the right. The balance is perfect, fully weighed, as is the delightful sense of depth, of space around, through and behind the dark slashes of leaves. Negative space here again is pregnant, fulsome, seems to contain something, yet nothing is there. A fine mist subtly veils the background and the receding leaves and branches behind the exciting leaps and cross-patterns of the central mass, where rich strokes of ink create a dense and starry maze. These same configurations of light and dark, of shape and pattern against light effuse and diffuse a special vitality and unity when seen as a whole, yet they are expressed by an amazing variety of brushstrokes, patterns and empty spaces which are everywhere unalike and individual.

How was this complex tangle of leaves and surging stalks done by the artist? Only by spontaneity, by the freely moving action of the brush. He worked from the inside out, from the centre of the composition outward toward the edges. First the inner, more distant, hazy and lighter washes of the farthest leaves and branches were laid in upon the general background wash and blended, lighter

tones of the far open space. Upon these lighter values and leaf strokes the flashing grace of the darker strokes was added. The brushwork of this is simply exquisite, a combination of single stroke dashes of the brush, each of which by its own type of action and movement naturally ended each leaf in a flicking point. Before this was done, however, the pliant, drooping stems were placed, each one following its own inner direction and natural flow, a symmetry that once again must continue along its own rhythm to its own destination. To these, final leaf strokes were appended and attached, much as nature herself attaches them. Well worth noting are the two delicate, smaller tendrils which shoot upward and outward on the upper right, the sensitive placement of each where it butts against each stem, and the use of a broken line here and there which is so effective as suggestion and so evocative, by its understated economy, simplicity and feeling of nature, of something infinitely beautiful.

We are fortunate that Li K'an also wrote, and left several treatises on aesthetics and artistic method. In one of these, his *Essay On Bamboo Painting*, we can enjoy a real insight into his way of working, as well as finding certain hints at the Taoist cultivation of creativity and its use:

> Really, one should start by painting joint after joint, leaf after leaf, concentrating the thought on the brush-manner, continuing the training without getting tired. The painter must thus accumulate his power until he arrives at the stage when he can rely on himself and possess the bamboo completely in his mind.[12]

The phrase 'accumulate his power' is thought-provoking and significant. Evidently the creativity of the artist was tied to a principle of nature, because Li Jih-Hua, a philosopher of art and connoisseur of the Ming dynasty spoke of 'the creative power of nature' and further observed: 'That which is called spirit resonance (*ch'i yun*) is inborn in man, and it is in a state of emptiness and tranquillity that most ideas are conceived.'[13]

Most ideas are conceived in tranquillity? How novel! Surely this is the opposite of what we are accustomed to believe – everyone knows the mind uses words to step-by-step build up concepts in a logical manner. And yet artists have minds like everyone else – obviously it would not be reasonable to say the artist has a different kind of mind, a species apart. Even if we indulge Freud in his usual presumption and pomposity it is glaringly apparent now that he was left with egg on his face where art was concerned. No, the Chinese may have come much closer to the real nature of creativity and

intelligence than we realize, a state or condition which the working Chinese artist, and the Chinese work of art, may very well typify and specifically indicate.

Both art and Taoism begin with nature, with the basic principles of reality. What the Chinese artist learned from Taoism was how to naturalize and augment his own natural creativity and artistry in a special method of self-discipline and a special method of working that was linked to Taoism and its meditative practices. It can be said unequivocally that this type of cultivation had a definite beneficial effect in improving the perceptions, insights and creative expressions of the artists. At the same time, it gave focus to and realization of certain natural phenomena involved in effective artistic production. Many of these creative phenomena would, in turn, add a remarkable validity to the Taoist view of nature and the universe. In a word, artistic creativity coincided with Taoism most effectively and powerfully, each lending a growing sense of veracity and conviction to the other. Where art was concerned this was more than an influence – it was on the contrary the culmination of much of what the artists experienced in art. How different this reception was from that of Freud's view of art, which most modern artists find to be totally alien to their experience. In China, consequently, many artists like Wu Chen and others became Taoists or practiced Ch'an Buddhism, which is closely related to Taoism.

It is a mistake, nevertheless, to attribute what we find in Chinese art to a mere circumstantial influence or the superficial injection of Taoist ideas into painting, for in reality it is by far the opposite. What the painters perceived in nature was something universally common to all art and all creativity, and was ever the result of real and original insight. The principles of art, it is to be remembered, did not come from Taoism; they were primary, were there first, preceding Taoist ideas and as much first principles as nature and *its* nature was for Taoism. The insights of Chinese art are just that, perceptive insights, and they spring not from Taoist philosophy but from the penetrating vision of the creative mind. This is the reason why they substantiate Taoist principles so thoroughly by their agreement, and because they do, suggest an intriguing application of them to life and nature, and certainly lead in that direction. But they are relevant only insomuch as we are aware of and sensitive to that broad common ground and mutual foundation and the order of their relationship.

The strange presence or power that emanates from Chinese painting is the result of those artistic perceptions of natural reality and what that means, which may well involve a mystical, spiritual

source and many other ramifications which seem to have quite escaped our notice. It may, as well, be the artistic evidence of something which arises naturally in the greatest works of art as a true phenomenon of reality and our ability to perceive it. It may relate to a spiritual principle of nature and to the very workings of the universe.

We will resume all of these musings in due course, but I should like to point out here that Taoist meditation became seriously incorporated in the working method of the Chinese artist, making us wonder exactly what its relationship to creativity was, and what effect it had on it. This unusual circumstance was the only instance in art history, of which I am aware, where an actual religious or mystical-religious practice became a part of art. The ritual inclination of Chinese art was primarily concerned with meditation in one form or another; ritual-like practices and methods only enhanced a preoccupation with progressive spiritual control of the mind and a search for the true source of creativity within the inner self. Notwithstanding its conscious application by artists, the Taoists believed that creativity itself was a form of meditation and spiritual integration with reality that the artist practised naturally as he came to his work, hence the alliance of art with meditation was a way to make more optimal and conscious an already inherent, natural artistic practice.

A prime goal in the life of every artist is the search for truth, for the meaning of reality, and often this quest begins within, in the inner self where truth first dawns. Reaching into the depths of his own spirit, the artist learns to confront reality, to see clearly, to light his work by the light of intuition, to be true to that real self he finds there. Such an artist was the great genius Wu Chen, who is an excellent example of the bond between art and Taoism and of the potential in the latter for amazing creative development, because he had been a Taoist himself at one time in his life. Lest we elevate him to the misleading glamour which genius always seem to invoke, Wu Chen was, like most great artists, first and foremost eminently simple, human and natural, with human weaknesses and problems. Probably in his impoverished youth he had learned to be a farmer, and so supplemented his livelihood by working the soil of his land or the garden of his home, called the Plum Blossom Cottage, in Wei T'ang village where he lived for most of his life. At some unknown point he became a Taoist monk and made a sparse living selling prognostications from the *I Ching* in the countryside and along the highways and canals of Chekiang Province. Although his early life has been lost to us, an obvious devotion to Taoism speaks eloquently

of a long and arduous spiritual journey that took place before he became an artist. It was this spiritual base from which his great humanity and sensitivity grew.

It was not until the age of 39 that Wu Chen began to paint. This late beginning presupposes a sudden conversion of some kind and certainly an even more rigorous period of training, study and self-discipline that was to follow, both in art and Taoist meditation. His first mature painting does not appear until a decade has gone by, and even at that point he is still groping, still learning, still probing for a voice and a style, still searching for the meaning of ultimate reality which he knew lay dimly hidden in nature.

These two things, Taoism and art, were what made up Wu Chen's life, and it is strange how they had interacted together to produce a master painter, that his studies in Taoism had led to a seemingly far different course, that of art. But was it? Evidently in the case of Wu Chen it was precisely what made him become a painter. Certainly Wu Chen saw no difference between the two, for was not the Tao nature, and life itself, the same, and was not art the voice of that same spirit which was within and without? Whether he was a Taoist monk or an artist was undoubtedly the same thing to him, and we know from the mature period of his career, when he was in his fifties and later, what an extraordinary union it was.

So it is unlikely that at some definite period in his life Wu Chen stopped being a Taoist monk and became an artist; what he had experienced in Taoism became the fulfilment of his life and the centre of his art, and the two remained as inseparable as they had always been once he came to that realization. There came a moment in midlife when Wu Chen found his reality, found the Tao of art, and found his own true self.

From his work it's clear that here was a man who loved life, who had a joyousness in nature and all creation, a sense of wonder and reverence, childlike and fresh, for all things. His flamboyant personality, his love of freedom, nature and spontaneous experience led him to regard art, poetry, love and festiveness all as ways of reaching the Tao and all as part of the same experience, the art of life. Like many Taoists, he saw human creativity as part of the spiritual purpose of Tao, liberating the human soul from the conditioning of civilization and society and the illusionary egotism of the unrealized mind, the intellect blinded by its own chatter and limitations. Indeed, he looked upon painting as 'play' and to him it was a kind of play, a joyous dance of creation upon which the mind could soar upon the cosmic energies of spirit.

This was Wu Chen, the joyful lover of life, but there was another

Wu Chen, the devout contemplative, the seeker after hidden spiritual mysteries and the central truths of nature and the universe. We could discover him when he is alone, in the silent and still hours of his solitude when his face radiates with a serene calm as he paints or in the hours of silent meditation when he is lifted to sublime levels of being he could never explain.

But most of all we could see him when he is with nature. Outdoors, wandering with his sketchbook and brushes in hand over the hills and valleys of the province he loved, a strange peace comes over him. We could see him roaming for miles over this mystical, magnificent landscape, watching, learning, experiencing. He comes to it early in the morning when the first silver mists are rising in the bamboo groves or at sunset when the sky turns gold behind twisting and jagged mountain peaks and far hills. He seeks it out in the heat of day or in the foggy rain – he becomes one with it.

He *sees*, he senses, he learns. He is there when a flock of mandarin ducks breaks out of the reeds to take flight, he knows the beating sound of their wings on the morning air, the quickening rhythm of their colours. He observes the fragile heron against the porcelain sky, studies the pink delicacy of the plum and cherry blossom, lives in the dashing waterfall, the bowing willow, the lily pad floating on its own splendid universe.

He wonders, listens, watches. He runs sensitive fingers tenderly over the rough bark of a cherry tree, feels the strong smooth coolness of a bamboo trunk, studies how it gracefully gives with the wind. He wonders, listens – and from it all something still and tender in his own heart speaks eloquently, in feelings, in vibrations, but he can't tell what it says, only that it moves him to happiness, to art. And he finds it again many times, when he paints – the same stillness, the same feeling and spirit as the wind and the bamboo, in paintings like *Bamboo In The Wind*, (Fig. 3).

Sheer poetry, this painting simply sings with life. Laid adroitly along one side of the paper, the negative space where there is nothing is just as important as that occupied by form, as we saw earlier to be so typical of Chinese art. Here the brooding emptiness on the right side of the picture has the effect of virtually infusing atmosphere – approaching, rising mist, the hint of coming rain, of fog, of a vast and undefined distance which again transcends and erases the limits of the picture surface and all containment within that surface. It literally breaks free. The left side of the composition, in contrast, is all driving action, dynamism, vitality, a sweet rush of wind and fresh air.

But what stops us is the brushwork. It is thrilling, perfect,

magnificent. In it lives the very spirit of nature, for whatever it means and with all its invisible meaning, created merely with masterful, simply but precisely placed, indescribably free strokes of a bamboo brush. How does this magic come about? How was this great painting done? How and why do we feel the wind which flutters and lashes the leaves, the suggestion of rising wind, rain and mist, the whole feeling of raw nature which is so alive, so evocative of something, some vague, intangible reality within it or beyond it?

The technical details of this painting alone will not yield the secret of its magic. A simple composition, the springing vibrancy of the wind-driven bamboo is balanced by the restful, obscure suggestion of the picture's voluble negative space, already noted. The long and sweeping main trunk with its lissome arch was probably done in a single stroke of the brush, the dragging effect of a half-dry wash on the paper producing its rounded, softly blended shape, the joints added afterward with another single stroke when this was dry. Next, the artist laid in the smaller trunk, and with it, in a somewhat lighter wash, some of the limb shoots and shafts which so dramatically soar upward at an extreme angle, as well as some of the most distant, farther leaves, thereby intensifying the sense of depth and receding space with this lighter, more sensitive value. Over these came a slightly darker wash of inked leaves, dashed in very quickly and freely to indicate those masses somewhat nearer in space. These can be seen in the upper right mass of leaves and in some of the leaf shapes and forms near the lower portion of the main trunk. Last of all came the darkest leaves, literally thrown in with almost sublime artistry and freedom, loosely and spontaneously with a finely pointed brush, and these cascade across the trunk just above the centre of the picture.

All of these things go to make up this great painting – its carefully placed, dynamic composition, its precise and powerful brushwork, its magnificent portrayal of elemental atmosphere and a single simple moment of nature, its wonderful sense of actual life – but there is again something more in the painting, infinitely more, something we have not yet completely understood in Western art – the Chinese called it *ch'i yun*, 'spirit resonance'.

Wu Chen's thoughts remain here too, revealed by his poem decorating the right side of the painting and inscribed in his own inimitable, freely fluid calligraphy. As with much Chinese writing, it makes you think, so that the meaning of the words is full of subtlety and must be carefully and deeply pondered. Loosely interpreted, it reads:

The bamboo, without a mind, yet can send

Thoughts soaring among the clouds;
Standing alone on the mountain, quiet,
Dignified, it typifies the will of a gentleman.[15]

To which is added, touchingly, 'Painted and written with a light heart', and the signature of Wu Chen.

There is a curious passage in the Chuang Tzu which says: 'The painter takes off his clothes and sits cross-legged.'[16] It implies that in order to paint the artist assumes the mental and physical disposition of meditation. The 'clothes' are both literal and figurative. Indeed, many a Chinese artist went into a sort of spiritual training to paint a particular picture (an idea which may surprise Western artists), the way an athlete trains for a competition, drinking only the purest cold clear mountain water, rising before dawn, abstinence from food and sex, and long hours of meditation on their subject before a brush was ever picked up.

Perhaps *Bamboo In The Wind* was done in meditation on part of Wu Chen's own garden. Perhaps the bamboo grove was visible from his terrace doors, where he could see it in his daily passages, observe it in every kind of weather and season, know it, love it intimately. He decides to paint it, and begins meditating on it. He sits before the view in complete stillness of mind and body, without any thought, daily, for hours, for days, perhaps for weeks. He waits for the right light, the right condition of day, the moment of poetry, the moment of spiritual truth.

The moment arrives. The soft foreboding shadows of a rising morning storm settle on the garden; a silvery, softly misted fog lifts among the bamboo, obscuring its other surroundings; the wind gathers, whistling and flapping through the leaves with a subtle insistent song, gently swaying and bending the yielding stalks and shafts; the first drops of rain fall. Something in the artist's heart says yes.

Wu Chen sits cross-legged on the floor before his rolled out paper, quietly, with deep concentration, his brushes, his ink stone and ink stick, his water jar nearby. He grinds the ink stick lovingly and carefully on the stone, adds water, makes a thick black, adds more water, produces a wash of just the right consistency and value. He selects a brush.

The strange familiar stillness rises within him, the confidence, the boundless inner ocean. He is no longer conscious of himself or his intellect, no longer conscious of the brush – hand, arm, mind and brush have all become one. An infinitely tender harmony guides his

hand, a spontaneous freedom his heart – he paints *Bamboo In The Wind*.

Notes

1 Lee, Sherman E. *Chinese Landscape Painting*. New York: Harper and Row, Publishers, 1954, 3, 4.
2 Siren, Osvald. *The Chinese On The Art of Painting*. New York: Schocken Books, 1963, 26.
3 Ibid., 27, 163.
4 *Tao Te Ching*, XI.
5 Siren, 15, 159.
6 Ibid., 163.
7 Ibid., 23.
8 Ibid.
9 Sze, Mai-Mai, *The Tao of Painting: A Study of the Ritual Disposition of Chinese Painting*. New York: Pantheon Books, 1963, 104.
10 Siren, 38.
11 Ibid., 53.
12 Ibid., 113, 114.
13 Ibid., 157, 159.
14 Ibid., 111.
15 Sze, 6.
16 Siren, 51.

Chapter II
Art and the Principles of Taoism

If we were pressed to classify Taoism in dusty academic terms it would have to be called pantheism, i.e. a doctrine which equates the forces and laws of the universe with God. But this is somewhat like calling Mount Everest an oversized hill. For Taoism is probably the only religion or philosophy which teaches us more about the central truth of spiritual life and the nature of the Divine Intelligence than we are ever likely to learn by any other means.

Is the Tao, then, the same thing as God? The answer is 'yes' if we are willing to accept God as Life, Supreme Spirit and the Source of Life, and 'no' if we imagine He is the Ruling General or the Great Business Executive in the sky. For all practical purposes Tao is God, if defining it in Western terms will help to clarify some of its main meaning. Nevertheless, we should like to emphasize that Taoism is of considerable help in enlarging our commonly limited ideas of the Supreme Being, and in achieving a clearer understanding of its nature. Taoism, in fact, succeeds in penetrating the most basic foundations of life, into the very heart of reality, and establishes, far more deeply than many other religions or philosophies, the real meaning of creativity and spirituality.

The drawing of parallels between Taoism and many Western spiritual beliefs is not unprecedented. The Taoist writings are full of suggestions which Christians can readily understand, and modern Chinese thinkers and Western sinologists have made such equations repeatedly, among them the novelist and philosopher Lin Yutang, who defined the Tao as 'Divine Intelligence'.[1] Other interpretations and translations have yielded 'Principle', 'Creative Principle' and 'Ultimate Reality' as accurate definitions of the meaning of the Tao.[2] Alan Watts spoke of it as 'most certainly the ultimate reality and energy of the universe, the Ground of being and non-being'.[3] Even so, the idea of Tao may continue to challenge, test, and gently

nudge some of our notions of what God means.

Taoism will not, of course, cause us to change our ideas of God, but rather to expand them through progressively advancing insights and a more lucid spiritual knowledge, a consummation devoutly to be wished, considering the modern world's continuing tendency toward egoistic materialism and the deification of science and technology. Taoism completely shatters this tendency, for it forces us to open our hearts and minds to the world of spirit, to infinity rather than to the worldly verbalism of logic, to experience something of the Divine as it is in itself – without limit, creative, cosmic – and not as we may wish it, in our fondest dreams, prejudices or dogmatic theologies, to be. In short, it is one of the most exalted, most spiritual, and, it may be, most accurate visions of the Godhead ever achieved.

Taoism is almost embarrassingly reverent; it is also un-compromising in the simplicity of its beliefs. To the Taoist there is only one reality, the Tao, the spiritual world. We have all deviated from it and we must all get back to it as soon as possible; it shows us the Way to do this even as it explains the principles of that reality. The word Tao in Chinese (pronounced 'Dao') literally means 'Way', i.e. a road, a path, the way to take. By implication this also means principle.

So the Tao is a principle. But what kind of principle? Since we have likened it to a pantheistic mysticism, and since God is a spirit, it is first of all a *spiritual* principle. Accordingly, it is a basic, or first principle, so we are here beginning to grapple with the primary nature of things, with our own inner self, with the nature of being and the being of nature, with the very roots and firmament of what it means to be alive and what life is.

At first this may seem an odd combination, that Taoism involves both fundamental reality *and* spirituality, but no contradiction is involved, because to the Taoist the spiritual side of life *is* the foundation of existence. Taoism begins with spiritual life as the only unchangeable reality, as the One, the life essence. From it all things have their beginning, and in it all things have their character, realization and fulfillment. Tao, or the spiritual centre of the universe, is spirit and life united.

Oddly enough, art is also concerned with being, with the reality state. It is not only deeply involved with truth, harmony and beauty by its traditional interests, but also with nature, with the spirit of things, with the very stuff of life. It was no coincidence that the ancient Taoists looked on art with special interest, for it seemed to correspond in many ways to the principles of Tao. This agreement

17

was welcome among the artists, who saw in Taoist philosophy an organized conception and codification of much that remained inarticulate in art. The impact on Chinese art was, of course, without equal – Taoism became the primary basis of Chinese aesthetics. Many centuries ago Chinese artists began to learn that a spiritual principle lay at the roots of their creativity.

Tao, however, seems not content simply to *be* a principle. It also *works* or *moves* as a principle. It is an operant, or living principle which infuses and governs all of nature, including the heart, mind and soul of human beings. This is like saying that spirit has action, flow or energy, clearly a novel and unusual idea in Western religious terms – yet the world is full of its evidence. Tao works in cyclic rhythms of constant transformation and change. The laws of cause and effect, and the cycles of nature are among the best proofs of that idea. This real phenomenon was identified by the Taoist doctrine of *yin* and *yang*, the natural balance of polarities and opposites, a point on which we shall elaborate later.

An essential interblending and unifying harmony of opposites is also typical of art and the basic nature of creativity. This is apparent on several levels, but is best seen in the transformative quality of art and its characteristic of uniting the inner, or subjective world with the outer, or objective world. The creative process is perpetually engaged in changing things from one form to another to achieve its purposes, i.e. building, renewing, manipulating space, forms or ideas. Its ultimate end is harmony, beauty, a state of tranquillity, the balanced resolution of previously unshaped or discordant conditions. On its very simplest level an example of this is when the artist begins with a blank sheet of paper and transforms it into a beautiful watercolour, or the sculptor begins with a raw block of marble and makes it into a lovely nude. Creativity is a transformative process in which opposites become united or balanced out, and as such evolves and evokes harmony.

Secondly, the Tao is a *universal* principle. This means it pervades every form of organic and inorganic life and is everywhere of the same nature, i.e. spirit. As the dynamic centre of spiritual being it is the elemental basis of foundational truth, or reality, and is therefore the base of all existence, of all real being. Consequently, Tao inheres equally in all things and all people in their most essential and natural souls, but in a form beyond any logical or rational knowledge, which may not be the paradoxical dilemma it seems. So once more the insistent Taoist idea arises that spirit is the life essence – the soul of humanity, of nature, of the universe itself. The universal Tao nature then, is also original nature, original being, and it follows

that *our* real being must consist only of that which most resembles Tao or springs from it or reflects it. More importantly, such ideas suggest that our true self, our very life and identity, lie entirely in spiritual life.

A time-honoured Western maxim says that art sees the universal in the particular. This suggests that there is a single essence or chord which runs throughout life (to the Taoists, this is the Tao) that can be identified and revealed by art. If the overriding principle of spiritual Tao is what governs all truth and universal being (when the mind and soul are of the Tao nature), then art can become a medium for the making real (realization) of Tao in the physical world, which is exactly what the Taoists claim. Certainly great art is always deeply involved in the depiction of the essence of things. Ever seeking essential spirit and meaning in form and content, rather than superficial surface characteristics, art perceives and defines essences through a variety of means, such as artistic conventions, 'looseness' or spontaneous freedom of style, suggestion, symbols, intuition and other devices of creative liberation. The oneness of the spiritual world, beautiful and omnipresent, and the spiritual essence which pervades all of life, are what make the artist, or any creative person, the expressive voice and reflection of Tao.

The third major principle of Tao – and possibly the most interesting, startling and refreshing – is that it is a *creative* principle. This factor links the spiritual world with creativity – an idea practically unheard of in Western religion and generally un-considered by Western theologians, who prefer to keep God wrapped in a manageable little package. The fact is that the seasonal, evolutionary, physical and biological changes and stages of the natural world are a rich creative process, and that all of the universe is in a constant state of creative renewal, as even physics circuitously proves. Cyclic ebb and flow as found in nature and human life is not merely a mechanical, mindless accident of the universe, but a living, growing, changing, harmonizing state of infinite creative activity and infinite quiescence. In a physical world imbued with spirit, the vital energy generated from the latter is the sempiternal life force, the intelligent activator, the creator, the transformation dynamic of all that we can observe about us in nature. Beyond doubt here is the creativity of transformation in its most primal and elemental form.

Taoism tells us that the end purpose of this transformation process (i.e. the cyclic rhythms of the cosmos) is to bring about an all-encompassing harmony designed for the good of every living thing. From this, it was wisdom for the Taoists to assume that total

harmony returns to and unites with Tao, so equating harmony with the 'Highest Good' and the ultimate meaning of the universe, a sweeping but thrilling idea. The creative principle of Tao flows out into nature as a positive, beneficient and constructive good, vitalizing and shaping all forms of life; and so do all things created flow back into it again on the infinite tide of life. *Yin* and *yang* are not abstract Taoist enigmas but intelligent observation of the Creative Intelligence manifested in nature. And once again we find a Taoist principle coinciding significantly with the formal requirements of art – harmony is intrinsic to music, to painting, in fact to all of the arts.

This is not by chance. There is a deep, abiding unison between the nature of art and creativity and the nature of reality, and this common ground is the spiritual dimension. This accounts for why the Taoists could not avoid art as part of their philosophy, for Taoism explains art and art explains Taoism. Art validates Taoism's identification of the fundamental principles of reality; Taoism defines the fundamental nature and meaning of art and creativity.

Perhaps both together can offer important clues as to what we should be doing with our lives, for some of the subtle revelations of Taoism suggest in comparison that some of the values of our society and civilization can be called destructive, that somehow many Westerners have not yet discovered their full creative capacities, nor the art of living, nor the key to spiritual fulfillment, that perhaps we need to cultivate our garden, as Voltaire put it.

In a universe in which all things are ordered and motivated by invariant principles of harmony and renewal, not only art but all human creativity takes on a special value which nevertheless raises many questions and innumerable implications, such as the necessity of defining the most natural or highest principle of the mind, the nature of intelligence, and the processes through which real being and bona fide creativity are achieved. If creativity is a fundamental action of the universe, art is simply the human or material extension of an inward and invisible tendency. While we are aware that art is a primary human expression, springing directly from human feeling and the basic humanity of man, its real significance relates to even deeper levels. For beneath the principles of transformation and regeneration which are the drives of the creative universe lie the primary shapers of reality and the life essence – spiritual energy and spiritual character or effect, which in the physical world translate into, and are perceived as, form, states of being and intuited essences. If the Way is creative, there is a Tao of art.

The historical, formal world of art and the work of the professional artist represent the epitome of this human creative Way as it is achieved in human life. Yet they differ from other kinds of creativity (while having the same source) only in that the perfectly executed work of art is able to give concrete expression to essence or reality in an enduring form – the form of artistic media.

This connection with real meaning detaches art from ego and situates it in the level of fundamental being which is identical to the spiritual state of existence. This is why the Taoists regarded art as a spiritual means and the formal realization of the principles they saw as the very fabric of the cosmos. On a symbolic level this is like the fusion of spirit and matter which is the creative movement of Tao. But in human terms it is the mind which creates, the pure mind, the mind at one with itself and the spiritual flow of Tao. It is a concept which places some emphasis on the special development and achievements of the individual artist, yet even so, all creativity was one to them, since it was but a facet of the Tao principle and shared equally as the mind-reflection of the spiritual bases of reality and the fundamental harmony of nature and life itself. Art is only innate human creativity taken to its most advanced degree. The professional artist simply acquires the in-depth training, discipline and means (and sometimes the spiritual development) to give that inherent potential the most lasting and qualitative expression that it is possible to give.

This amounts to much more than the wedding of art to a universal system. It involves, as we have seen, the whole basis of being, mind and reality. Art is the living human mind reflecting the spiritual essence of reality, or as Chung-Yuan Chang observed, 'When creative intuition and ontological experience become one, great works of art are produced'.[5] The primary nature of being and spirit are inseparable from the natural creative process, so art is one of the ways they become manifest in the world. Since art is a true manifestation of the primary creative principle it contains Tao. Containing Tao, it conveys beauty, spirit and meaning.

Thus there is a Tao of art, the reality of the spiritual world emerging through the human mind and the voice of creative expression. But art is not only a window on reality; it is also a medium of mystical spiritual knowledge carried through the higher mental process of intuition. I believe this vital relationship between the Tao nature and art has a twofold importance. The first side of it is that art reflects spirituality (Tao) as an institution and as a historical experience. Over the course of cultural history man's mental growth has not been proportionate to his scientific progress,

21

but rather to his cultural and creative development. This refers to the essential nature of the mind as well as to the likelihood that the historical passage of art has been one of a subliminal learning experience which, considering the findings of Taoism, has become infused into human life and has catalyzed the intellect into progressively advancing stages of developmental refinement, over the mass of humanity in general. The second aspect is one of more immediate interest to modern readers, that art is a Way by which the creative process can be improved through its bridge to Tao and through which the further limits of spirituality may be better known and incorporated into self-improvement and spiritual development.

We are interested in the ways this phenomenon works, and how we attain it or fail to attain it, even though the Taoists have warned us that the Tao is beyond any precise definition. In terms of rational knowledge, this is certainly true. We can't know or see the spiritual dimension completely or fully as long as we are joined to the physical world – we can only see or know 'around' it – 'as through a glass, darkly' – but this is a great deal. We can progress by following Taoism's lead and by utilizing the experience of art and creativity only up to that point where all words fail and the mystery and mystical heart of Tao come through. But at that point we may be at the doorway of unity with it.

Two exemplary paintings from widely varying periods in Chinese history express two of the most vital principles of the Tao in nature – quiescence and power. These are *Autumn Skies Over Mountains and Valleys* by Kuo Hsi, (Fig. 4), and *Evening Mist On A Strange Peak* by Fang Shih-Shu, (Fig. 5). These paintings come from almost opposite poles of the Chinese historical spectrum. In the case of the former, from the twelfth century Sung dynasty, and in the latter from the near end of dynastic history, the eighteenth-century Ch'ing dynasty. The correspondence with Taoist principles in each of these paintings remains remarkably fresh and consistent, despite the fact that nearly 700 years had passed between them.

Kuo Hsi brings us to a broad and serene river in the fall. From the lower right a very strong and freely rendered tree in a rather dark, staining type of wash leads along the active foreground, past a mass of rocks and a roofed belvedere on the bank overlooking the river. A little farther on two sprawling pines continue this leftward thrust toward the river, emphasized by the movement of the land shape to which they cling. The pines push the eye upward, across the broad, tranquil plane of the river, toward the ridges and mountain peaks. At the same time, the river forcefully directs movement toward the

evanescent, hazy middle ground. There the edges and pagoda-style rooftops of a city or palace appear, rising amid soft and muted masses of trees and mist. From thence another bank of misted fog picks up a jutting mountain crag with a strangely expressive shape, flows along a wall of cliffs and peaks and leads once again toward the left distance. The same flow of mist unites with the flatter, almost tabletop ridges of the peaceful middle ground, wandering off further and further into the distance and the timeless space it evokes, touching only two or three indistinct mountaintops as it melts into the sky and the far land beyond, which we do not see but somehow know is there with an unmistakable sense of continuity. The final mountain forms near the top centre and top right, are also shrouded in fog as they vanish into an infinite space, are so airy, light and suggested as to be hardly a whisper, a mere breath of tone, yet they register their own character and reality very succinctly, containing a knowledgeable identity within their form, a 'hidden idea' of their being, their existential reality. And this was not brought out through a detailed representation, but through their essentials, their spirit.

Artistic conventions, mastery of technique, suggested space and symbolic design, as well as a deep sensitivity to, and perception of, the character essence of natural forms – all are abundantly evident in Kuo Hsi's painting. Such conventions are expressive and expressively rich, as expressive of natural character in their own way as natural forms are in reality, and this suggests most pointedly the existence of a very singular phenomenon – a common basis for nature and art.

A typical convention is shown here in that middle ground mass on the right where tree forms and the pagoda building forms seem to rise from an all-enveloping mist, a means Ma Yuan used in an almost identical manner in the little fisherman's home of *Bare Willows and Distant Mountains*, (Fig. 1). This is not imitation nor even influence, but simply the use of artistic convention to help express an essence, the essentials of a part of reality. The wonder of this kind of artist shorthand is not that it is originated by artists and often commonly used and re-used by every artist, but that it so effectively describes the subject in such brief, but altogether effulgent and convincing terms. That they are so effective is brought home to us very clearly when our eyes can't escape the poignant beauty and reality they suggest.

Kuo Hsi's pines are another good example of conventions combined with liberated and spontaneous brushwork to grasp the essential spirit of a form. What we have in these writhing shapes, done with short, jerking sprints of the brush or with graceful,

meandering rhythms, which follow an inner vitality and an outer symmetry, is not literal physicality, not wood and resin and biological fact, but *spirit*. And the spirit of the trees – with their rough trunks and roots grasping deep into the earth like dragon's claws, the casual, offhand dots which suggest their bark, the delicate threadlike brushstrokes of the needles and the long, fluid streamers of ancient moss hanging from the limbs – is brought to conscious reality through these artistic means.

Other interesting and notably brilliant details are evocative of the artist's insight and the infinite, universal quality which pervades this painting. These are the gay, even playful branches and limbs of the tree on the right with their calligraphic line which reminds us of the bistre drawings of Rembrandt, the flat shelf of rock next to that tree which so well defines and characterizes the far river bank, and the stabbing accents in the sweeping, swirling fluency of the hazy ridges and plateaus in the middle distance. Close to this point, in the exact centre of the composition, several tiny figures and miniscule structures add a sense of scale and grandeur to all of this open air and space, bringing to mind man's insignificance in comparison to nature and the universe. Incidentally, if we have any doubts that this painting is an accurate depiction of a real scene in the Chinese landscape of long ago, and not a work of the imagination, we need only compare it to a companion piece by Kuo Hsi in the Freer Collection, *Autumn In The River Valley*, which is the same scene shifted toward the right to include much more of the far right mountain, and cause the pagoda and wooded area to be more centred. All of the trees and mountains look exactly the same in this second view, as do all of the other forms, and all are depicted with the same methods.

In *Autumn Skies Over Mountains and Valleys* a dynamic tension is established between the prominent mountain peak in the right middle ground which pushes left, and the smaller crag in the foreground which echoes it and thrusts right. An almost perfect balance between these two forms is, in this way, achieved. And yet, paradoxically, out of all this tension and force and swirling movement there comes from this painting, when viewed as a whole, a definite air of serenity, of calm, of stillness, the infinite sweet quietude of tranquil nature we have experienced many times in her presence.

Some of Kuo Hsi's sayings and observations on art and creativity have luckily come down to us in written form,[6] providing a more personal meeting with the artist and a closer insight into his work. The following example is revealing:

Whatever motif the painter represents, be it large or small, complicated or simple, he should do it by concentrating on its essential nature. If something of the essential is lacking, the soul is not manifest. He must do his work with his whole soul; if he does not work with his whole soul, the essential will not be clear. He must be severe and respectful in his work, otherwise it will lack depth of thought. He must apply zeal and reverence to complete it, otherwise the picture will not be properly finished.[7]

Other writings of Kuo Hsi laid a very important emphasis on artistic detachment, both as related to distracting or disturbing external circumstances as well as on 'a profound tranquillity or emptiness of mind'.[8] This precondition led, according to Kuo Hsi, to a self-identification of the painter with the soul or spirit of his subject, a 'becoming one' with its spiritual import. In and through this process the 'inner significance' of a subject is visually manifested,[9] and art becomes the concrete expression of an individual essence or fundamental reality. Furthermore, Kuo Hsi believed the visual phenomena of nature, in their *appearances*, such as those of mountains, rivers, mists, lakes, etc., to be 'individualized manifestations of an all-pervading spiritual life',[10] and that it was this which gave them their expressive quality. Both of these ideas very much confirm Taoist principles.

Shifting to the work of Fang Shih-Shu, we find *Evening Mist On A Strange Peak*, (Fig. 5), to be nearly a study in contrasts to Kuo Hsi's work, for where the latter was all smooth movement and lyrical serenity, Fang's metier seems all forceful, vigorous vitality, filled with a driving, electric dynamism, with some inexplicable, self-contained power.

The style is, of course, typically Ch'ing and reminiscent of the naïvety of Tao Chi and other eighteenth-century painters, yet here there is substantially more solidity, polish, depth and discipline. The picture leads us into it from the left foreground, as we ramble down some foothills and a flat path through the near woods which break up and dominate the foreground. This path makes a hidden connection with two houses on stilts sitting upon the lapping depths of a large body of water, the wide river which flows into it along the course of a winding rock shelf on the far right. On the same natural thoroughfare are the small figures of two fishermen or farmers who have met and stopped to chat, their ridge-poles and baskets still suspended over their shoulders. Above them a sheer precipice covered with pines overshadows these figures, even as the eye is led along the same border toward their destination, a village half-hidden behind a

stand of evergreens in the middle ground. Mist rolls up behind the village, over and through some more pines and into the base of the spectacular wall of mountain which makes up and commands the entire centre of interest. Although we are awed by this massive form, we can escape across it over the ridged saddle of the left centre, to view a large lake on the other side. The waters of the lake move rapidly to the left again, suggested by the downstream flow of two or three boatmen, whose craft glide in a swift movement farther left toward a rough footbridge, under which course the bubbling backwaters of the lake, an inlet which will return us once more to the beginning of our idyllic journey through this rugged landscape.

On the distant surface of the lake, reeds and water plants outline the flat marshes of its banks, from which more misty peaks and an opposite belvedere arise. In the far distance, also veiled in mist, a receding mountain range is delineated by the merest twisting accent. A strolling twirl of the brush then passes behind the mysterious high peak and picks up again in the most distant apexes of the upper right, as they disappear in space and atmosphere.

The intense vitality of this painting and its vigorous feeling of life are tied to the intensity of the painter and the way he has so deeply understood and brought out the essential, expressive character of the landscape. For example, in the immediate centre foreground we can not only see, but *feel* the rounded mounds, swellings, hollow pits and depressions of the earth as they turn and move, rise and fall. We can also experience, in the turning of these forms, in the way the outer rim rolls over itself and pours down into the steep, flattened space of the slope, the shape and form of the land which are indistinct from its character, which can only be called its inner nature. And, strangely enough, the splashing washes, drybrush effects, and curving, liquid brushstrokes which follow these forms, and so effectively express them, are not carefully thought out, not contrived or calculatedly planned, but are spontaneously executed.

The same is true of the trees, the rock faces and their formations. The artist never forgets the soul of his landscape, making us also participate in its being, in the way the trees of the left and right foreground cling to and grow down along the sloping lay of the downward spilling valley, even as the centre stand of trees, growing on a high point, must tend upright. Is this knowledge, observation, or instinct? Perhaps all of these, but clearly there is no fakery here, no lack of honesty or deep concentration. Despite the seemingly naïve, even childlike pattern of the leaf brushwork and other accents on the pines, cliffs and deciduous trees, each stroke is placed with intense restraint and reverence, on a solidly accurate form. And the

land is solidly there, too, underlying massed and massive forms which hold up the structure of this painting more powerfully than the iron girders of a skyscraper. A main master form unifies the composition. It is picked up, perceived as the heart of this landscape, and thrown across it like a giant lightning bolt, shooting in undulating, diagonal thrusts which begin in the foreground and continue right up through the main mountain peak, its climax.

This is a large painting, almost eight feet tall by two feet across, sweeping and big as nature herself, and must have been extremely difficult to execute in a water medium, which doesn't easily lend itself to such size. More remarkably, it loses none of its primeval majesty by being reduced to a smaller size in reproduction. Its overall impression, which is one of vigour and the splendid roughness which we have so often observed in nature, has also in it the intangible, mysterious qualities noted in earlier examples, but which are here much more evident and easily perceived. Perhaps some of this is amplified by the electricity of the moving lines which surge up and down the cliff faces and feel their way up and around the forms, ledges and ravines of the main peak. Such brushstroke accents were called 'dragon's veins' by the Chinese painters and were thought to add vitality to a painting. Their interlacing, surging movement certainly does contribute a mighty flow of energy to the rock masses as they explore, define and describe their form and character.

It is easier to observe this elusive sense of something radiating from the painting when we can concentrate on it or isolate it in a particular area, where it seems omnipresent, pervasive and clear. This occurs most definitely in the largest rising mass of the tallest mountain, with its flattish, rounded peak, the 'strange peak' noted by Fang. For in this form we can't fail to notice that it seems to be pervaded by some powerful dynamic, that it seems to generate a strange, unexplainable sense of *power*. There is something we can see here which, it is true, typifies its character, even its being, its very essence, but which in addition also transcends those qualities – or inheres in them and makes them one. Does spirit, nature and character, then have *power*? Certainly it can here be known as such, as a bursting vitality which the artist saw in a natural form and translated perfectly into art, so the real presence of nature comes through the painting with all its uncontainable force. Is it the fusion of spirit and matter we see here? Is it spiritual reality which radiates such ineffable power?

A third example of the intimate relationship between art and the principles of Taoism can be found in a painting by Tu Chin of the Ming dynasty, *The Poet Lin P'u Wandering In The Moonlight*, (Fig.

27

6). The artist has depicted a famous Taoist poet, painter and scholar of the tenth century, Lin P'u, who withdrew from the world to live the life of a contemplative in the West lake region near Hangchow.[11] Lin P'u became a spiritual master in his lifetime and in later centuries was canonized as a Taoist saint. It was said he was so close to nature he had tamed Manchurian cranes to fly to him and call him in from his fishing vessel when he had visitors.[12] We see him here walking in the cool, clear moonlight of his island home, Ku-Shan on the West lake, where all of the strong mystical character and ethereal spirituality of the poet-saint comes through very clearly for us in Tu Chin's painting.

The numerous aged and twisted plum trees which grew on Ku-Shan were traditionally believed to have been planted by Lin P'u, who greatly loved their gnarled character and delicate blossoms, and Tu Chin uses such a plum as a dominant background and symbol of the poet, as well as an arresting compositional device which cleverly eradicates the picture's limits as it exits from and returns into the painting. This feature not only compels and satisfies our imagination as the mind completes the unseen portion of the tree; it also serves to unify the objective, outer consciousness of the viewer with the subjective, inner world of the painting. It unifies what was beforehand essentially opposite and seemingly differentiated. In making that bridge we are directed by a pointing, staggered limb downward to the massive boulders by whose side the venerable old plum grows. There we are tantalized by rich, masterful ink accents which sharpen a cleft in the rocks, and are led along the vegetation and luminous moonlight which plays over their surfaces down toward the water's edge, where the tree in its great age grows down and dips into the liquid ripples of the lake.

Only the slightest touches and subtle suggestions show us that Lin P'u walks on the shoreline of his island. The mists which rise at the water's edge near the tree, the random swirl of the brush which creates the lapping water surface on the far bank, the little dots of plant life along the sharper rim of the near bank, the glowing middle-range washes which feel out the gentle slope of the ground where the figure walks, all create an imprecise but solid land body which is the complementary opposite of the rising space of the background, where lake and sky become one, where universe and water conjoin. The choppy, eroded and pitted limestone of the foreground, too, completes this circular, ringed environment around the poet, leading us back to him as it picks up the deft, slender line of his staff and returns us to the figure, and finally, the face. This primitive, angular form of rock in the foreground echoes and

balances out the lightning-like angularity of the plum tree beyond. We could sit in the hollow of this cool rock saddle, feel the leaves and ivy which grow on its flat planes, pits and facets, run our hands through the vines and roots which trail down into the water and move in reflection beneath its surface – a mass of slashing strokes and translucent washes have transformed a section of white rice paper into an intensely real natural form.

The magnificent handling of the washes and pointed brushwork on the rocks, ground, tree, and especially on the figure are certainly virtuoso and typical of the mastery of the 'conservative' Che school of painters which flourished in Chekiang Province during the Ming dynasty, a similarity of style which probably originated with Ma Yuan and his Southern Sung followers. The wonderful ease, effortlessness and facility which so typified this and other examples of Chinese expertise with the brush had, nevertheless, a basis which quite superceded any concern with style, manner or artifice whatever. It was a facility which was not facile, so to speak, and was always grounded in intuitive direction on the performance side, and in the expression of nature and its character on the content side. This repeated merging of inner and outer means reinforced and broadened not only a typical artistic preoccupation with the essential nature of the subject, it led as well to the almost unavoidable philosophical conclusion that as the essential form and its intrinsic character were expressed, so was their spirit, their essence also revealed. The idea was that the essence of something also involved its fundamental nature, or what we would call, in the religious sense, its fundamental spiritual reality.

A good example of this in this painting is in the vigorous darker accents which permeate and give so much life to the upper and lower forms of the plum tree. On the lower section those accents are particularly noticeable in fluidity and freedom, as fluid and free as nature's own vining tendrils must be and are, even as they encircle, define and express the rounded perfection and symmetry of the limbs and trunk. In the upper branches these same tendrils and their liberated brushstrokes express character and spirit both by their own masterful execution and by the way they depict the tree's spirit, the essence of its character. The same is true of the dashed-in limbs, twigs and other calligraphic accents – the inner character of the artist, the characteristic way of the brush, and the character of the tree have all become one unified expression. This kind of harmony, of artist, medium and reality, is intrinsic to art, and the 'art' of it lies entirely in the non-contrived, non-artificial union of spirit and matter, as we shall later see.

When we come to the figure of Lin P'u we find the drapery forms of his robe to reveal very solidly the frame beneath them, demonstrating an excellent knowledge of anatomy, for which the Chinese are not often credited. The folds of the voluminous-sleeved *p'ao* style robe fall gracefully in the flowing, freshly varied ink lines, as they express this underlying form. The arm which wraps across the body, the long line which runs down to the outstretched foot, the perfect gathering at the waist and the flair of the fluttering sash are rendered with an absolute economy and austere purity of line, and yet the essential essence of both robe and figure are very well realized and transmitted. The same is true of the poet's face, with its whispers of line which turn the form in space, express the strong jawline, chin and piercing gaze, which seems to be rapt, fixed on some far-off vision which is both inner and outer, some glimpse of a distant reality we can't see. And he smiles – the face is lit with a radiant wonder and joy from within which is like the outer light from the moon.

The figure of the poet walks in the moonlight, his face lit with a translucent glow, a halo of light surrounding his head and his right hand enclosing the staff. The figure is ethereal, spiritual; it would be more accurate to say he flows, rather than walks, that he dances in a graceful step and hidden rhythm which appears at the moment of readiness to move again. Yet even as we know he moves he is somehow very still, self-contained, perfectly poised in time and space. And we know the man, we know his character, his mind, his wisdom, his spirituality, for all of these come through to us in the character of the painting, which has so well reflected the essence of a reality.

Art was a Way of spiritual fulfillment to the Taoists because they knew that its relationship to nature and to fundamental reality had its origin and likeness in an inner principle – in the way the human mind was a part of nature, and the way it reflected nature and the Tao in it. Everything, for man, came from the mind, for the mind was the mirror of Tao and the centre of spiritual activity and its ongoing activation. It was to the mind and its creativity, then, that they turned to seek out its bond with nature and the spiritual cosmos, discovering in human intelligence a special spiritual and creative power, intuition.

Notes

1 *Tao Te Ching: Interpreted As Nature and Intelligence.* Archie J. Bahm, Translator. New York: Frederick Ungar Publishing Company, 1958, Commentary, 74.

2 Ibid., 74, 75.

3 Watts Alan. *Tao: The Watercourse Way.* New York: Pantheon Books, 1975, 40.

4 *Tao Te Ching.* R.B. Blakney, Translator. New York: Mentor Books, 1955, Introduction, ix.

5 Chang Chung-Yuan, *Creativity and Taoism.* New York: The Julian Press, 1963, 229.

6 Siren, 43.

7 Ibid., 45.

8 Ibid., 51.

9 Ibid.

10 Ibid., 52.

11 Ibid., Footnote, 159.

12 Barnhart Richard M. *Peach Blossom Spring: Gardens and Flowers In Chinese Paintings.* New York: The Metropolitan Museum of Art, 1983, 49.

Chapter III
The Rational and Intuitive Mind: The Power of Te

When Wu Chen picked up a brush and began his masterpiece it was not because he had just completed an elegant reasoning process, or even because the subject had a logical appeal to him. Nor was a rational method involved during his execution of the painting. On the contrary, he acted according to inner dictates which were entirely non-verbal. He did not think at all of what he was doing or how he was going to do it – it was just done, without a thought. He suspended his rational mind to let the 'mind within the mind'[1] come through. This is intuition, and it is the basis of all great art and all true creativity.

The human mind can be conceived as having two major aspects or departments, the rational and the intuitive. These are the theoretical correspondents of the well-known functions of the right and left brain, and so have a basis in physiological fact. The left brain operates in a verbal manner, the right brain in a non-verbal one. Thinking (as the conscious mind knows it), reasoning, abstraction, objectivity, logic, memory, speech, language, analysis and the conscious are all related to the left brain. On the other hand, intuition, imagination, subjectivity, feeling, symbolism, perception, synthesis and the unconscious are right-brain activities. Until very recently science was inclined to devalue the right brain (the intuitive mind) as the stepchild of reason and the primitive remnant of a primordial past, even though the duality of human nature had long been observed and pondered in our philosophic history. This dualism is more apparent than actual, for the rational and intuitive sides of the mind can, and should be, mutually complementary. Obviously nature intended them to interact, and if we can develop their proper integration, newer and higher levels of

intelligence and creativity can be reached than have ever been dreamed possible by humankind. Of this we can still learn much from art and the wisdom of Taoism.

We know so little of the nature of intelligence, particularly of creative intelligence, that we have been generally disposed to dismiss intuition as a vaguely unattainable intangibility. Conversely, we are given to emphasizing and celebrating that which we know best and most trust, the rational mind. Western culture, in part due to our rich and comprehensive languages, is decidedly verbal in its consciousness, more so in modern times. In addition, we have been conditioned to admire logic, reason and the rational process through a persistent scientific philosophical current that began with Aristotle (even though he observed that the intellect was divine), and which eventually ran dry in the sterility of pragmatism.

The rational mind is commonly believed to be superior for a number of other reasons, not all of them rational. Some of our fondest fallacies about intelligence have the flavour of elitism, racism, or downright intellectual conceit; others have roots in the type of medieval theology which does its best to stamp out human nature. Not having complete, exact knowledge of the mind which our overworked rationalism might wish, we have characteristically taken what is most consciously evident as best and most fundamental, thereby ignoring the possibility of an alternative or higher kind of intelligence. This is typical of a kind of mechanistic thinking, originating in science, which moves us steadily from facts to empty negations. Indeed, much of our scientific information tends toward suspicion of whatever can't be physically explained, so that we have difficulty with discerning meaning or principle. And we have in effect given over our minds and universities to totally scientific attitudes and scientific orientations which dominate our education and outlook in a dangerously one-sided manner. Both the general nature of modern science and the rational bent of modern educational systems have so overstressed the verbal intellect as to bring about an extreme prejudice toward non-verbal mentality.[2] In other words, our glorification of the cerebral consciousness is starving our creative spirit. In reality, the rational intellect is neither the pinnacle nor totality of intelligence.

This tendency to 'scientify' ourselves, to reduce existence to the spiritual poverty of strictly rational terms, to equate reality with verbal meaning, has resulted instead in a separation from the inner life where most existence really takes place. The aesthetics and essential significance of things escape us because the forms of true meaning move in energy patterns which are beyond the functional

capabilities of conscious thought. And the rational intellect may be the mere craftsman of thought, processing the promptings and symbolic indications of intuition. Henri Bergson was aware of this when he remarked:

> There is no durable system that is not, at least in some of its parts, vivified by intuition. Dialectic is necessary to put intuition to the proof, necessary also in order that intuition should break itself up into concepts and so be propagated to other men; but all it does, often enough, is to develop the result of that intuition which transcends it.[3]

We can become insensitive to intuition, even cut off from it, by blind scientific prejudice, distrust of insight, excessive externalization of thought and an unbalanced verbal mentality, and thereby not gain a truly creative, truly complete intelligence.

The mind as it is used in art is wholly intuitive. And so it is in most kinds of creativity. The artist, as he works, is not using his rational mind. True, he may reason or inform himself about the picture when he is not working on it, or his conscious thought may deliberate on technical problems. But while in the explicit act of painting, his reason is suspended and the intuitive side of his mind takes over. Some artists may not be conscious of this process, of how the rational mind normally becomes quiet during the creative process. But they quickly find it out when a great deal of conscious thought interferes with and inhibits that process. In the Chinese philosophy of painting artists sought to ameliorate and enhance their work by knowledge of how the Tao works. Through self-discipline they aimed at quiescence – they strove for an actual stilling of the rational mind. In this way they were in touch with the intuitive faculty, which to them was synonymous with the spiritual Tao.

In the Far East the exact opposite of rationalism has always prevailed. We have not yet fully understood the intense spirituality of Eastern culture, which in many ways is more advanced than our own. There it is the intuitive mind which has emphasis and is given greater value, yet surely we are not so arrogant as to believe that there they are any less intelligent. Nor can we fairly remark that their intelligence is less scientific, for some of the world's most important and earliest technology came from ancient China. In Asia the intuitive mind is revered because of Taoist and Buddhist beliefs which relate intuition to spiritual manifestation, and which equate the rational mind with purely functional aspects of living and

egoistic and inferior levels of being. Easterners do not understand, consequently, our preoccupation with what is to them the lower mind. And just as clearly they notice that our rationalism produces our vulgar commercialism, our materialistic obsessions, our compulsive drives for precision and control, our competitive struggles with each other, and our willingness to reject life, nature, and creativity in favour of these things.

The resistance of the Western academic and scientific communities to this ethos has been particularly noticeable and especially difficult to understand. Perhaps significantly, it has been the general public in recent years who have forced a breakthrough to greater understanding of Eastern philosophy and its whole mystical and spiritual viewpoint. For so long it seems the world was literally split into separate spheres of consciousness, Eastern intuitionism and Western rationalism. This deep division may reflect the same schizoid conflict in the Western mind. Such conflict now needs to be resolved.

The Western intellectual tradition has accused the Eastern attitude of not dealing in empirical evidence and fact, of illogic, inexactitude, and especially of impracticality, typically rational objections which could apply as well to Western religion, the Western creative arts, and the Western right brain. Yet no one seems to suggest that we should dispense with any of the latter. It is heartening, however, that the Western intellectual community seems to be at last becoming dimly aware that the most creative advances in science and scholarly research are brought about precisely through inexplicable intuitional leaps. Nevertheless, we wonder what the effects have been on education and creativity from such an overemphasized rationalism and verbal consciousness. They may be more shocking and pervasive than we think:

The polar opposite of the intuitive artist is the pure intellectual who verbalizes everything. Many of the 'scholarly' fields, such as literary criticism, education and philosophy, provide a refuge for left-brain types. While the real contributors to these fields combine insight and intuition with their verbal and logical abilities, a frightening large number of intellectuals have lost touch with reality. While words and logic are powerful tools, some people seem to forget that they are only meaningful as symbols of reality. Many 'intellectual' discussions are no more than arguments about the meaning of words. The truly creative person uses logic and words as tools, yet knows their limitations.[4]

It is a further paradox of our culture that the more we have 'scientified' ourselves and leaned towards rationalism, the more egoistic, narcissistic, selfish, unfeeling, materialistic, self-contradictory and dehumanized our institutions, societies, governments, and many individuals have become. The effects of the rational ethic apparently leave something to be desired in psychological equilibrium and human development.

Societies which have been most rational have also always been most materialistic – the two seem to go hand in hand with each other and even coincide with a record of downfall. The most rigid, regimented and controlled societies have typically been least spiritual and most destructive, both historically and in our own time. It is the very tendency of rationalism toward exactitude, precision, mechanical order and science devoid of feeling which makes it so anti-human and anti-spiritual, so totalitarian in its social tendencies and so apt to oppress and inhibit the whole human being. Intellect without heart can become manifestly evil, without a doubt. Nazi Germany was a veritable model of precision, rationalism and order. In fact, they envisioned a scientifically controlled 'New Order' and felt justified in considering themselves superior beings who could scientifically 'exterminate' the 'vermin' of their logically conceived and precisely carried out racial theories. We can call this mere megalomania and jingoism if we wish, but at its bottom lay a coldly dehumanized rationalism with deep roots in German thought.

Against all of this our spiritual development has struggled. Only the artists and mystics of our civilization have truly perceived the dangers and the remedy – the real possibility of an innate spiritual spark guiding the intellect and the need for offsetting the technological and functional syndrome derived from an overactive rational consciousness which was rapidly becoming perverse. The ancient Taoists knew well how society in its processes of conformity tries to shape and control the free individual spirit to fit its own purposes. Their rejection of civilization was an effort to salvage the spirit, a reaction to the sort of 'training' which buries the soul beneath layers of worldliness.

The Taoist view of the nature of mind can't be separated from its overall philosophy, which is highly unified and, above all, spiritual, and which places spiritual realization and fulfillment at the centre of a meaningful life. Several key points, however, provide better understanding of, and insight into, this view. These are the principles of *yin-yang*; *Te*; and the pure or spiritual mind as the reflection of Tao and as realized in art and meditation.

The *yin* and *yang* ideas can almost be considered analogues for the rational and intuitive sides of the mind, as well as for the cyclic forces of nature, transformation and creative energy, but they also denote the actual physical laws of the universe as activated by spirit. The mind of man is included in this cosmic dynamic simply as an element of nature. In Chinese *yin* and *yang* literally mean the dark and sunny sides of a hill. They are symbolized in the Taoist iconography by the eight trigrams (*pa kua*) of the *I Ching*, and the familiar *yin-yang* disc divided into its S-shaped, symmetrical black and white segments which indicate the masculine and feminine, active and passive, positive and negative manifestations of nature and the physical universe. *Yin-yang* represents all the dualities and polarities of nature and so carries the idea of all opposites (and their balancing complements), such as the sun and moon, light and darkness, male and female, heat and cold, strength and weakness, activity and receptivity, etc. Qualities of the mind are also within the *yin-yang* purview, and they correspond very closely to our concepts of the rational and intuitive – *yin* is consistent with right-brain activities, *yang* with those of the left brain.[5]

Special qualities of art and creativity also interact with *yin-yang*, corroborating and helping to demonstrate it as well as the overall accuracy and importance of Taoism in assessing the principles of reality, creativity and spiritual development. This will be pursued further in a later chapter.

Opposing energies or principles of the mind are pointed out by the *yin-yang* idea, but these are not so much diametrical as indicative of a polar completion or equalization. The Taoist pursues the middle ground of these complements, for that is where the Tao lies.[6] What he seeks, therefore, is neither wholly reason nor wholly intuition, but the balance or unity between these two.[7] In so doing, however, he prefers the *yin* approach, the avenue of intuition, since the latter is represented by the quiet *yin* side of the mind and the Tao itself is neither *yin* nor *yang*, but rather infinite quiescence, infinite harmony and peace. Only man and nature are affected by *yin-yang*. It is the action of the physical dimension of being. Man can, however, also reflect the inner spirit of nature, the Tao, the mind of God:

When *yin* and *yang* are united in their character, the weak and the strong attain their substance. In this way the products of Heaven and Earth are given substance and the character of spiritual intelligence can be penetrated.[8]

Te is also directly related to the mind and character in Taoism.

This is the same *Te* as in *Tao Te Ching*, that which joins things to the Way and toward which the Way points. Usually *Te* is translated as 'virtue', but is an idea of virtue that is implicit with power.[9] *Te* is, simply put, the reflection of Tao in individual things. And just as the Tao is universal and spiritual, so can its presence in individuals endow them with spiritual virtues and cosmic force. This startling possibility has qualifications, however, and is closely connected to the necessity for spiritual cultivation. Part of this developmental potential is the consummation of character and intelligence. Although *Te* is inherent in, or infused into nature and particularity by the diffusion of Tao throughout reality, specific character is not complete or spiritually evolved until *Te* becomes actual, i.e. reunited with Tao. Thus the achievement of *Te* is bound up with potentiality and mystical power, and the 'Way' is the way of cultivation that leads toward it. The spiritual virtue of Tao, when attained by individual things becomes *Te*, the Tao nature manifested in them.[10] In this way, *Te* is the virtue or power of Tao found in spiritual realization or fulfillment. The Tao actually enjoins with, becomes one with character in this process;[11] this is also *Te* and virtue by reason of spiritualization. *Te* exists only as the emanation of individuation of the Tao, so its nature is the same – it is identical with Tao as the Tao is made real in objective reality.

It is better, however, to think of *Te* as the recovery of something which man possesses, but loses contact with, his real spiritual being. The transmitter of such being can be, must be, the mind, but the mind as it is relative to a soul or spiritual centre. This is what Lao Tzu thought of as the true and only self, the original, primal state of untouched being as it existed in its pure state, as it exists naturally in human beings before the thick hide of conditioning, the preoccupations of personal life, and the limitations of the physical world have grown upon it. He called it the 'Uncarved Block',[12] and the thought is of something pristine and pure. It was this spiritual intelligence, this reflection of the Tao nature, which the Taoists sought and found through the Way, and through which they reached the higher consciousness and mystical creative power of *Te*.

It was in this sense of a return to our original nature, 'man as he was meant to be',[13] this search for the higher spiritual mind, that led Lao Tzu and his followers to surmise that the most natural principle of the mind is undoubtedly the most untouched, most original, and closest to the Tao source, hence, most spiritual. Now the rational mind, which is largely an artificial, acquired intelligence, the repository of education, conditioning, and experience as encountered in physical life, can't fill this requirement and so must be

eliminated as the most natural or original intellectual principle. What remains? Precisely those characteristics of the mind which are least like the rational; the non-verbal, unconscious, unconditioned, unacquired, unattached, silent, free enlightenment we call intuition. For this reason, Taoism saw the intuitive mind as a formidable, mysterious creative force, linked directly to spiritual life.

The Taoist doctrine of 'sudden enlightenment' is obviously a description of what we know of intuition and the way it works; undoubtedly the spontaneously arising is the most unlearned and natural of all mental principles. But this realization also leaves us with a virtually staggering consequence – that intuition and spirit are the same.

It means that intuition is the voice or medium of the purely spiritual as it is found in the human mind, the voice of total transcendence. If this is true, then what we define as intuition is in fact a spiritual principle which governs the mind and represents its highest and most fulfilled character. It may even be the soul, the spirit of each of us and the way spiritual truth is revealed to each of us.

To the Taoist sages this wonderful capacity of the mind was something far exceeding an ordinary mental process. They saw its outcome as *Te*, as a highly charged and mystical creative force which 'gives power over outside things'.[14] This rather amazing suggestion goes much further than mere speculation when it can be observed empirically in the form of dynamic human creativity, and endows that creativity with a new meaning. More hidden factors in *Te* suggest the possibility of a masterful, even transformative power over physical reality. Some of this is suggested by the feats of the martial arts and other phenomena, as available to the properly disciplined and spiritually integrated person, and fine art, in its power over form, material and meaning, is certainly included in this panoply of unlimited potential as well.

How, then, does one come to find or regain this true self, this 'Real Self',[15] as Chuang Tzu put it, that which is more real, more basic than our outward personality, that which constitutes the very elements of our being? According to the Taoists, we can discover it through spiritual growth, and thereby achieve *Te*, the fulfillment of true being, which will have its own rewards. This also included the actualization or spiritualization of our material lives and an eventual oneness with Tao. For the true self, the primal mind, is identical in substance with Tao.

Following the Way, then, is the path of cultivation, of development, of self-improvement. But what is meant by this

cultivation? It is clearly not the accumulation of knowledge and learning, nor the rigorous studies and scholasticism advocated by the Confucians, still less the advancement of the rational intellect. The winding path of the Way and the totality of that mystical experience leads, in fact, in the opposite direction, to the inverse of intellectual knowledge. As defined by the Taoists, it is a way of 'knowing by not knowing', – 'the knowledge of no-knowledge', and as obscure and paradoxical as that may seem, it is toward this suspension of the rational process that all Taoist development and cultivation gravitates. An understanding of this quieting of thought, as difficult as it may be to us in the West, is essential to a grasp of how intuition works. For the further unfoldment of the spiritual experience may depend on the ability to achieve this sense of free-floating consciousness and liberation from the forms and constraints of material existence, and this begins, at least on specific occasions, by shedding the mind of all preconceptions and expectations and allowing it to roam freely, unfettered by rational activity, by thinking. This process is not as easy as it sounds. A lifetime of using the rational consciousness habitually in our daily lives, the constant verbalization of thought, the limitations of material life, and the distractions of our personal lives all tend to bind us to the physical dimension of being and interrupt the flow of Tao and our sensitivity to it. Taoist cultivation, then, takes practice and self-discipline, and is carried out through two main methods or fields of experience, creativity and meditation.

The idea of meditation as a key to spiritual development is one we are familiar with and can readily understand. But why creativity? Because creativity is the action of Tao. Since the Tao is the essence and origin of spiritual being, since the Tao *is* spiritual being, and since its main and most observable manifestation in the physical world is creative transformation, it follows that creativity in any form is an involvement in spiritual activity.

In order to grasp and agree with this idea, we must recall that the primary and most evident principle of nature is constant generation and regeneration. This is transformation of an undeniably creative sort, i.e. it is an infinitely changing, making and remaking, birth and rebirth which is the epitome of creation and creative meaning. If we dismiss this natural creative order and creative flow of the universe as unintelligible and meaningless physical phenomena we shall be atheists. But if we see, as Lao Tzu did, that this generation of nature has at its centre a spiritual principle, and that the essential creativity of that principle denotes a vast Creative Intelligence (i.e. intelligence as we know it, because we are able to identify and recognize its kind

and quality), then we shall see that the creative principle *in itself* involves the nature of spirit and the means of spirituality.

Just as the spiritual Tao is a creative principle, so does art (and all creativity) become the mirror image and realization of this spiritual principle in the world. For the same reason, creativity is a powerful bridge to the spiritual realm and to spiritual integration. The creative experience, if practised according to the general rules of the mastery of technique to the point where it can be forgotten (which can consume many years), and the proper use of the mind, can lead the devotee along the exact same path as meditation,[16] and can have the same rewards, i.e. spiritual growth and fulfillment and perhaps the attainment of the higher powers of *Te*. The practice of creativity, then, is in effect simply the *yin* and *yang* principles of nature brought to perfect completion and harmonization in man, who, if he perseveres, can achieve a creative power close to that of nature and the Creative Intelligence of Tao. This possibility may seem to have a miraculous aura, but it is considered rather the harnessing of the creative power of nature through spiritual integration and creative spirituality, which results in limitless inward resources. If we look around we will find many instances of how human beings have already achieved these things countless times in past and present history, in doing the seemingly impossible and in transcending every limitation of material form. The perfectibility of human nature and its creative potential has no limits, no more limits than nature herself. Man is nature, he is a part of it, yet only man can transcend the physical world and achieve the creative power of Tao. We are already on that road when acting in harmony with the creative dynamisms and flow of nature and the stream of life, so that even the smallest actions of life can be made creative and brought to express and reflect the spiritual Way.

Every act of true creativity is the utilization of Tao energy and of the Tao nature which is inherent in the intuitive mind and foundational being of man. Indeed, such creativity is indistinguishable from that spiritual mind and from the Tao, for they are one, and of the same substance and nature. The creative force is the energy and flow of life – it is life itself.

Our problem is to find and know our spiritual being, to learn how to read and understand its inscrutable and fleeting voice. Finding that original being in ourselves, that non-verbal place in the mind where reunion with our spiritual origins takes place, and acting consistently in harmony with it, is the path of cultivation, the path of living naturally and creatively which leads to spiritual life.

The involvement of creativity as a major part of spiritual

cultivation is also seen in the Taoist attitude toward art, to be explored more fully in the next chapter. The Taoists regard fine art, especially painting, not only as the tangible proof of their beliefs and a demonstration of the principles of Tao, but also as a means of bringing these principles into objective reality, where meditation on them could be enjoyed. As we have seen, this influence ran both ways. Both moral and spiritual development were certainly implied here, and tied creativity directly to benefits available to society from contact with it. 'Although painting is only one of the arts, it contains Tao',[17] wrote the art critic Wang Yu of the Ch'ing dynasty. Implicit in this was the identification of art and creativity with the Tao nature, and with the cultivated Way, as in the following remarks by Chang Yen-Yuan:

> Painting promotes culture and strengthens the principles of right conduct; it penetrates completely all the aspects of the universal spirit, (exhausts the divine transformations).[18]

Taoist meditative principles, when applied to art, conceived the painter potentially united with the Tao (hence his work the real objectification or externalization of it in material life), at once both the realization and expression of the great cosmic harmony – 'exhausting the divine transformations' of *yin-yang*. Accordingly, the activities of art were seen as a medium whereby the spiritual unity of the universe could be directly expressed and be the perfect reflection of Tao.

The habit and use of the mind in growth patterns is a very serious question. Not only does it involve the whole range of educational, psychological, characterological and social implications of the traditional social purview, but the happiness, spiritual development and overall life potential of the individual as well. Creativity, or the ability of the mind to rise above its own limitations and consciousness levels, is also definitely relative to this question. And if the Taoists were correct, and I think they were, in relating the most natural and fundamental to the highest and most qualitative, then mental growth and the peak of intelligence must swing over to intuition, not to the rational intellect.

It can be argued, of course, that the rational mind is just as natural and just as much a part of the cosmology of things as the intuitive. This is quite true, and necessarily involves us again in a matter of priorities and values, of what has the greater value, even as it brings us further along in the ramifications of the Taoist position. For what is called for is not a renunciation of the rational process – that

is not possible, given the nature of the mind. Rather, it is a modification, a disciplining of the insistent rational bent and habit with which we identify. And this in order to achieve a *higher* level of intelligence, greater creativity, a fulfilled character, and a spiritual life not repressed or mangled but in harmony with the natural order.

Undoubtedly the rational mind is a form and vehicle of nature, but just as truly, much of rational consciousness is artificial and acquired, shaped and moulded by the environment. In its physiology, rational process may be a reflex, subject to the same involuntary responses as govern other parts of the central nervous system, as much a means and motion of brain mechanism, in its own way, as the way my legs permit me to move and get about. It is the great error of human nature and individual will, however, that we tend to insist we are the authors of our souls rather than the captains.

And here is where we confront the illusions and artifices of the ego. The ego may be a natural result of external conditioning, but as in all other distortions of nature, it is not the manifestation but the forcing or unbalancing effect of excess which creates a disharmony or a conflict. It is in the mobilization of *all* the powers of the mind that true balance and the most natural state or condition lies. This requires, as importantly as the work of rational thought, all the attributes of serenity, the calm, peace of mind and equilibrium that we know as tranquil psychological conditions, not *yin* or *yang*, but *yin-yang*, the natural balance of mental energies. Consciousness is, or should be, centred in the inner self, not in the externalized form which the socially patterned ego presents. Identification with this outer shell of the self is, however, encouraged by the continued outward thrust of an overactive or overconditioned rational consciousness.

Oddly enough, the rational mind by its habit and training does not want to remain in a state of equalization or inaction. It is an objectifier by its process. Anyone who has practised transcendental meditation knows that the main impulsion of the conscious, the rational mind, is certainly toward the outer world. It strives for continual action, probing, calculating, solving problems, for examination and critical analysis, for arranging the means of conception and the means of survival. Its action is incessant, not so much by its nature as by its owner's interests, desires and needs of the moment. It is therefore not in immediate touch with the unchanging substance of things, and certainly not with the infinite or the transcendent. Its function is not this. The rational mind is like a watchdog, ever waiting to pounce on some intruder into reason or some malfeasance of logic. It maintains sanity. The thrust of

rational thought therefore has the tendency toward over-compensation and objective overkill, to continue in a blind, often self-perpetuating course of endless speculation or intellection. It does not want to give up its 'most cherished habits', as Bergson put it. Nor can it readily relinquish or yield up its functional authority, and in so doing it is ever conservative and ever enthralled by facts and comfortably conventional concepts, to which, quite naturally, its performance is most adapted.

But there can be overadaptation, there can be imbalance and obsessive distortion, and there can be a running and continual insistence on entering transactions only with those conceptual forms into which it is accustomed to see things fit. Bergson, one of the greatest scientific philosophers, saw this as a peculiarity of cerebral physicality, a functional deficit, like a clock that never runs down, but thought that consciousness was not limited because of it – that 'consciousness is not bound up on that account with the destiny of cerebral matter'.[19] He successfully summarized this in a distinguished passage which is remarkably close to the findings of Taoism:

> Those fleeting intuitions, which light up their object only at distant intervals, philosophy ought to seize, first to sustain them, then to expand them and so unite them together. The more it advances in this work, the more it will perceive that intuition is mind itself, and, in a certain sense, life itself: the intellect has been cut out of it by a process resembling that which has generated matter. Thus is revealed the unity of the spiritual life. We recognize it only when we place ourselves in intuition in order to go from intuition to the intellect, for from the intellect we shall never pass to intuition.[20]

'Philosophy', he continued, 'introduces us thus into the spiritual life. And it shows us at the same time the relation of the life of the spirit to that of the body'.[21]

The real meaning of intelligence, then, is neither the rational nor the intuitive mind, but the blending, interaction and integration of these two ways of thought. Further, we might presume to elaborate on Bergson a bit by a symbolic equation and a new definition – that true intelligence is spirit and matter united, and is best understood as the combination of reason and intuition, which is what I call Creative Intelligence. From this proceeds the higher forms of knowledge, the virtue and power of creativity, the mystical potential of *Te*, the achievement of a more advanced intelligence, and the fulfillment of the human mind 'as it was meant to be'.

Notes

1 Waley, Arthur. *The Way and Its Power: A Study of the Tao Te Ching and Its Place in Chinese Thought*. New York: Houghton Mifflin Company, 1935, 48

2 Edwards, Betty. *Drawing On The Right Side of The Brain*. Los Angeles: J.P. Tarcher, Inc., 1979. See the quotation by R.W. Sperry, 29.

3 Bergson, Henri. *Creative Evolution*. New York: Henry Holt and Company, 1911, 260.

4 Blakeslee, Thomas R. *The Right Brain: A New Understanding of The Unconscious Mind and Its Creative Power*. New York: Anchor Press/Doubleday, 1980, 44, 45.

5 Edwards, 34.

6 Chan, Wing-Tsit. *A Source Book In Chinese Philosophy*. Princeton: Princeton University Press, 1963, 321.

7 Waley, 112.

8 Pu-Wei, Lu. (d. 235 BC) In *The Spring and Autumn Annals*. Chan, 246.

9 Waley, 31, 32.

10 Chan, 136, 178.

11 Ibid.

12 *Tao Te Ching*, XXVIII. D.C. Lau, Translator. New York: Viking Penguin Inc., 1985.

13 Waley, 44.

14 Ibid., 48.

15 *Chuang Tzu*, XIII. Chang, Translator. 149.

16 Chang, 205.

17 *The Chinese On The Art Of Painting*. Siren, 209.

18 From the *Li Tai Ming Hua Chi* (Origin and Development of Painting) by Chang Yen-Yuan (c. 845 AD) Siren, Appendix III, 224.

19 Bergson, 291-5.

20 Ibid., 292.

21 Ibid.

Chapter IV
Spirit and Character in Nature and Art: The Flow of Ch'i

Who has not stood before some splendid vista of nature – a great mountain, perhaps, a sunset stippling myriad colours through darkened trees or over a lake, or simply the soaring expanse of a summer sky – and has not felt something in it, some sense of unexpected and inexpressible identity, some perception of an immanent *presence*? Or again, how many have not perceived in the beauty and being of animals, or even in the forms of inanimate things, an idea, a likeness of being which we understand so well because it is like our own? We have, because we are able to perceive an identity of spirit, a similarity of essence, and our ability to see it comes from that same spirit within ourselves. This is to say that spirit itself has identity, a perceptible character, and that it is the essence of every created thing. This is the emanation, the interfusion, the spirit of God that is life itself, the Tao, the moving and vital spirit pervading all of reality. The ancient sages of Taoism called it *ch'i*.

The idea of spirit as conceived by most dogma seems to be defined by elevation, loftiness, and dissociation from anything remotely connected to humanity and the natural world, especially the latter. Heaven, it appears, is too high to have anything to do with nature. The spiritual world had to be raised to an exalted plane above all, as if to prevent it from assault by those innumerable creatures below, and those below could only attain those remote heights through shuffling off any resemblance to nature. This is all well in its intentions, and doubtless there is a great deal of true reverence in wanting to remove spirit from anything physical. And the need for explanation of such an ethereal and distant spiritual realm no doubt formed the conditions of doctrinal requirements which were to be

preached as the gospel. Yet the error of such doctrines may lie exactly in that same conceived remoteness.[1] They may have placed the spiritual domain too far away to seem real.

Unfortunately these same purposes and needs – the separation of spiritual life from life itself and from the human or natural condition, and its uplifting to a level far above the physical dimension – had the effect merely of making it seem beyond the reach of most people. When that happened, it became increasingly less a living reality and a possible achievable experience and more and more like the product of strenuous academic or dogmatic intellectuality, an illusion. It was then the reality began to escape us.

The Taoist conviction, on the other hand, of spirit directly active in nature advances all possibilities for spiritual union and a profound and cogent explanation of reality and the spiritual world as well. The Tao is not far away, but here, immediately before us in the physical world, in nature and its principles, in our lives, in our minds, in our very being. As indicated by *yin-yang*, the dynamic quality of the Tao was proven by its cyclic patterns of constant change, motion and regeneration. As an unending current of creative energy and spiritual activation, it harmonized all things and inevitably blended them into one. This closeness to nature, this brilliant synthesis of the tide of life and the flow of spirit, saw human beings as an integral part of that natural process, rather than as something foreign to, or separate from it.[2] Nature, uniting with and being an inseparable part of this process, partook of and expressed the Tao in each and every level of its reality and its universal, intrinsic being. Just as the Tao was the centre and primary dynamism of the universe, so was it naturally present as the being-state, essence and character of individuals, and thus 'Tao is the inner reality of all things'.[3]

The indivisibility of man, spirit, and nature may as much involve psychological as spiritual health, by reason of that same inseparability. Jung, who was very interested in Taoism and its psychological implications, noted how the cosmos and man are attuned to and governed by the same laws. Man is microcosmic and can't be excluded from the natural world by rigid limits. He is part of the great cosmic nature and it is a part of him. Indeed, a symbolic parallel could well be drawn – the inner, psychic world corresponds to the outer events of the cosmos, so human destiny and meaning are ineluctably intertwined with the cosmic scheme, both from within and without.[4] Humanity, to be well, must respond to the movement of nature, to the forms of natural being.

The existence of the soul or inner spirit in Taoism is not looked

upon as an external essence that comes to reside in the body, nor can it be understood as totally isolated from physical form. Rather, spirit was something inhering naturally and simultaneously in both the inner and outer worlds.[5] This is mystical, of course, but it is a Nature-Mysticism,[6] one which discovers in physical reality the effect of spiritual laws. The Taoist thinker Wang Pi strongly emphasized the Tao as original spiritual being and the invariable principle of life, nature and reality. This incorporates the idea that an original life centre, the Tao, is pure being and original spirit,[7] and thus constitutes the essence of real being. If Tao is the only real being possible then all reality, all substance and function are identical with it,[8] and somehow express or manifest it. Moreover, this suggests that spirit pervades material form and produces quality, trait or character.

This same emphasis on the spiritual permeation of the particular can be found in the writings of Han Fei Tzu, (d. 233 BC). Individual things, far from being swallowed up in Tao, are instead reinforced and given greater reality by its principles. They are vivified and fulfilled by Tao's spiritual energy, renewed and reanimated by the life-force. Things become what they are, what they should be, through Tao, i.e. they become more definite, more realized in being. This can only grow toward a more specific,[9] sustained quality, toward individual character and kind. It is the inescapable determination of being which creates the solidity of that character and hence the further establishment of its specific individuality. Thus spirit, while itself formless, acts through form and is reflected in it. Or we could say, conversely, that all natural forms are the embodiment of spirit, and are shaped by it.

The Taoists did not fail to recognize that the world is full of individual things, each with its own principle and character, but regarded the Tao as the common denominator of all.[10] It is easy, nevertheless, to forget that we are part of nature and can never escape that fact. Man's destiny, while not bound to the earth forever, is still subject to natural laws as long as he remains in the material level of being. But if the natural world is also filled with spiritual meaning, is he not then fulfilled by living in harmony with those laws? Even though people are each unique in character, form and individuality, they have no real existence apart from nature,[11] whatever else the ego seems to suggest. For while the individual essence and its form are one, their substance is Tao, and the spirit of things can't be other than their source. It was for this reason that Ch'an (Zen) Buddhism, which was in itself a synthesis of Buddhist and Taoist tenets, saw the ego as an illusion. Both life and essence are the same; both are total

meaning and fundamental spirit; spirit *is* life, and, in the final outcome, the only essence there is.[12]

The issuing forth of the Tao Intelligence in the physical realm, in nature, was defined as *ch'i* in Chinese. *Ch'i* is both a presence and a form of energy, or rather, the energy of spirit. Its best translation is cosmic energy, vital spirit,[13] or life spirit. In our sense of the word it also meant soul, which Chuang Tzu spoke of as 'life-breath'.[14] The earliest reference to *ch'i* was in the *Tao Te Ching*, where it was stated that *ch'i* or spirit, is what unifies *yin* and *yang* and creates their harmony.[15] The doctrine of *ch'i* is all-important in Taoism and in Chinese art as well, for it is the whole and vital spirit of Tao infusing nature and man with life, and is thus the dynamo and source of creativity. When the soul was of the same nature or substance as the spirit of the rivers, the mountains, as all of nature, then it became a matter of great importance to be able to identify it in nature, and so be able to transmit the spirit of things and the spiritual experience to all people. This fell to the master sage, to the adept in meditation, and it fell also to the artist.[16]

The distinctions between *Te* and *ch'i* are clear. Things obtain their perfection and fulfillment of character through oneness with nature or through cultivation – this is *Te*. Even though this virtue is inherently present to begin with, it must be regained, rediscovered and reintegrated to become active. *Ch'i*, on the other hand, is the direct spirit of Tao as it dwells in form or moves through reality. *Te* is virtue, or realized power of spirit; *ch'i* is actual spirit, the pure essence of every being. All living things possess *ch'i*, or they would not be alive; *Te* is reunion with that spirit in its most perfect form. *Ch'i* is innate spiritual character; *Te* is perfected character.

Ch'i could also be described as the perceptible presence or manifestation of Tao in the natural world, which was later to be characterized by the historical Chinese art critics and aestheticians as 'life-movement' and 'spirit resonance', as *ch'i yun*. It is the essence of reality and life here also, as the observable energy or operant spirit of Tao in physical form and existence. Chuang Tzu called this process *ta t'ung*, 'the grand interfusion'.[17] It is the closest definition we have of pure being, a highly spiritual concept of soul which shows it to be infinite, resident in all things, and without any possible limitations of time, space or continuity. In itself it is formless and non-intellectual, and it is perfectly and unequivocally free. As we might expect, it is one, as already noted, with Tao.[18]

Together with *ch'i*, Lao Tzu used another term almost interchangeably – essence, or *ching*, and in Chinese the latter also means 'intelligence, spirit, life-force',[19] which makes it very nearly

synonymous with *ch'i*. Knowing that essence and *ch'i* are similar will be very helpful when we consider the meaning of Chinese art and the further implications of art and creativity in general. It is even more useful when we think of nature, which, again, is vitally important in art as well. For what we know of reality and the spiritual content of nature and form comes to us in large part from art and from our own ability to be creative.

In nature every form has its essence, that which perfectly describes its spirit and character. We know things by their identity, which is to say that we know them by their particular character or form. Yet as we learn from Taoism, character is universally permeated throughout nature by spirit, by *ch'i*, and such spirit is fundamental to life itself. There is something, then, in the character of a form which manifests its own essence, and that same essence is identical with, or the reflection of, its larger Tao essence, or the universal substance of all spirit. This explains why insomuch as we can perceive character we also perceive spirit, for the essential and the spiritual are one and the same.

Nature can't be other than it is, and whatever is outside the natural realm has no real life or can't endure. While this may seem like a moral mandate, it is actually the self-protection of life and the real being of things. Real character only exists fully, persists truly, in *natural* forms, which nature has foreordained. Whatever is *not* natural (and this can take a much narrower range than usually attributed) has no real being, validity or substance in the existential sense of ultimate reality. Things have real truth only as contain spirit, since material form is but a carrier or shell of that spirit. Whatever diffuses character (whether by attrition or the passage of time) also ultimately weakens life and the life energy given by spirit, and proportionately as spirit weakens its hold on form and grows faint so does the diminution of vitality portend the dissipation of that form and its eventual transformation into another form. This is the ultimate law of nature, and if it is moral it is only so because it guards life and continued growth. We should remember, however, that life gives happiness and joy in its natural forms and spiritual essences, and that nature allows for a very wide latitude of variation.

If an individual essence has in it the essence of spirit we might as well say, as did the Taoists, that natural, formal character expresses spirit. We may not realize the validity this has for our lives until we consider the real being of things and the way nature and the visual world appear. Naturally, all people do not have the same degree of perception or perceive things in the same way, but if we really look into it we can become aware that all of nature has essentially the

same character, the same type of spirit. Artists learn to discern the essence of forms while still in art school, and while this is an intellectual exercise at first, long experience in art usually leads them to see a vast and consistent unity of character in all of reality. Essence has a characteristic typology which emerges again and again in art. A tree, while differing in its particulars or individual form, nevertheless has the same *spirit* or life air about it as does a mountain, a tiger, or the human figure. And this curious phenomenon is so because all reality is one, has but one essence, one spirit, which is what the Taoists defined as the Tao. This uniformity of spirit is what life is – it gives life and unifies it, and that life-spirit is everywhere the same as it vivifies form and takes individual character. It is the soul of things which we see radiant in their form.

This essential character of reality, this discernible *ch'i* is identified, can *only* be identified by an inexplicable recognition, a *feeling*, a sense of presence, a sense of quiet magnitude which is nevertheless vibrant and dynamic. And all of these descriptions are merely approximations – there are no words which can really describe it, for ultimate reality can never be conceived wholly in verbal terms. The nearest we can come to it is when we intuit it, most certainly, but this is because it is also a moment when intuition finds its reflection in the objective, outer world – for while the soul of things may be indefinable, they *are* perceivable.

Whether we perceive essences visually, through feeling vibrations, intuitively, or a combination of these, it is certain that we can understand them and respond to their spiritual meaning. Philosophers of art have long known that art does not so much simply imitate natural forms and their details as it expresses and 'captures' their spirit, their essence. Artists, too, know well the impossibility (and undesirability) of exactly rendering nature – the camera can do it so much better. Instead, they aim instinctively at the essentials of their subject, the broad, overall reduction of details and shapes to their most characteristic and significant expression, i.e. they strive for the *essence* of a form. No artist could paint every leaf in a tree – it would be a herculean task (even though some, such as the Primitives, actually attempt it) – he looks rather for large masses, essential and descriptive lines, a totality of spatial and value relationships, and intuits artistic conventions which will express the character of the subject, rather than its literal details. This important requirement of artistic technique, however, continues to confirm the unique position of art vis-à-vis the nature of reality. For as the artist attempts to depict the characterological essentials of his subject, he is also engaged in identifying its essence, which is the

spirit of something. Since all spirit is one, and inherent in the forms of nature and reality, the artist is actually giving voice to a principle of the spiritual world and to the spiritual meaning of character.

The intentions and selections of the artist tend to be focused exclusively on this preoccupation with essentials, and if only by the limitations of media, art gravitates, in this way, toward the expression of essence. Unwittingly or not, even the technical drift of art is bound to be involved with the fundamentals of reality. Even so, although the artist proposes, it is his intuition which disposes – his intention toward essentials comes from his inner intuition of reality as much as from artistic requirements, and the artistic requirements are but confirmations of that knowledge. His selections are governed by his artistic instinct, which, again, is wholly non-verbal and intuitive, and therefore not only the effect of the artist's will or conscious choices. In all, it is in the nature of art to seek essential meaning. By reducing form to *artistic* essence the artist is already clarifying the natural essence, *ch'i*, or spirit, which is innate in every form.

Furthermore, the artist does not have to paint or create in order to intuit reality. His media are merely the vehicle for others to experience what he already knows, or can disclose. The artist is bonded to his materials, but he is not bound by them, for it is he who gives them life through merging his spirit with them. It was in this great communication or harmony between matter and spirit in art, both in its form and content, that the Taoists saw fortunate effects for their philosophy. And it was also the moment when Chinese artists discovered in Taoism the key to greater truth and creativity. For it was *ch'i* they had known all along in their work, and it was *ch'i* they encountered in their continued search for reality and essential meaning. Spiritual realization could then be found through art, and from that potential it became viewed as a form of meditation with deep spiritual roots, as a 'Way' to reach Tao.

From this arose the literature of Chinese aesthetics and the Taoist artistic principles which became the foundation of Chinese art. To the Chinese painters the source of creativity was intuition, which was regarded by them as the well-spring of artistic expression. This was an idea identical with, and originating from, the concept of the intuitive (spiritual, *yin*) mind in Taoism. Second only to this was the pervasive spirit of universal Tao, the *ch'i* that flowed through all of nature and reality, which was of great interest to the artist because of his experience in identifying essences. Spontaneity, as a prime characteristic of intuitive intelligence, also came to be seen as vitally important to artistic and other creativity. The recurrent idea of a

universal spiritual essence inhering in the natural world as well as in the mind of the artist was what led to the conviction that intuition was the true source of creativity. If *ch'i* was spirit, then the spiritual side of man's mind held the same creative potential as the Tao. Both of these Taoist tenets, intuition and universal spirit or essence, then, had a distinct and unique significance for art, since artistic activity is fundamentally intuitive by nature, and the Chinese artist saw in nature the movement of a reality which was identical in spirit everywhere and in all things. During the Southern Sung dynasty the painter and biographer Teng Ch'un wrote:

> Innumerable things with all their details may be rendered through the intelligent use of the brush, but there is only one way in which their character can be fully expressed. What is it? It is the transmitting of the spirit. People think that men alone have spirit (soul); they do not realize that everything is endowed with soul (spirit).[20]

Spontaneity also involved a further ramification, one well-suited to the new medium of watercolour. Enlightened insight was a special feature of creative intuition, and was what linked the cosmic Tao to the artist's mind and work. And the need for free, spontaneous expression also favoured media where spontaneity was required, such as calligraphy and ink painting.[21]

The life-force, the essence of spirit or pure being which infused the character of all things, the *ch'i* which was the creative energy of Tao, was taken by the Chinese painter as the guiding principle of his art. This led to the foremost doctrine of Chinese aesthetics, the term, *ch'i yun sheng-tung*. The meaning of the first word, *ch'i*, we have already discussed extensively. It indicates the spiritual vitality or life which is perceivable in man, nature and the cosmos,[22] i.e. the spiritual principle of all life and the flow of spiritual energy which gives things their character. *Yun* in Chinese means accord, resonance, or harmony, particularly as harmony has vibrations, as well as the correspondence or unity of parts.[23] *Sheng-tung*, in turn, commonly meant life, combined with physical movement or motion,[24] The whole, then, is translated as 'resonance or vibration of the vitalizing spirit and movement of life',[25] or simply as 'spirit resonance' or 'life-movement'. In other words, *ch'i yun* referred precisely to the Taoist idea of an all-pervading spirit reflected in nature and inherent in form, and the Chinese artist turned his attention wholly to the search for essence.

The need for *ch'i yun* in painting required something of the

painter – the meditative disposition whereby his spirit or intuition could become 'the perfect reflection of Tao'. This lent a ritual quality to art by which the creative process and its products became the symbolic and actual wedding of matter and spirit, the unification of opposites, the harmonization of *yin-yang*.[26] Although it demanded great self-discipline, concentration and asceticism of the painter, the end of such meditative creativity was the actual realization or expression of *ch'i yun*, the 'life movement' of the Tao found in form and nature. The benefit of this, for artist and observer,[27] was the spiritual development and knowledge that came from spiritual experience – reflecting and uniting with Tao was an important means of spiritual growth and regeneration.

Whether or not we agree that this is possible to art, it is evident that the positive effect of Taoism on the development of Chinese painting was without equal. For even though there was an abundance of storytelling or mythological Buddhist and Confucian art, it was Taoism which proved to be the main foundation of Chinese aesthetic and artistic standards. This solidly based influence continued unchanged in importance and consistency down through the varying styles of dynastic history. If there were not some very convincing concordances, some great truth which the Chinese painters could see in Taoism which corresponded very closely to their own personal artistic experience, it is extremely doubtful that it would have been able to gain or hold such an influence even for a few weeks, much less for 2000 years. The principle of *ch'i yun* alone, so directly derived from Taoism and so dramatic in its aftermath on watercolour painting, must be considered the most important rule of Chinese art. Indeed, constant insistence on it in the literature of art criticism from the Han to the Ch'ing dynasties makes that observation clear. It was Taoist philosophy alone which consummately shaped the future of China's painting, just as it radically influenced poetry, calligraphy, and every other art form. Nowhere is this progressive alliance of art and philosophy more vivid than in the adoption of the painters of the same Taoist terms to describe the artistic essence – *Ch'i*, the vital spirit of Taoism, and *ch'i yun* expressed in art were the same.[28]

The ramifications of these developments for art and philosophy are milestones in the history of culture. Taoism became one of the world's first mature cosmologies, and the only philosophy ever to find in art a tangible proof of its propositions. Chinese art, on the other hand, gained an important focus, was able to better understand the creative process, and instituted unshakeable artistic and aesthetic standards through Taoism, as well as becoming aware

of its spiritual meaning and value to mankind. Taoism and art expressed a whole, an enduring and meaningful philosophy of reality with timeless and far-reaching implications for humanity and its creativity.

This unique agreement is all the more exciting and dramatic today, as it offers new keys to religious faith, a deeper knowledge of the spiritual world, and a series of renewed insights into what reality actually means. More than one modern thinker has seen in Taoism the answer to this question: Of what does the creative process consist, and what *is* reality?

There is the absolute reality from which all multiplicities spring. We are further convinced by Bradley that reality is above thought that cannot be reached by rational analysis, but only by immediate intuition. This is also advocated by Whitehead. To answer this we have the Taoist philosophy of sudden enlightenment, and its further development by the Ch'an Buddhists.[29]

What, then, is Tao-painting? We may, from what we have already said, define it as the spontaneous reflection from one's inner reality, unbound by arbitrary rules from without and undistorted by confusion and limitation from within. In this spontaneous reflection one's potentialities are set free and great creativity is achieved without artificial effort. This method of no-method in painting is the application of Taoist philosophy. As we know, Tao is the ontological experience by which subjective and objective reality are fused into one. This identification does not take place in the conscious realm through a logical process, but is that inner experience of which Chuang Tzu speaks when he says: 'Heaven and Earth and I live together, and all things and I are one.' This unity in multiplicity is not invisible and unfathomable and its emergence is not intentional but natural and spontaneous.[30]

Taoist thought was what helped Chinese artists to become consciously aware that 'art is dedicated to the expression of the inner spirit instead of physical verisimilitude'.[31] Coinciding this way with the natural aims of art, it could not help but have been strikingly effective and familiar to the artists, who then gave it their whole attention and utter loyalty. Demonstrable effects occurred in the creative/meditative process, in the expressive or content requirements, and also in the innovation of explicit media and techniques

to accomodate such expression. For example, where the aim was spontaneity, a whole new approach to painting technique became necessary, and probably co-operated with ink techniques originating in calligraphy and later carried over into watercolour, or may even have led to the invention of watercolour painting. Certainly the need for spontaneous and spiritual expression contributed to developing the watercolour techniques which are now universally typical of that medium. Among these were the 'wet-in-wet' method, or the use of subtly gradated and blended washes (called 'splashed-ink' in China) which so well characterized the nebulous mists, distant mountains, lakes and lyrical river valleys of the Chinese landscape, the sense of space, mystical atmosphere and essential character which so typified the soul of nature to them.

The need for 'uninterrupted flow' of the brush to 'transmit the spirit' no doubt originated and promoted the wet techniques, as well as the incorporation of an evocative cursive brush style and other linear treatments which had been especially Chinese since prehistoric times, but which now were turned to painterly daring and liberated simplification. These conventions were used to 'render much by little', i.e. the 'spirit resonance' or vitality of a form as it was expressed by its character, its 'inner spirit'. A range of codified conventions, conforming to many requirements of method and skill, had to be mastered to express the characterological features of nature, whose essences 'had to be brought out by the proper handling of the brush and ink'.[32] Cursive line, the full and ingenious use of artistic conventions, and a more vigorous 'axe-style' of the brush all were added to the softer watercolour techniques and used interchangeably with them to achieve a variety of technical effects which would be mastered through exhaustive practice, and once mastered, forgotten. All of these means were ways to facilitate creativity, so that the forms of technique themselves would become the most effective means of expressing the spirit of things.

In considering the correspondence of Taoist thought to the real world and to a basic foundation of reality, we find some startling agreements in places we had least expected. The first of these was of course in art, where a natural activity of man, creativity, proved to be a feature of nature herself, and where the typical focus of artistic effort corresponded both to the nature of mind and the phenomenon of specifics which we know as character.

Next was the rather unforeseen idea that the essential qualities of a material form are identical with spirit, both by definition intellectually and by nature ontologically, so that when discerning character or essence we can't avoid encountering real meaning and

realized spirit. The real world, therefore, is wholly pervaded by spirit, as all things have character. The idea and real being of Tao is confirmed by this, for since such spirit is recognizable to human intelligence, it follows that it issues from a similar intelligence, that an original Creative Intelligence is the source of spirit and is identical with it.

Thirdly, and most surprising, is to find in the idea of *ch'i*, as the universal nature and substance of matter and energy, an amazing correspondence with the physical structure of reality, as defined by modern physics. We have seen how *ch'i*, or spirit, was identified by the Taoists as the underlying or continuous essence of all reality. In the quantum field theory of physics, the very same property is found to make up physical reality and is demonstrated as a real physical phenomenon. This means that there is actual evidence in physics to prove the existence of a universal unity in reality, or rather the unity of the physical or creative energy of spirit, even though physics confines itself to science and does not speculate on such religious implications.

In this theory, the field (which corresponds to the Taoist *ch'i*) is the underbase and unifying atomic substructure of all matter and all form, and bears within it as well the constant interchange between particular atoms and the field. This takes place through waves of mutually unifying, transformative energy which makes them actually merge or be of one essential quality or essence.[33] What is this if not the physical evidence of the Taoist theory of reality, of *ch'i* and the interaction of *yin-yang*, proven empirically? A noted physicist has observed this close relation of the findings of physics with Taoism, and the following explains the scientific basis for such credibility:

> With the concept of the quantum field, modern physics has found an unexpected answer to the old question of whether matter consists of indivisible atoms or of an underlying continuum. The field is a continuum which is present everywhere in space and yet in its particle aspect has a discontinuous 'granular' structure. The two apparently contradictory concepts are thus unified and seen to be merely different aspects of the same reality. As always in a relativistic theory, the unification of the two opposite concepts takes place in a dynamic way – the two aspects of matter transform themselves endlessly into one another.[34]

If we think of the universe and all in it in this way it occurs to us that the spiritual presence, the *ch'i* which is the creative impetus of

the cosmos and the source of energy, has a special quality associated with movement and motion, which is graceful or symmetrical continuity. It *flows* out into all things and through all things, and all things flow back to it. And this was why the Chinese painters identified it so closely with resonance, with a sense of prolonged tone, with harmonious movement, as in *yun*. Flow is something which moves freely and continuously in an uninterrupted current, but it is also smoothly graceful, light, soft, totally natural, and effortless. Flowing and alive, ever vibrant and changing, *ch'i* is never static in its action, even as it is in its essence incomparably still, undifferentiated, and all-encompassing. This is not contradiction, but integration. It is the harmonious kinship and unity of all real being as it is made one by spirit.

It is this rhythmic echo of spirit, this hint of its unimaginable vibrancy and life, that makes possible its visible perception in the natural world. It is this that the artist senses, perceives or intuits, as the faint chords of a music dimly heard or felt, and it is this that he must express to be truly creative or to produce great art. So it was that the Chinese artists sought the expression of the character of natural objects, their spiritual reality, as the 'individualized manifestations of all-pervading spiritual life',[35] and thus it is that true art is the expression of spirit.

It is certainly the expression of spirit and its natural life forms, the moving vibrancy of nature and the immanent power of spiritual presence that can be observed in a painting by Li Shan, *Winter Landscape*, (Fig. 7). Its theme is familiar and deceptively simple. Two lonely travellers, dwarfed by nature's might and grandeur, struggle against the wind as they make their way, one on foot and one on a young ox, across a tottering wooden bridge toward a snow-covered home.

Their route takes us past a bent and aged, wind-lashed pine, over rounded hills and snow-draped boulders, sweeping us into a stormy cataclysm beyond. Rolling masses of snow, clouds and mist blow across a mountain range and a wide river. On its opposite side, dark foothills pick up the rising and falling forms of mountains, flat planes of valleys, and distant peaks. Nearby, the rushing downpour of several waterfalls surges into a mist-filled, foaming mass of water which rushes past boulders and boils over the rocks below as it joins with the waves and advancing currents of the river.

Three main masses form this composition: the foreground, with its very low placement of the bridge and figures moving up into the surflike form of the pine tree; the unifying, open space of river, cloud masses and sky; and the mountains and falls of the middle ground.

The sky and the snow-filled cloud bank which billows down onto the river surface are masterpieces of spontaneously executed, very free and wet washes, the density and fluidity of these washes eliciting the mysterious, expressive of turbulance, of wind, of blowing snow and mist. Its counterpoint, its balancing element, is the rugged, vital lines, textures and wild roughness of the tree, with its highly varied drybrush effects, gradated washes which turn the form, and vigorously bold pointed brushwork, laying down an array of dark accents which intensify the expression of the tree's character. The surge, thrust, and racing electricity of its movement with the wind and its own growth augment this overall feeling and character of the pine, as well as the thrilling sense of wind rushing through it, bending it, lashing it backwards. The figures on the bridge below, sketchy, yet perfectly scaled and anatomically rendered, give a subtle but important oppositional action against the tree as they struggle against the wind. And although they are small, details are nevertheless very expressive of their character, and accurate in drawing, as for example in the leading figure, whose essentials are caught so well in the balanced stance and step and the way his head hunches below his shoulder against the wind. The fat landowner behind him on his ox is also a delightful note, and we can feel his discomfort against the cold as his servant leads his mount home.

This painting is a masterpiece, not so much because it is the perfect expression of nature's power and force, and of factors very difficult to express artistically, such as the action of wind, storm and weather (although such creative virtue is certainly important), but because it has so well given believable and concrete artistic form to the fundamental spirit of living things. It has done this solely through perceiving and mastering their essential character, as in the tree, the figures, the moving bodies of water, and especially in the open, and extremely evocative, masses of clouds, mists, and space. These forms are not painted but alive, and they seem so alive to us because each has a definite spirit resulting from that very complete expression of its essence, its character. More, there is a deeper oneness about them, a common harmony, a unity of something in each essence which is everywhere identical in the painting. This is not a design contrivance of the painter, not something he tried to do or aimed for, or added. It hangs upon, permeates everywhere the wind-blown clouds and mists and emanates, spontaneously and naturally, from the powerful form of the tree, from the character of the rocks individually, from the half-hidden mountains. It is resonant; it vibrates with living energy, just as it does in nature; it is *ch'i*. The Taoists said that it was 'all-pervading' – it is spirit,

immanent spiritual presence. We can perceive it in nature, and we perceive it here in art.

Huang Shen was a contemporary of Li Shan (they were nearly the same age) and like the latter did his best work in later life, painting the superb virtuoso masterpiece *Eagle On A Tree Trunk*, (Fig. 8), when he was 68 years old.

The ontological link between the spirit of things and their innate character is again exemplified in this sensitive and deeply felt painting. Its composition is refreshingly direct, uncluttered and straightforward, allowing us to concentrate freely on its excellent brushwork and its meaning. An eagle, its wings beginning to spread for flight, its feet poised at the exact moment of releasing their hold, peers downward from an old, top-broken tree which stretches a veteran shard aloft in a gentle curve that arches into and picks up the curving grace of the bird's beak, body and wings. Maximum space was achieved through cleverly tying these forms to the extreme right of the picture, a compositional device notably modern but typically Chinese, and beneficially used here. The extended, airy body of negative space contributes to and amplifies the appreciable sense of height, loftiness and poised lightness of the eagle's impending flight. And once again it lifts the onlooker into an infinite depth and distance which is implicit with spiritual suggestion. Is it the faintly visible, horizontal tones of light wash that contribute to this, or is it the shape of the negative space itself, which enhances the curving symmetry of the eagle's back? Or is it yet something else? Of course this is the opposite of the dynamic tension of the eagle's figure and the flowing, fluid vitality of the tree, leading us to surmise that some aesthetic culmination may occur in this visible and invisible polarity, this meeting of spirit and matter. The composition is also harmonized and rescued from being one-sided by the stream of calligraphy, which is made part of the design as it balances the left side of the painting, where its dark abstract beauty creates an equilibrium, a complementary whole. The eagle stirs itself to fly, to become what it is, and the airy vitality of that moment is very like the empty space beyond.

Most enjoyable of all in this painting is the fluid grace and magnificent artistry of its brushwork. Four or five single, stabbing strokes of black ink create the eagle's bristling tail feathers. Judicious, loose, elegant, the bird's body is made as much out of what is absent as with touches of lighter and superimposed middle value washes and fluttering dashes of the brush. These, and the masterful top and rear feathers are unbelievably natural in their power and action, even as they move smoothly with the curving

beauty of the head, neck and body. Combined with the intense and detailed clarity around the eyes and beak, the effect of the whole is the inimitable expression of the eagle's spirit, through instinctive perception of essentials and the fine art of expressing them spontaneously.

The same is true of the tree form, for here spontaneity has a field day. Fluid, energetic, loosely masterful and deceptively casual, the tree form is not merely rounded and filled with light by the initial wash that trails down beneath the eagle's feet – it is a form alive and charged with the spirit of nature. So much freedom and life here – the dragging drybrush 'fitness' which epitomizes the tree's notches, knots and rough textures, the bone-like shafts of black expressing holes and deep decay, the tender, poetic touches of independent and vining leaf growth, sprouting here and there on the upper and middle trunk and lower right, and again the perfection of drybrush texture dragged over the paper which melts into more fluid washes near the base, over and around knots and the slightly suggested concentric rings of the wood – all of these are expressively alive. Yet they are not living things, they are the work of a bamboo brush. Why, then, do they express life so successfully? They do so because they are the essence of character expressed by spontaneous spiritual means, and in that essence lives a universal spirit.

If Li Shan's work was the reality of spirit present in nature, so is that of Huang Shen the epitome of character in art. From their work we can learn something of how they conjoin in content, of how the character of something is inseparable from its spirit and from a spiritual principle which pervades reality, and how art for that reason becomes expression of both reality and spirit.

Notes

1 Bergson, 292.
2 Watts, 16.
3 Chang, 65.
4 *The Secret of The Golden Flower.* (Tai I Chin Hua Tsung Chih). Richard Wilhelm, Translator. Introduction and Commentary by C.G. Jung. New York: Harcourt Brace and Company, 1931, 11.
5 Waley, 52.
6 Creel, H.G. *Chinese Thought From Confucius to Mao-Tse Tung.* Chicago: University of Chicago Press, 1953, 101.
7 Chan, 316.

8 Ibid.
9 Ibid., 260, 261.
10 Ibid.
11 *Tao Te Ching*, Bahm, Translator. Commentary, 80.
12 *The Secret of The Golden Flower*, 23.
13 Legeza, Laszlo. *Tao Magic*. New York: Pantheon Books, 1975, 12, 13.
14 Waley, 28, 48.
15 Chang, 211.
16 Waley, 33. Siren, *The Chinese On The Art of Painting*, 66.
17 Chang, 35.
18 Ibid.
19 Waley, Footnote, 150.
20 Siren, Osvald. *Chinese Painting: Lead Masters and Principles*. New York: The Ronald Press Company, 1958, 89, 229.
21 Siren, *The Chinese On The Art of Painting*, 23, 25.
22 Ibid., 21.
23 Ibid.
24 Ibid., 22.
25 Ibid.
26 Waley, 52.
27 Legeza, 13.
28 Chang, 93, 205.
29 Ibid., 106.
30 Ibid., 203, 204.
31 Chan, 210.
32 Siren, *The Chinese On The Art of Painting*, 80, 163.
33 Capra, Fritjof. *The Tao of Physics*. Boulder, Colorado: Shambhala Publications, 1975, 200.
34 Ibid., 201.
35 Siren, *The Chinese On The Art of Painting*, 51, 52. Hereafter all citations of Siren are from this work.

Chapter V
The Unification of Opposites:
Yin-Yang and Wu Wei

The principle of *yin-yang* in Taoism is the doctrine that conceived all action and events as the effect of two primary elements or forces, the positive and the negative. It is a simple idea with a number of hidden and multilevel meanings, many of which relate significantly to how we can cultivate and improve our spiritual growth, deploy harmony and effectiveness in personal relations with others, and step more firmly along the path of creativity in our lives.

This doctrine is best described as the observation in nature of its primary and most basic principles, and although such principles are physical, they are always seen as having a spiritual source, the Tao, and a creative quality, generative transformation, as the action of Tao. This places the laws of nature and physical action directly in the hands of God, so to speak, and unless we insist on God being a figurehead, far removed from nature, such regenerative implications thereby become associated with an inherent law of compensatory harmony or balancing out, in other words, with justice. The idea of *yin-yang* is, in effect, the law of natural action and the action of natural law.

Is this a moral quality? I think it is, if moral is a name we give to the principle of rectitude. It is one inbuilt into physical reality, which out of the nature of things maintains a constant balance of conflicting elements for the good of all, which is really what the idea of law is all about. Moreover, man is not exempt from this self-righting natural order – it is a universal law of nature which has an unavoidable and explicit authority over all that exists. Man is part of nature, and so is one with it[1] and governed by its laws. This is to say that he can't exist outside of nature – since he is a physical creature, he is bound by the same principle of balanced opposition,

63

and this will be so as long as he lives in the physical plane of existence.

Yet this process of constant transformation through opposites is not simply the bouncing off of things against each other. It is more like a continuous interaction,[2] for only in such interaction, such blending, does harmony become possible. The polar forces of *yin* and *yang* must work together, *will* work together, or the unnatural state of disharmony, inquietude and suffering will result. The application of this to the human mind has intriguing ramifications. Inner conflict may result from a too-rational approach to living. It is remarkable how in ancient and historical China two opposing philosophies, Confucianism and Taoism, arose in response to, and appear almost as archetypes of this principle, and further, served to literally harmonize and balance the society in the same way. Confucianism represented the rational resources of the mind, the *yang* of society, while Taoism took the place of the spiritual or creative/intuitive *yin* need. It is noteworthy also, that common to both of these philosophies was a doctrine of the mean,[3] a harmonious balance of extremes.

So *yin* and *yang* are not merely alternating rhythms of nature – they depend on one another; each is the complement of the other, providing a unified whole and a creative universe between the two. The goal of the Taoist was the perfect equilibrium between these positive and negative principles.[4] One could well surmise from this that the ideal state of things is eternal peace and tranquillity, and recall that the Tao nature was so described.

Applied to psychology, this condition implies a complementary, interdependent quality of the rational and intuitive faculties. Applied to art, it was the union of form and spirit. Both of these conditions required work and development, 'the art of the mind', and it is pertinent that it was *ch'i*, or spirit, which was the unifying agent, that which brought together *yin* and *yang* in creative, created harmony.

The need for the mind to be in touch with *ch'i*, through the spiritual medium of intuition, was vital to achieving a spiritual unity of the positive and negative polarities – the blind forces of nature – to harmonize them, as the Tao did, through the knowing, creative power of spirit. Creativity, whether in meditation, life, or art was the human reflection of the creative spirit of Tao at work in nature.

This creative blending of opposites signified a higher consciousness, the spiritual completion or fulfillment of life. With this eventuality, the cyclic nature of existence would come to rest

through the higher integrative powers of spirit. Whoever achieved its mastery would be a spiritual master, and would possess the power and virtue of *Te*, the Tao nature actualized in human life.

Another special aspect of this formula was that it was necessary for man to live in harmony with nature and the given nature of things. This amounts to a willing acceptance of nature's laws and requirements of life, and has the same implications of harmony and attunement to spirit, to other beings and to one's natural place in the natural realm. Important insights into effective living and proper being arise in connection with this stipulation, and many of them represent the core of a creative and healthy life. To the Taoists, an important part of spiritual development lay in finding this natural Way, in reverence for the cycles of life and nature, and in learning to live harmoniously with them. 'To be in harmony with, not in rebellion against the fundamental laws of the universe is the first step, then, on the way to Tao.'[5] They believed that man had ceased to know how to do this, whether as a result of social conditioning and the overdevelopment of the rational mind, or because of the self-conceits and illusions of the ego. To return to Tao, to one's original state of pure and free being, one had to constantly harmonize with nature and live within its laws.

How was this to be achieved? By the practice of meditation, by using the creative power of *ch'i*, and by moving in concert with the ever-changing currents of *yin-yang*. The latter was more like a flowing with the rhythms of nature than a form of compromise, a going, happily, with life; a blending of characteristics; a swimming with the nature, spirit and grain of things, rather than always trying to oppose, compete with, or push against the currents of life. And from this came another important Taoist idea, *wu wei*, which we shall shortly take up.

Some of the *yin-yang* doctrine may seem circular or enigmatic to the Western mind, yet it compares favourably to the findings of psychology and psychiatry. If, for example, we compare the Webster's definition of the id, as 'the undifferentiated source of the organism's energy from which the ego and libido are derived', with *ch'i* and the universality of the Tao energy, there is little difference. The ego, as derived from the id, is also congruent with the Taoist idea of spirit inherent in and shaping character. Conflict surfaces, in Taoist terms, when the outer self is not in harmony with the inner, or real self, or when the inner self can't harmonize or integrate in some way with the outer world. In psychology, the conflict is the same, put into different, scientific terms. The ego must harmonize the energies of the id with the standards of society without totally

repressing the latter. Here again the rational and intuitive functions become relevant – the conscious mind, the guide for the outer (ego) self, becomes the integrating agent, in the world, of the unconscious (id) energy, which is the guide for the inner self. The main point of diversion between Taoism and psychiatry is that the latter fails to recognize the spiritual origin of the id, and links it instead with primitive biological urges, which is amusing. We must, however, allow science the complete freedom to be incomplete.

Much of this seems to revert to the idea of the real self and the effective use of creative energy in action, points which were highly pertinent to the Taoist thinkers and to artists as well. What is the real self? What is the most effective way to equilibrium and psychic harmony? What of aggression and our reaction to it? Taoism gives us valid answers to all of these questions.

It may be surprising to learn that the Japanese self-defence of *judo* (which means 'gentle way') is based on the Taoist principle of *yin-yang*, as are many martial arts, such as Chinese *Tai Ch'i Chuan*. *Judo* is also called 'the art of giving away', which hints at its *yin-yang* qualities, for the *judo* fighter never opposes and is always yielding. In effect, he steps back to win, and uses his opponent's weight or positive force against him. Once I had a Japanese judo teacher who taught his students that *judo* was love, in that it merely helps the attacker to do what he wants to do. *Judo* works on the principle of imbalance, the weakening effects of the loss of stability, and if an opponent is off balance the *judoka* can assist him to the floor, since by his positive attack that is what he seems to want – forward motion must come to rest somewhere, and the *judo* expert simply helps the process along, teaching his opponent a rather painful lesson about love.

The point of this little example is that it demonstrates the Taoist attitude toward *yin* and *yang* and the Way the spiritual adept must live in relation to them. As things advance positively, so does the Taoist give way; as they recede, so may he move forward; and his response to this ebb and flow will be governed and guided solely by his intuitive intelligence. This is an actual harmonizing with the transformative, creative forces of nature, and it gives to such action (or non-action) an incomparable authority and key to magnetic power. It is creativity in action in life, for to be creative means to bring together the objective and the subjective.

Figuratively speaking, the spiritual centre of balance is *ch'i*, which must be sought out and not be destabilized by the fluctuating changes of *yin* and *yang*. The necessity for harmony, as a requirement of advancement in spiritual realization, is thus

translated into the creative practice of habitual mental calm and moderation. And the need for detachment and self-restraint which characterizes the spiritual laws of all great philosophies and religions is here given a new meaning and a corresponding physical substantiation. The law of polarities in nature shows attachment or excessiveness to be unnatural – since things are always in flux they are never attached; since they are always balanced by opposites they are never excessive.

In searching for this quiet centre between extremes, this spiritual haven in the vicissitudes of life, in seeking spiritual realization, the Taoist sage avoids all excess, all points of possession and opposition, and instead harmonizes such conflicts by stilling them with his mind and his creative spirit. His spiritual equilibrium comes from neither *yin* nor *yang*, but lies somewhere in between, in mental composure, just as the Tao is neither positive nor negative – it is *still*. So does the Taoist *ch'i* gather its strength, its spiritual energy, from consolidated expenditure of energy, from the harmonious median between all poles, all extremes, and this was what the idea of *wu wei* implied.

As a special distinctive feature of Taoism in spiritual development and its attainment, *wu wei* was cited numerous times by Lao Tzu in the *Tao Te Ching*. Paradoxical and enigmatic, it means literally in Chinese 'non-action', or, as used by him, 'taking no unnatural action'.[6] The seeming enigma and obscurity of this will not lead us astray if undue weight is not attached to the words and consideration is given instead to the metaphorical sense in which much of the *Tao Te Ching* is written. Actually, *wu-wei* does not refer to explicit action at all, but rather to the detrimental effects of forcing things, of excessiveness, and of attachment, points made above. Its greatest importance and full meaning is that it sets up intuition as the guiding principle for action, and leads to the idea of spontaneous knowledge as the main path to real creativity, in the fullest and most spiritual sense of that word.

An 'unnatural action' to the Taoist is a disruption of the harmonious flow of life and nature. In itself, a disharmony is interference with, and rebellion against the spirit of Tao inherent in nature. This prime emphasis on the 'natural' and the 'unnatural', therefore, is the basis for Taoist ethics and its code of conduct, which finds nothing wrong in nature, but only in that which exceeds nature. To make sense, *wu wei* must be understood in these terms. Non-action to Lao Tzu did not mean passivity or doing nothing;[7] it meant not pushing anything to its extreme limit, or acting in accord with the laws of harmony. To the Taoists the natural is the spiritual

and the unnatural is the unspiritual; they do not separate spirit from nature or man, and nature is not low, mean, ugly or immoral.

This reverence for nature and the natural, then, is at the same time a reverence for spiritual life, and it carries the mandate, for the spiritual person, to remain spiritually centred – calm of mind, intelligently detached, and poised between all extremes. This would be the stage for perceptive intelligence, mature authority, advanced spirituality, creative growth and the happiness that life naturally promised.

By letting nature follow its own course in daily life, by refraining from action which is contrary to nature, the life of man is not sublimated, transcended or repressed. On the contrary, it is liberated and fulfilled.[8] The spiritual person, rather than resisting the incessant changes and transformations of life, flows with them, joins with the oneness of the universal rhythm by not opposing anything or forcing his will upon it. Remaining in the centre of balance, adapting his life to nature's laws, he will enjoy life and greater creative intelligence; he will be liberated proportionately by living in harmony with the natural Way – more than liberated, he will be purified,[9] and will move closer to his 'Real Self' as it was intended to be. For the complete relinquishment of excesses and attachments clears the way to the rewards and joys of real being and destroys the fog of illusion.

The gentle discipline of *wu wei* inevitably leads to intuition and one of the most important aspects of Taoist creative power, the improvement of creativity which we have already seen many times as so effective in art – this is *spontaneity*.

The Taoist meaning of spontaneity is exactly the same as ours. The spontaneous is that which arises of itself with little or no volitional effort. This refers unconditionally to thought and to the mind, since all actions necessarily begin there. The only department of the mind where thought arises spontaneously is in intuition, so we can see that spontaneity is a main characteristic or quality of intuition. It is in fact the way intuition works – intuitional perception or enlightenment is entirely spontaneous, and the will has little to do with it. It is the kind of immediate knowledge which interjects itself into the conscious stream of the rational mind, which latter agency acts upon the information. If spontaneity is characteristic of intuition, and we know it is, then the spontaneous idea (or symbol) is an indicator of the creative direction the mind (and actions) should take. We have already noted in an earlier chapter the importance of intuition as the expressor of non-verbal meaning, of essence and spirit. Consequently, spontaneity is an

authoritative guide to creative action and spiritual meaning, because intuition is the transmitter of spirit. It may be the only guide to it we have. The practice of *wu wei* – that of suspending the will, reducing egoistic extremes of unrest and possession, and the stilling of the interfering rational process – releases the spontaneous and creative manifestation of spirit, which becomes the judge and arbiter of all spiritually valid actions.

These ideas, unparalleled in their significance for creativity and spiritual practice, appear repeatedly in Taoist thought. The implications of not 'straining' the mind and 'emphasizing the intuitive, spontaneous element',[10] of avoiding that which does not come of itself, were basic to integrity and non-prejudice. Change was innate in life and nature. It occurred naturally, without pressure or force, resulted in both positives and negatives, and was a permanent tendency of all material situations and natural directions. The action of Tao itself was naturally spontaneous and creative – no one could predict its course or improve on its methods, and men should pattern their lives according to it. To act in harmony with nature therefore meant acting according to one's true self or inner being before all else. Such conditions alone reflected Tao, were original, true and free, and made themselves known spontaneously, as did the Tao. It meant 'trusting one's intuitive intelligence',[11] as the creative barometer of life. When the ceaseless verbalisms of the rational mind (which the Chinese call 'monkey chatter') were still, when the will did not force itself into consciousness and ceased to compete with the spirit, then all action would come from the Tao.

All of this bears dramatically on the nature of creativity, what it is, where it is, and how we use it, and in the next chapter we shall explore that topic more fully. It also relates importantly to art and creativity in human relations, human development, and as the process by which the Tao becomes real and known in the world.

We have seen how Taoist spiritual development lays great stress on finding or 'returning to' the true self, the immaterial self, the original substance which is the soul or spirit, and which is of the same nature as the Tao.[12] Lao Tzu called it 'simplicity' or the 'Uncarved Block'; to Chuang Tzu it was the 'Real Self'; elsewhere it is referred to as *tsu-ran*, literally, the 'self-so'. The Way, the Taoist path to fulfillment, is directed to finding and living in this real or spiritual self. The conduct of life and the requirements of creative action both stem from this central identification with spirit and the spiritual realization toward which it leads. The Way, indeed, is a way of life, and what we wish, or what we want, what we like or

dislike, have no part in the detachment and impartiality, the just neutrality, the still, self-directed composure necessary for attaining spiritual and creative integration.

> With a tired body and a frightened mind, they toil to avoid this and to take that. The sage alone has no prejudice. He therefore proceeds with utter simplicity and becomes one with transformation and always roams in the realm of unity.[13]

The expenditure and consolidation of energy are viewed in Taoism as vital factors in creative performance, and since creativity is synonymous with spiritual action, they have a bearing on spiritual development as well. Such consolidation is simply put – we have only so much energy, which, if it is spread everywhere or in too many directions at once can only become depleted and result in an excessive diffusion of the life-force. Many things, then, must be eliminated from one's life in order to follow the way of spiritual fulfillment and the finding of inner peace, for full spiritual orientation depends on rest, in the physical sense, on stillness, in the mental sense, and on the cessation of activity in the worldly sense. Through such non-attachment to the externals of the world and the gathering of natural power to himself, the spiritual person will gradually grow stronger in mind and body, in his spiritual self and his physical vitality, and will achieve progressively greater enlightenment. Because such building of energy leads to increasing access to intuition, creativity will grow accordingly.

Spiritual cultivation and its accompanying creativeness thus has no limit to how far it can be taken in life, for the spirit and its potential are boundless. It is limited only by how much we are willing to bring to it, or rather, how much of the egoistic world we are willing to let go of.

The sixth chapter of the *Chuang Tzu* shows how the sage, through intuitional enlightenment, finally comes to know the spiritual unity of all things as a personal experience. Once that happens he becomes free of the boundaries of the ego and free from the conditioning which society has burdened him with throughout his life. Liberated, he achieves extreme clarity, and with it, total stillness of the rational mind. He has found the centre of his spiritual being and complete integration with life and spirit, with the Tao. He has found and united with his 'Real Self', for the soul is identical with Tao; the soul *is* Tao. And further enlightenment, further integration will proceed from this same stillness, this 'non-action' of the mind. In this state, things are no longer viewed as separate

distinct entities, but only as one spirit, and part of the One Spirit.[14]

A great deal of this very high level of integration can develop in creativity and in art, the pinnacle of creativity. Whatever the variety of factors may be that make up artistic ability there can be no question but that they are unique. Unquestionably also, they are a decided psychological advantage, according to recent terms of mental health:

> The creative process must be explored not as the product of sickness, but as representing the highest degree of emotional health, as the expression of the normal people in the act of actualizing themselves.[15]

The artist, whether he consciously pursues a spiritual way of life or not, nevertheless possesses a remarkable capacity for perceiving essence and integrating the inner and outer worlds. How *well* he does this may perhaps depend on the many conditions, some of which are very arduous, which make perfect creativity function at optimal levels. Some of these are tangible, such as his training, perseverance, self-discipline and willingness to sacrifice, and the financial and personal freedom to develop and master the technical fundamentals, the craftsmanship of his art. Others are less tangible, such as sheer good luck, the motivations and integrity of the individual, the kind of social conditioning and education he receives, and last but not least his degree of intelligence and spiritual consciousness. Withal, given the least chance, technical mastery and expertise can be advanced to the point where it can become second nature, which is the access point to that creative stage of which we speak, namely, to give meaningful form to an inner experience or perception. The value of this, in spiritual terms, is the creation of an objective expression of the spiritual character of things. In Taoist and psychological terms, it is to harmonize the fundamental conflicts of existence, the giving of form and order to the differences of subjective and objective reality, the making one of opposites, the harmonizing of *yin* and *yang*.

Mostly the artist takes part in this unifying integration of reality without noticing what is really going on there. The artist does it unconsciously, with little effort. It is as natural as breathing. It is this very lack of self-consciousness which makes such creativity possible; self-consciousness is, in fact, inhibiting to creativity. The artist does not interfere with the flow of Tao; caught up in the spontaneous creative act, conscious thought is held in abeyance as intuition assumes predominance over the rational mind during the

71

creative process. If the artist stopped to think about what he was doing, or began to mentally verbalize the process, he would slow down and check it, if not stop it. Creativity only takes place because the artist operates entirely in the intuitive mode of thought and obeys the spontaneous dictates of the artistic process as they arise from within, and these will direct his actions.

We are now in a position to appreciate how this creative phenomenon has a substantial agreement with the findings of Taoist philosophy. It is even more significant to find it's true in general of all creativity and all art forms, even those which have not the least resemblance to a Taoist orientation. The artist *naturally* assumes the same mental attitude, the same disposition that the Taoists say are the conditions for spiritual realization. Since it is a *natural* occurrence before any kind of conjecture or religious influence it is more than sufficient evidence, in reality, of the validity of the Taoist principles of spiritual creativity.

This unification of opposites in art is that same spiritual integration which takes place in meditation, in other kinds of creativity, and in spiritual fulfillment. Moreover, the artist crystallizes it in existence, in the enduring form of the art object. The artist unconsciously practices *wu wei*, becomes creative because of it, and realizes the spiritual unity of life in his work.

Art becomes a vehicle of spiritual experience when artistic perception merges itself most successfully with fundamental reality, both objectively and subjectively, when it unifies the inner and outer worlds. Why? Because as the Taoists tell us, the spiritual dimension is the original source of those two poles of existence, and this unification makes the artwork, consequently, a reflection of spiritual reality.

The Taoist art critics stressed repeatedly that the interfusion of *ch'i* in reality, merged with the *ch'i* of the artist, results in the objectification of spirit in the artwork, and that this in turn brings about benefits and cultivation for society and all who enjoy the aesthetic experience. This is as much true for Western art as for Eastern art. It is evident, however, that the Taoist painters were aware of these dynamic creative principles firsthand, and so were able to apply them with deliberate and focused concentration to their work. As a result, they were able to eliminate much of the conflicting aesthetic philosophies, artistic controversy, superfluous floridity, uneven performance and confusing diversity which plagues, and is so often found in, Western art. The impressive homogeneity and consistently high levels of Chinese and Japanese art attest to this fact. Great Western art will always be great,

however, and a thorough comparative study along these lines, which we do not have space for here, would doubtless reveal that the greatest have utilized and expressed the same universal spiritual and creative principles outlined by Taoism. Although they may have come from Christian mystical influence, or the close study of nature, they are powerful for the same creative and spiritual reasons.

In addition to a more consolidated creative focus, the Taoist artists also had a most effective creative support – their conscious interest in the spiritual dimension of nature and their alliance of creative discipline to transcendental meditation. This could not help but vastly improve their personal creative development and, in turn, their work. As I pointed out in the preceding chapter and will do so again, some Taoist paintings reveal an almost mystical power of brushwork – their skill shows technical feats which many Western artists would not even attempt or would consider inaccessible, and the results are clearly amazing. Yet this masterful efficacy (it is much more than facility) had a meditative base and a deep awareness of spiritual unity, both perceived and practised. It is precisely such practices which may align creativity with the very harmonics of reality:

> In stilling the heart an individual can become one with the elements of nature, the great creative forces of Tao. This becoming one is the true meaning of wholeness. In painting, this goal is translated into the aim of the painter to identify himself with the object depicted, i.e. to relate that in himself with that in all things which shared the Oneness of Tao.[16]

The work of art does not alter the consciousness of the audience; on the contrary, it reinforces it through confirming reality. The viewer does not need to intuit this experience – the artist has already done that for him. The work of art does nothing to the onlooker except to make him see the same spiritual essences which the artist perceived and was able to express in form. This is not to take part in a concept, but in an actual spiritual realization. The field of spiritual unity which is the Tao is continuous and all-pervasive; it is that same basic substance of reality in which all opposites, physical and moral,[17] are interrelated or united. It exists at once in the viewer as in the artist and the work of art. The artwork simply makes this reality more clearly perceptible to the audience, and it explains why art is sometimes felt as 'the shock of recognition'. I can hardly speculate on the full benefits of this experience except to say that it is both spiritual and psychological and amounts to a form of fully

natural spiritual, emotional and intellectual development or regeneration. Often such experience relates to what one needs at a given stage of life and inner growth. The audience is at times enlightened, at times gratified by recognizing the same essences and meaning as the artist, and is reinforced spiritually and psychologically by them. Further, the social benefits involved extend, once more to the blending and harmonizing unification of opposite entities, a cohesive effect on the human heart and the world at large. The subjectivity of the artist and the subjectivity of the viewer are united and harmonized in the objective work of art, again demonstrating and fulfilling the law of harmonies and the reconciliation of opposites – that which is different or was objective is now integrated, even though their forms remain distinct. Spiritual understanding improves, perhaps even the power of discernment, and consciousness, confidence and character are broadened and strengthened.

A work of art does not *compel* attention or consciousness and does not lend necessarily to any particular conceptual or conscious conclusion. Depending on its effectiveness, it draws the viewer into the work through imagination or identification. This still has the ultimate end of reunion, regeneration or harmonization with nature or essential meaning. The artist has made such identification possible. This experience may be as much potential in the audience as its objects are inherent with spiritual meaning. Commonly, we speak of *absorbing* an aesthetic experience, and clearly the immediate experience itself has no ground for conceptual analysis. Sometimes enlightenment becomes conscious from experiencing a work of art, sometimes not, and such variations may be partly subliminal or dependent to some extent on viewer concentration or receptivity.

Concepts originally formed by the artist prior to, or even during the work may be either redundant or irrelevant to the actual creative process, or may be intuitively informed. Only in the latter case do they have any creative value. A case in point is in writing – the writer's art is bound up with verbalizing ideas; the technical means are words; but the most valuable concepts are always the mere framing of an original intuitive understanding. To the painter, concepts are unnecessary. More often than not, artists are genuinely surprised by the unforeseen, non-conceptual twists and turns that the spontaneous creative process takes, and it is half the fun and adventure of creativity. This elegance of accident directs them rather than is directed by them, for artists will always be fascinated and

lured by the true and beautiful and led by the meaningful, whose essence they can intuit as keenly as bloodhounds on the search. In the direct act of creativity the rational mind and its laborious concepts can only hinder and encumber the rapidity of the creative response, which is instant and intuitive. True artistic attention, true creative perception, requires no conceptual structure or preliminary preparation to operate, for it supersedes, with a direct intuitive knowledge, the ordinary routes of conceptual consciousness. The artist knows what to do, so to speak, as he does it, and many artists have had this experience, although they may be unable to explain it.

Some thinkers seem to regard the identification of the artist with the object to be depicted as a sort of fuzzy aim or intellectual exercise on his part, but it is something much more than this. It is more basic, more instinctive, more natural, and much more non-conceptual. The Taoists would call it a movement of the soul, and if it is, it is an event so finely tuned, so subtle it easily escapes notice. The following experience of mine may clarify this point a bit.

Recently as I was walking in the countryside near my home I noticed a fine, interesting old tree and began to turn over in my mind, the way artists sometimes do, as to how I would go about drawing it. As I did so I noticed, practically at the same moment and for a fraction of a second, that as this thought occurred something in my deepest being, in my mind, instantly flew from my consciousness to become as one with this gnarled old giant of an oak! My spirit, my being, whether out of artistic instinct or whatever, had for a fleeting moment completely identified with the character of the tree. It seemed I had become, in that moment and without willing to do so, in total harmony with its being.

It could be objected, of course, that this is merely empathy, but empathy is a projected state linked to imagination and voluntary, and is besides a learned trait, an intellectual exercise. My experience was involuntary and wholly spontaneous, a complete inner identification with an external object, rather than the deliberate projection of my feelings onto that object. What had begun as a concept was transcended at once by a non-verbal sense of unity. My insight into this matter led me to be convinced that this blending or merging of the inner self with a formal, external object is a large part of artistic identification and the way creativity begins:

What is this atmosphere that moves from objects painted to the painter himself? And thence from the painting to the observer? This is the movement of the deep underlying harmony that

75

interfuses and interpenetrates between man and man, between men and things. It emerges with the immediate reflection from the absolute reality of our selves.[18]

By now we may be asking what does this mean, the Taoist doctrine of *yin-yang* and *wu wei*, in terms of the lives of people? Well, for one thing, it shows us how to use our creativity to maximum advantage, how to marshal all of our intellectual and physical abilities by consolidating them and concentrating them for total effectiveness at any given time. And it does this through completely natural means. The Way is implicit with creativity, and some form of creativity is essential to it. It is the explicit spirituality and naturalness of these means which give them their tremendous energy and their vital efficacy. It is a Way electric, magnetic, dynamic; yet it is at the same time just and gentle with an incomparable authority of rightness and proportion. It is the utilization, by human beings, of the limitless creative power of the spirit.

Creativity is not simply the talent to write a book, paint a picture, perform, compose music or sculpt. Creativity, as understood by the Taoists, demonstrates and involves the most fundamental laws of nature, and is a generalized natural ability and developmental potential which everyone has and everyone can develop, as we shall see in the next chapter. We have considered in this chapter its basis and its natural purpose, as well as some of the principles governing its use. The ramifications are as simple and direct as they are powerful.

To resolve any conflict, discord or extreme the Taoists advise us to apply *wu wei*. This does not mean not to take action; it means to be quiet enough to know what action to take. *Wu wei* is the habit and discipline of stilling the mind so that intuition, the voice of spirit, will penetrate our consciousness and supply a creative or spiritual solution to every problem of life. Such solutions can include a judicious doing nothing about the problem, and it is often extraordinary how things have a way of righting themselves if left alone. It may be that creative intuition suggests some other course – if action becomes necessary, it is the *right* action in the *right* amount that characterizes proper *wu wei*. The principle is that spirit, at the centre of all existence, can always restrain imbalance or excess, and so can't fail to be positively creative and renewing.

So we can see how the practice of *wu wei* is first and foremost stillness of mind, calm and poise. Next it is self-restraint, self-discipline and non-biased detachment. Finally, it is putting

ourselves in harmony with the Tao of things. All of these require practice, receptivity, commitment and spiritual discipline. To perfect the principle of *wu wei* is an art, but it is an art that anyone can learn, for we are all of the same spiritual fabric. It is many things, and many creative principles and actions of life follow from it. It is a vital part of the art of living.

Excessive expenditure of energy in any direction results in the exhaustion of its physical and spiritual balance. Nature, as *yin-yang* teaches us, is never excessive, always balanced. The same rules apply to us. Creative regeneration can't be utilized in the face of constant depletion – it will become weak, feeble, scattered, perhaps even distorted in some way. It is the way of nature to conserve its forces so that renewal is never in danger. Disquiet, agitation or restlessness in people, actions, or situations is an indication, certainly of imbalance, but more importantly of attempting to force things, of straining against the flow of spirit, of competitiveness and greed, of opposing the natural course of life and the *yin-yang* harmony. The Taoists show us that it is much easier to go with nature than against it, that by so doing we will accomplish our purposes far more quickly, efficiently, and with much less effort – even effortlessly – even if that Way seems passive, unhurried, and not suited to the demands and conceits of our egoistic rational minds and the pressures of society. This has a bearing on all of life and every human relation, from profit and loss to sex, the family and marriage.

In modern times it may be difficult for us to understand and accept this idea, since we have so lost touch with nature and our inner selves, but it can be done. Indeed, it *must* be done, for the warping of nature and human life, the destructive extremes of abused energy, ego obsession and excessive rationalism are all about us. The world desperately needs a spiritual rebirth, and a great spiritual renaissance is indeed in our future which will lift man far above his present intellectual and spiritual levels.

A natural law of complementary harmony is simultaneously a law against disunity, strife and aggressiveness, and a renewed mandate for the natural over the unnatural. Accord with nature, ourselves and others is the natural way. Because the Tao is harmony, spirit is endlessly creative, restoring life, renewing and nurturing nature and the universe. Whatever is unnatural will be eliminated by nature and the inalterable stream of natural process, since the unnatural has no real place in existence. If things can't be creative they may become destructive, which is another way of saying that if they can't regenerate and grow, they will degenerate, deteriorate, and eventually die. But the principle of life is eternal creation, not

destruction, and changes which seem like destruction are merely those in process toward new creation. Physical life involves opposition, but the best way to meet opposition is not by aggression, but to let the onslaught expend itself and to redirect it creatively. Spirituality is gentle and just, and spiritual energy is the final mediator and arbiter of nature, and when we reflect it, we have the same power of transformation.

Further, as we have seen in the phenomenon of *yin-yang*, all things pushed to their extreme point will change into their opposite. Yet as *wu-wei* also shows us, it is spirit which unifies and harmonizes and creatively restores equilibrium out of opposition. In this balancing of opposites lies the harmonious centre of creative power, and harmony is the law of life. Living in harmony with nature and *yin-yang*, it is this invisible centre which becomes paramount. With it comes the unspoken challenge to be our spiritual selves, to live up to the best within us, to accept and nurture the myriad forms of life and nature with the same tenderness and spirit in which they are given, and to live out our lives in a creative, meaningful way.

In this we will have spiritual help, for spontaneous creative intuition, as the natural reflection of spirit, must solve every problem of life and bring all disharmony to rest. Spirit, therefore, is the Way to creativity, and creativity is a Way to spirit.

Notes

1　Chan, 244, 246.
2　Legeza, 10.
3　Chan, 246.
4　Waley, 112.
5　Ibid., 55.
6　Chan, 43.
7　Ibid., 136.
8　Ibid., 136, 137.
9　Ibid., 177.
10　Creel, 106, 107.
11　Capra, 105.
12　Chan, 321.
13　From Kuo Hsiang's *Commentary On The Chuang Tzu*. Chan, 330.
14　Chang, 132.

15 May, Rollo. *The Courage To Create*. New York: W.W. Norton and Company, 1975, 40.

16 Sze, 103.

17 Welch, Holmes. *The Parting of The Way: Lao Tzu and The Taoist Movement*. Boston: Beacon Press, 1957, 57.

18 Chang, 93.

Chapter VI
Creativity and its Art

Many years ago when I was an art student in Paris there were numerous colourful characters living beneath the bridges along the Seine on the Left Bank. Some of these were protesting students or long-haired Existentialists, the precursors of modern hippies, some of them simply vagabonds or derelicts. Since I was often drawing along the river I had the opportunity to study and even sketch some of these people, and I remember one in particular who by anyone's standards would be called the most disreputable of vagabonds, a tramp. He was always dressed in the same unbelievably tattered overcoat that reached his ankles, patched, baggy trousers (a rope for a belt), a crumpled fedora jammed about his ears and his feet wrapped in bundles of rags. What distinguished my favourite tramp was that he danced – suddenly, joyfully, spontaneously, with or without music. When he danced – his arms floating lightly on the air to either side, his hands and fingers undulating expressively, his feet gliding surely and nimbly across the cobblestones, his body turning in parabolic, swirling, stately pirouettes to a measured inner rhythm only he could hear – he was pure poetry, and the bliss reflected in his crumpled, bearish face was a joy to see. For he became something entirely free that soared above life but was at once life itself in all of its diversity, all its turmoils and all its spiritual heart. He wasn't intoxicated or mad – he was creating, with all he had, with the inner material of life, which is what creativity is.

While we may not always be aware of it, creativity is a part of the human soul. The deep wisdom of the Taoists, in all its natural simplicity, spiritual accuracy, and ancient mystical secrets, shows the soul to have a profundity, dimension and power scarcely considered and seldom fully realized, even to the present day.

Taoism does this by joining the life force, the very energy of life, to creativity and the spiritual world. Life, life energy and creative

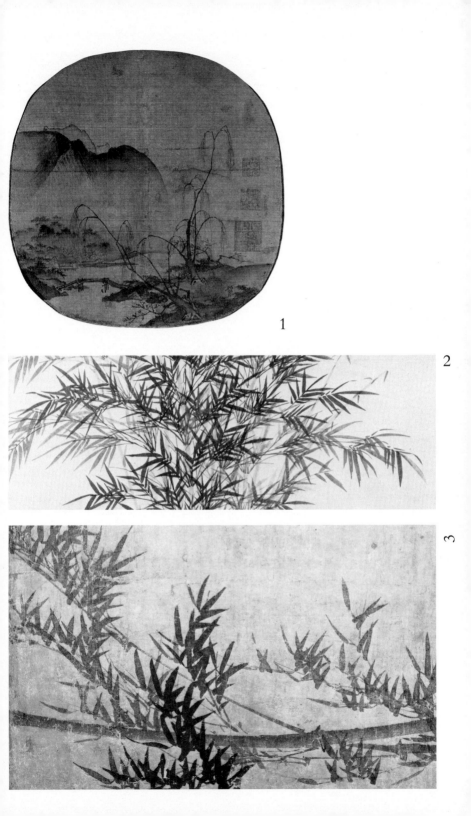

1

2

3

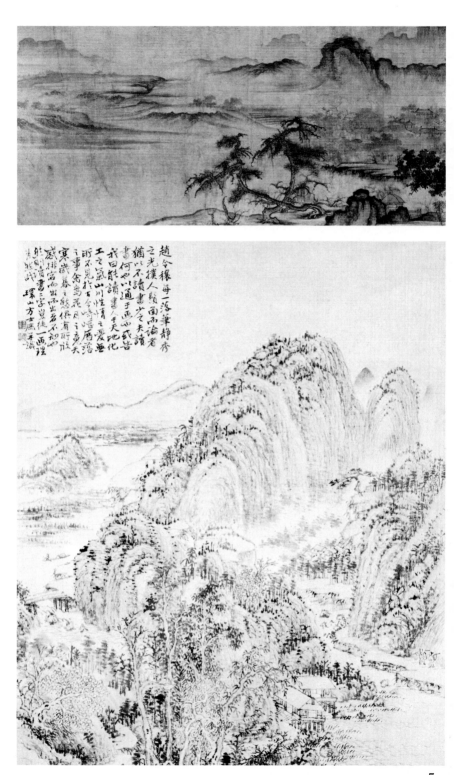

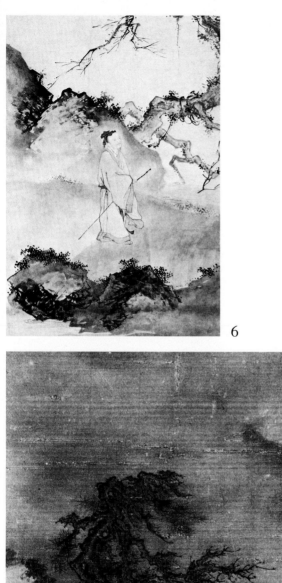

6

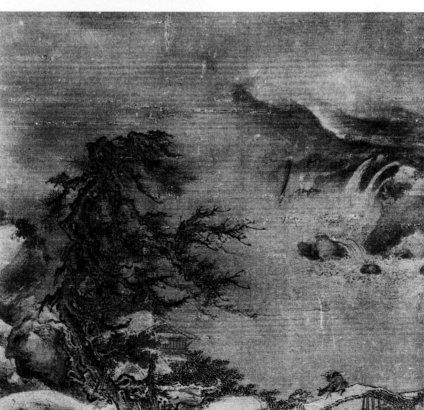

7

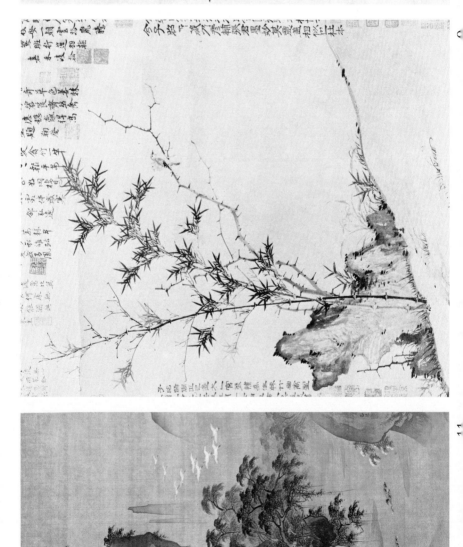

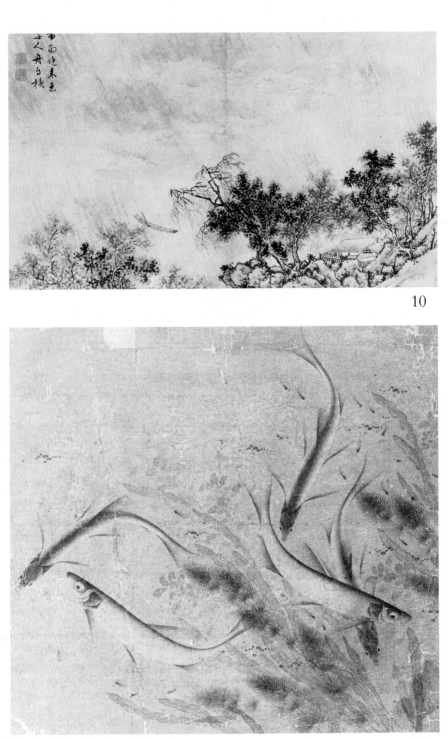

10

12

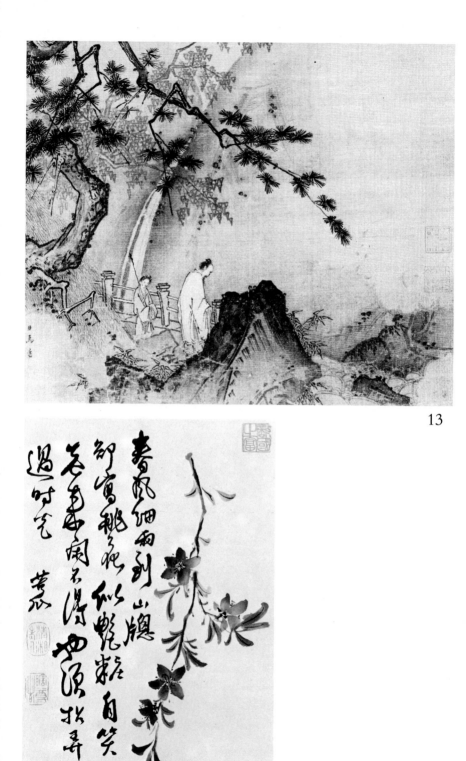

13

15

14

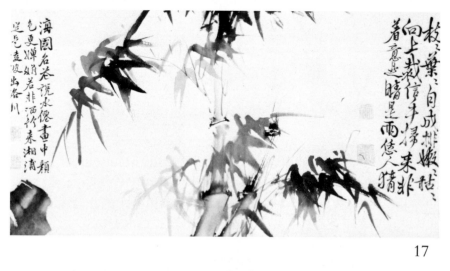

海國名卷説來優畫中頹
气更嬋娟若非酒行春湘浦
遂此麦波出谷川

枝之葉二自成排嫩枯二
向上出裁信手緣束非
着意述睛晃雨态入猜

17

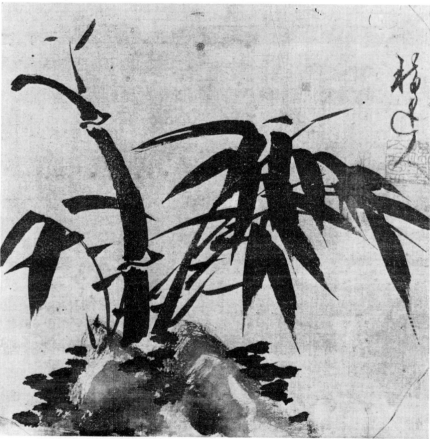

18

action are manifestations of spirit – they are so because they come from the Tao. The Taoists show how the soul, or the 'Real Self', is the reflection, same nature, or substance of Tao. Because the Tao is creative in itself and its effects, the energy of life, given its spiritual origin and its tendencies toward infinite rebirth, is essentially creative energy. Life energy, spirit, is the dynamo of all creation, both universally and individually. Although it is undifferentiated, this energy is not blind, raw power, it is intelligent and intelligible, since it is guided explicitly by the Creative Tao Intelligence, as experienced in intuition.

The creativity of Tao – the effect of spirit upon the physical world as observed in the law of opposite polarities (*yin-yang*) – is therefore synonymous with what we know as life. It is a constant source of animating energy that is now active, now quiet, but always governed and unified by spirit in purely creative terms. Whether we explain this phenomenon through physics, creative renewal or integration, or in a more mystical definition as light, it means that transformation, generation and regeneration are implicit and inherent in the nature of all things.

As the Tao is spirit and is creative, so spirit is the creative drive of life. This circumstance should show us that spirit is a form of energy, or is energy itself, and that creative energy and spiritual energy are identical. The oneness of spiritual being is the same oneness in man; the human soul is infused with Tao, which means the soul is active and alive with natural creative energy. It is electric, magnetic, vital. And indeed, that creative energy or force is life itself, just as the spirit is life itself. All things are in a constant process of remaking themselves, of renewing life, of making spirit actual in the physical realm. That *is* life, and that is creativity.

It is in the nature of life to be creative, then, and this creative energy is what vivifies the soul or spirit, as infused by the Tao dynamic. All of us are creative in some way or manner, but to fully tap into the flow of creative energy, of pure creative power is an art, and was called art by the Taoists. All of us have creativity potentially as well, and the more of it we have the more alive and vital we are. Well, someone may object, I know I am not creative because I have tried to paint and can't, or I have tried to write and can't, but they are failing to recognize *other* ways in which they are creative. People are creative and use creative energy every day of their lives – they simply don't know what creativity is or when they're being creative, often because their spiritual consciousness is buried, which is more a commentary on our educational system and our overemphasis on science than any fault of theirs.

Creativity is nothing if not wholly individual, so a person does not have to be an artist in order to create. Life is a most viable medium. The very sense of creativity is that it represents some highly unique facet of being and perception, which, filtered through individual character and the spiritual intuition open to that character, becomes a form of enlightenment and growth for that person and others. This may take as many forms and activities as there are people in the world and stars in the heavens, for spirit is infinite in its manifestations. In the physical dimension, spirit becomes individual form (*Te*), and the degree to which that individual grows to reflect spirit in his or her life is the degree of creativity or spiritual power he or she will have, which is also *Te*. This power has no limit, nor has the potential to realize it.

The relationship is so close to the inner self that it depends on the level of spiritual development of that self as to how far its creative capacities will be taken, and to what extent they will be developed, mastered and fulfilled. The more they are perfected, the more nearly will they approach art. The more they approach art, the more the real self will be fulfilled and will mirror the Tao creative power. Consequently, the more art that is achieved through creativity the higher the degree of cultivation and spiritual development, since art is a Way of Tao. What is vital, then, is not whether we are creative or not. Indubitably we all are, since we are all spiritual beings and the life forces of nature assure abundant creative energy. Rather, it depends on what we do with our creative energies and how much we can assimilate and be in touch with the spiritual resources on which they depend. For to become a spiritual master is to master the highest art, the art of life, and self-improvement is a lifelong process with possibilities that have no end.

The endless variety of ways, humble and high, in which creative energy manifests in human life are remarkable to see, and any of them can reach the point of art. It can be found in any craft, profession or activity where intuition inevitably is used and repeatedly surfaces, or where the rational process becomes at some point inapplicable or insufficient. Indeed, I can't think of one area where it can't be found, since creative regeneration is necessary in every aspect of life, and the Tao potential is innate in everyone. May noticed this reservoir of human creativity and the broad, universal effect of its energies when he remarked:

Creativity must be seen in the work of the scientist as well as in that of the artist, in the thinker as well as in the aesthetician; and one must not rule out the extent in which it is present in captains

of modern technology as well as in a mother's normal relationship with her child. Creativity, as Webster's rightly indicates, is basically the process of *making*, of *bringing into being*.[1]

Natural creativity, the vital energy of *ch'i* that is life, is all about us in every human affair. Slumbering and unconscious, active or inert, it is rarely wholly conscious in our lives because we are led by distracting illusions or ego-desires to unawareness and non-inner direction, and perceive the spiritual self very dimly, if at all. Yet the creative flow is constant in human life, and does not depend on our consciousness of it to exist. It is in love and romance; in sex; in having and raising children; in play; in humour, inner freedom and independence; in self-discipline, poise and composure; in compassion and heroism; in the countless interactions and communions we have with others, strangers and loved ones; in the work we do and the daily lives we lead. It is implicit with, and the heart of, the stream of human life in all its continual effort to build and renew itself, and this follows the pattern and movement of all of nature. And it breaks into consciousness and objective expression in the form of a free and natural spontaneity.

Uncultivated creativity is the most admirable and most characteristic trait of the fundamental being, and more or less represents the unconscious emergence of Tao in ordinary life, much as the sun, hidden behind clouds still warms and now and then glimmers more brightly. Yet the Taoist sages demonstrated by their lives that for those who seek the extraordinary, the realization and fulfillment of the real self, it is only the groundline, the vast potential to achieve higher forms. This spiritual advancement was the essence of the Way, where highly developed creative practices led to spiritual unity, and where all creative action is ultimately taken over entirely by pure spirit.

Certainly our real interests and whatever we do best are indicators of our present level, and are open doors to future growth. The potential of life and the rich natural powers available to us are always there for creativity to develop into higher, more essential, more effective, more spiritually advanced forms. The natural performance of a skill, or expertise in any direction, mastered to the point where rules and technique are forgotten, where the ego self is forgotten or uninvolved as the work is done, is nearing the terms of creative art. To the extent that work can be done spontaneously, intuitively, without a great deal of cogitation, to the extent that physical or intellectual process (co-ordination, manipulation of

media, performance) becomes essentially automatic or is consistently informed by intuition, to that extent does skill become creative art. That which 'takes over' and hits the mark unerringly is Tao – unity with the natural flow of spiritual energy, intuition directing the physical process, spirit informing action, spirit transcending matter. The spiritual unity of Tao produces this brotherhood of all creative work, because its foundation in nature and being is the same.

Creativity comes not from specialists and special skills, however, nor does mere speciality necessarily lead to creativeness. It comes from the concentration of creative spiritual power, the ability to respond to it and to apply it in life, for the energy is identical in no matter which direction it is turned. The 'art' of creativity is letting nature (spirit) take over.

> The Taoists saw in many arts and crafts the utilization of a power akin to if not identical with that of Tao. The wheelwright, the carpenter, the butcher, the bowman, the swimmer, achieve their skill not by accumulating facts concerning their art, nor by the energetic use either of muscles or outward senses; but through utilizing the fundamental kinship which, underneath apparent distinctions and diversities, unites their own Primal Stuff to the Primal Stuff of the medium in which they work. Like Tao itself every 'art' is in the last resort incommunicable.[2]

The ever-present potential of natural creativity, then, can lead to art, to the peak of spiritual creativity, and in doing so becomes a way to actualize spirit in the form of ourselves or in the form of the work. The Taoist master is a creative artist with the material of his own life, and what the Taoist does through meditation, the artist does through art, and art can indeed be considered a form of meditation.

Thus both the experience and practice of art are schools for the improvement of spirituality. That is why it is well to study the lives and works of artists, for the true work of art leads us into the spiritual world and silently indoctrinates us into the non-verbal language of creative intuition. Much of this was carried even further by the spiritual discipline of those Chinese painters and poets, who, learning that creativity originated in spiritual being, incorporated meditation and the Taoist Way into their lives for the sake of their work. Progressing in meditation and spiritual development, their creativity blossomed, their work achieved the greatness of spiritual integration. This was the result of those Taoist ideas which taught that the quiet and integration of meditation, its inner stillness,

serenity and reunion with the spiritual source of life, was also what opened the channels to the deepest realm of creativity. They believed also that it was through the spiritual dimension and experience that beauty appeared in the physical world.[3] Most importantly, they learned that meditation improved intuition.

The alliance of the Chinese artists with a meditative method of cultivation tells us a great deal on how the uncultivated self is wont to react as opposed to how it should react naturally in creativity. The ego, and especially the rational mind, were seen as barriers to creativity, and the purpose of meditation was to quiet the physical and rational mental activity of the individual and thereby maximize spiritual union. It could almost be compared to music playing from another room which can't be heard because we are overactive, talking or jumping about. A receptivity, a deep calm and composure characterizes both meditation and the art of creativity. The ego self, the rational mind and the physical organism must become perfectly still and unified within the inner self, which incidentally is the same form of deep concentration that takes place in art, and the person can learn this disposition most effectively and successfully through meditation. The Chinese artists saw how closely this resembled those great moments when free creativity manifested, and how effortlessly the work 'did itself' when the mind was calmly relaxed and empty in the same quiescence as meditation.

The benefits of meditation for those artists was much more far-reaching in many ways, however, than mere physical or mental relaxation. The latter is superficial and we can have it by taking a warm bath or the modern panacea for everything, a tranquillizer. Meditation brings deep, profound *rest*, far better than sleep, where the psychic and physical batteries are totally recharged, renewed and revitalized. This is more than a side-effect; it is inextricably tied to the meditative experience itself and to the mind–body continuum. The physical and psychic natures interflow and interact harmoniously in meditation, as they were intended to do naturally.

One of the most important terms of *wu wei* was not violating the laws of overextension, overactivity, strain, and creativity is ameliorated immeasurably by the same means. In obeying the rules of creative regeneration and natural renewal in ourselves, in learning how to harmonize the inner self with Tao, we grow increasingly vibrant and increasingly creative, as the physical body is invigorated and as we adjust to the flow of real being within, as the physical form responds to, unites with spirit and is vitalized by being in touch with the source of life. Creativity requires that we be inwardly mobilized, self-directed, and centred in the reality of ourselves, in

the true self, not in identification with the outward form the ego mistakes for identity.

To have contact with this creative, renewing energy, this *ch'i*, this source of life issuing from the spiritual Tao, is to be one with its creative, transformative power, to be transformed ourselves by it, and to learn and absorb the inner kind of consciousness that is inherent in creativity. When this is so, the higher creativity that is art can begin to manifest in any activity whatever. This experience, this confirmation of the spiritual relation to creativity and its way of improving it, was what fostered, among other things, the mystical–religious attitude of the Chinese painters toward their art.

In the creative process the artist comes to know deeply his fundamental inner self, and it is from there that his work is mined. This process is so much akin to what takes place in meditation as to be practically the same. And both of these methods, these Ways, move toward reunion with their source, their foundation in being, in ontological reality. When the absolute basis of being becomes unified with, identical with the inner self, then the intuitions of that self will reflect absolute reality. From that reflection comes art,[4] the ability to master physical form.

Because the Tao is 'the inner reality of all things',[5] the creative artist is able to draw others, spontaneously and unintentionally on their part, into the same unity and harmony, as his intuition becomes identical with the primordial roots of life that are the same in everyone and in all things. The art of creativity, emerging from the spiritual growth and development of the adept, thus becomes the voice and vehicle of Tao, which 'gives power over outward things'.[6] When Lao Tzu said, in the *Tao Te Ching*, 'I act only by inactivity',[7] he was referring to creativity guided solely by the inactive stillness of the intuitive mind, the Way of Tao, which is non-intellectual and far above the limited processes of rational reasoning. Art calls upon, and is infused with, the actual spiritual reality of life, and it represents the same transformative and creative power, to whatever degree it is realized by the individual.

To an enormous extent, the impressive creativity that is exhibited by art is due alone to the artist's natural receptivity to intuition. Intuition is, as we have seen, the only mode of spiritual perception available to human consciousness. The spiritual centre of life and the universe is far above even the most advanced rational or verbal understanding we may have of it. A great gulf separates the physical and spiritual dimensions of existence in terms of consciousness and intelligence. The only bridge between these two cosmic poles of being is that part of the mind which still retains its connections to

the primordial, immaterial self, is innate and not acquired, is wholly natural, pure and transcendent, and operates in symbols or the subtle vibrations and variations of energy which we call feelings. This is intuition, the expression of spirit and the 'Real Self' which is a reflection of that spirit, which seeks expression because it is creative by nature. Because the 'Real Self' is one with the universal spiritual reality, with the Tao, to receive genuine intuitive impressions is to know the spiritual meaning of things, to perceive them as they are in themselves, in their essence. This is certainly the epitome of knowledge and enlightenment by any terms, and is the reason why creativity, the bringing forth of new knowledge, new facets of being and truth, is centred entirely in intuition.

One of the main tasks of becoming creative or improving creativity is learning the art of identifying, listening to, and *responding* to intuition, for it is our rational tendency to question it. Once questioned or ignored, the intuitive solution to a problem quickly vanishes, and nothing is left in its place except further circular ruminations of reason, which endlessly examine the problem but never the essences themselves which are its solution, proving what a functional tool the rational mind really is. Alone, the rational process is incapable of creativity; joined to intuition it is peak intelligence, the whole mind with the forces of the universe at its command.

If we cling to safe, rational answers we shall never become creative nor wholly integrated either, nor will we know what intuition is, for its reception will be barred and blocked by those same doubts, hesitations, reservations and fearful inhibitions of the trained and socially conditioned mind. Spiritual confidence is conviction, faith, and saying yes to our inner nature, even when society has taught us to distrust it as something to be suppressed and hidden. One might say that to enter the world of fundamental being requires shedding our intellectual clothes and going there naked, as Thomas Carlyle and Chuang Tzu suggested. Encountering the spirit and the 'Real Self' takes courage, to face truth and reality, as well as to have faith in it and its ultimate and supernal Intelligence, Wisdom and Goodness. Intuition indeed requires a leap – a leap into spiritual meaning and so into the unknown, the new and untried, the original, without any kind of sham, expectation, preconception or bias, better known as honesty. Spirit doesn't deal in poses, facades – or lies.

Earlier we mentioned how we can absorb and learn the inner state that is characteristic of creativity. Both art and meditation offer very valuable and viable experiences to become acquainted with the

perception and tone of intuited meaning. Meditation, particularly, is unequivocally recommended as a precondition for creativity and for its improvement, especially for non-artists. Artists also will benefit immeasurably from its practice, both in their lives and work, as we learn from the example of the Chinese painters. A special kind of consciousness arises in meditation which is identical with the intuitive mind, and which spills over continuously into life. This consciousness has a particular quality or 'feel' which is sensitive and similar to the inner organization of an artist as he works, and fosters an equivalent mode of perception, which is why meditation is creative, and why it also promotes intuition. In turn, this special inner consciousness becomes a means whereby the creative voice of spirit can be directed into and utilized in life. The mental mode of meditation is an increasingly spiritual consciousness, which is at the same time creative, by reason of the nature of spiritual life.

We may say the knowing inner state of intuition can be learned, but it is more accurate to describe it as infused, for there is nothing with which to compare it. It differs radically from rational consciousness, especially by its non-verbal quality, and must be experienced to be identified. That experience can be confirmed only by practice. It is by the practices, customs, and habitual modes of inner being (and the consciousness of them), experienced and realized in art or meditation, that the creative or intuitive mind can be known as a consistent, identifiable inner entity, and increasingly recovered and returned to in daily life. When this inner identification has become so integrated as to become one with the objective personality, then spiritual realization has been achieved, the soul has unified with, become one with Tao, and every creative act then becomes the natural movement of spiritual power. Cultivated to more advanced levels, it is then that the saint, the mystic, the great religious leader, the sage and the creative genius emerge in human life.

This unity of spiritual and creative power is, however, available to everyone when the terms of spirituality are met. The fact that this miracle is still potential to most of mankind shows how little we know of the mind, and why less than ten per cent of its power is utilized. And yet the potential is always there, in nature and our nature, and its discovery and utilization, which was 'art' to the Taoists, may have possibilities both mystical, and even supernatural, to act upon physical life in a way which far surpasses our usual notions of ability or the possible, leading even to 'a power to transform matter',[8] a power over the physical dimension which can only be called miraculous.

Many evidences for such a capacity have occurred, and we see them appearing in advanced mysticism or recorded in ESP literature, in cases of extreme survival, and in Zen and Taoist experiences. When Eugen Herrigel was studying Zen archery in Japan, for example, he learned that his master, Kenzo Awa, could bulls-eye targets *in pitch darkness*:

> It was so dark that I could not even see its outlines, and if the tiny flame of the taper had not been there I might perhaps have guessed the position of the target, though I could not have made it out with any precision. The master 'danced' the ceremony. His first arrow shot out of dazzling brightness into deep night. I knew from the sound that it had hit the target. The second arrow was a hit, too. When I switched on the light in the target-stand, I discovered to my amazement that the first arrow was lodged full in the middle of the black, while the second arrow had splintered the butt of the first and plowed through the shaft before embedding itself beside it.[10]

When the human body is stripped almost to its spirit, as in extremes of survival, miraculous powers often emerge. These can become as much, or greater than, the ability of the Zen bowman to transcend physical form and to command nature. The spirit grows stronger as it nears its essence, as physical life weakens, and appears to marshal the intense spirituality where spiritual and creative energy are revealed as the same, literally forcing survival through its power over physical reality, even when death seems imminent.

Adrift in the Atlantic for 76 days in a rubber raft, Steven Callahan survived through his intelligence, his creative ingenuity, and through a strange occurrence in spearing fish, dorados. Emaciated, weakened, near death from exposure and near-starvation after weeks on the open ocean, he found that dorados began to follow his raft and became easier and easier to spear, finally even *rolling over on their sides and seemingly offering themselves to his speargun.*[11] I believe that this was a case of actual transcendent spiritual power over material life, that Callahan's spirit, nearly all that was left of his life, was so close to its source that it overcame the physical and literally attracted the fish to him through pure spirit, its presence in nature, and its powerful primal force. Was he one with Tao, with God? Very nearly, although in his suffering he was not aware of it. Was it a miracle? Yes, definitely, but it shows the relation of spiritual energy to life and the physical dimension, and it shows what that energy and that power can do.

The spiritual awareness we can learn to absorb in art and meditation also comes to fruition in the increasing experience of spontaneous enlightenment, as the effect of intuition which we touched upon earlier. Spontaneity and intuition are so intermutual and essential in spiritual consciousness and creativity that we have devoted the entirety of Chapter IX to understanding them and how they work. Spontaneity is certainly one of the main requirements of higher creativity. The principle of creative action of the Tao in nature consists of infinite transformation *which occurs of itself*. Nothing can resist it or alter it except as in harmony with that same principle. The natural is the fundamental Way of spirit, and to be natural we must follow that Way. That which occurs of itself can't be learned, studied or forced into existence – it is determined only by its own innate nature. So should we be directed only by spontaneous inner means.

If I throw a ball against a wall the way that ball bounces back is not directed by me, nor does it have anything to do with the way I throw it or what I want it to do. The law of force and motion govern its return, which are more or less invariable. Its movements are spontaneous, not the product of my mind or imagination, based firmly in reality and uncontrolled by any outside force except that which is natural to its principle. To be spontaneously and naturally creative, as paradoxical as it may seem, we must have the self-discipline to give up opposition. When we have relinquished our competitive resistance to nature, our clumsy attempts to throttle it to our will (which is a result of the critical/analytical propensities of forced or overactive rationalism), only then can we begin flowing with its instinctive rhythms, become part of it, and introduce its superb creative dynamic into our lives. Self-disciplined spirituality means to listen for that accord with inner reality, when the light of creative intuition moves through us of itself. This intuitive action always moves freely and spontaneously through harmony with nature, and one can learn to be attuned to it through artistic and meditative experience. Developing this 'art' of being in touch with intuition and the spiritual self as a means of solving problems in the physical and intellectual spheres, is the art of creativity.

In the same way, we can't force the inner life of ourselves to conform to preconceived mass formulas, fixed ideas, or unnatural social patterns. We can and should act only according to our true inner nature, and gain practice on listening to it. If we do this always, or even a little, we will proportionately become more creative and liberated, for we will be living our lives in concert with the spiritual foundations and creative integrity of nature, which is

the invariant, natural way of life. Once the ball leaves my hand it is in nature's way, and so can I let my inner self go free and learn to trust its spontaneous movements that are the result of being in harmony with natural creative law. No need to fear here that the rational mind will cease to do its busy work. Its tireless vigilance and activity are as much innate to the ego self as intuition is to spirit. Our problem, in being creative, is in keeping rational thought quiet enough for a higher consciousness to manifest.

There will always be those who think that inner strength and liberation mean an egoistic giving in to impulses which are antagonistic, competitive or self-indulgent, but it is on the contrary in learning to let such things go that real liberation begins. Spiritual discipline means giving up learned and immoderate excesses of self-will and putting the will and consciousness to work in nature's free, creative, often miraculous way. Everything has its Tao, its spirit, which must be respected and revered even as our own. It is only by blending and unifying with the Tao of things that we are able to transcend the physical barrier of form and the resistant opposite consciousness which is objectivity. This can only be done through nurturing the life process, through creativity in the spiritual sense. To be understood as truth, things must be known in their essence, not confused with their form – the objective and the subjective, once more, must become one. By identifying with the inner spirit of things we are able to penetrate into and know their absolute reality and meaning.[12] The liberating field of intuition induces a felt identity of essence when that occurs – an inward conviction or agreement when the soul glimpses its own truth in a like essence. To have the power of a strong mind we must, as the Taoists tell us, control the mind with spiritual discipline.

We have seen earlier how technical requirements and the mastery of a craft or a profession form a main precondition for creativity and supply the foundation that is indispensable to it. Happily, the needs of creative discipline are valuable training for spiritual discipline, and can be expected to lead to some of the same benefits, but constant practice and perseverance are vital in both cases, especially for young students. One does not merely put on a creativity hat and become creative. For one thing, the full realization of creative power is individual in experience in the higher stages (although it has general characteristics), and can't really be taught. Teachers may suggest it, point the way, and even close the gaps that intervene, but in their heart of hearts know that the farthest they can take their students is to impart knowledge and command of technique, and it is beyond that point that creativity begins.

The teacher may be the master of his art or profession, but he knows that the 'art' of it depends on inner responses which are highly subjective. Nevertheless, since intuitive creativity rises out of freedom from technique, its rigorous mastery, practised to the point where control of materials and craftsmanship becomes unconscious, may at least be regarded as formative of it. This essential form of self-discipline is a potential bridge to creative fulfillment, and if we look to the example of the Chinese painters, who as students spent years practising a single brushstroke, we may accept the hard work of rudiments with greater reverence and effort, for there is a point at which they become Tao:

> If one really wishes to be master of an art, technical knowledge of it is not enough. One has to transcend technique so that the art becomes an 'artless art' growing out of the Unconscious.

> In the case of archery, the hitter and the hit are no longer two opposing objects, but are one reality. The archer ceases to be conscious of himself as the one who is engaged in hitting the bulls-eye which confronts him. The state of unconsciousness is realized only when, completely empty and rid of self, he becomes one with the perfecting of his technical skill, though there is in it something of a quite different order which cannot be attained by any progressive study of art.[13]

Two great paths of creativity and its continued development lie open before us. The first is to actualize spirit in the form of ourselves, the meditative way. The second is to actualize it in the form of work, the artistic way. The two ways are mutual and reciprocal as forms of spiritual discipline, spiritual realization and spiritual growth. The cultivation of the spirit leads to creativity, and creativity leads to spirituality.

For the first instance, meditation is highly creative, perhaps the highest form – there is nothing more creative or more important than our own spiritual development. As we discipline the form of ourselves in its daily practice we are building our own spirit and character into the finest work of art, fulfilling the real and eternal self within and growing into and with its knowledge. In the second path, the idea is inherent that all work can become art. Insomuch as we are using and developing the spontaneous creativity and intuition which are our natural and spiritual heritage, making real and actual in some way the creative energies with which we are endowed, and introducing into the world the essence of character and meaning as

we can intuitively perceive and express them, in that making real of spirit in work does work become art. For it is only by using the methods of art that any work can become, or will be, creative or meaningful.

The Way of artistic cultivation, the Tao of art, and the spiritual basis for it contain remarkable implications for human development. All that we are or do is inseparable from what we must do in life, in the material world. We can do it creatively, spiritually, bring it to its highest form through spiritual guidance, master life and ourselves, spread spiritual meaning throughout the world, live naturally, happily, and be fulfilled through creative work – or we can be incomplete, waste our creative energy and be dragged through the boring and spiritless machinations of a half-life, through greed, competition, never-ending wants and materialism, where the light of nature does not shine and non-existence and illusion haunt the decline of our spiritual selves. To live creatively is to live spiritually and actually, and one's life *can* become a work of art.

Taoist and Zen monks in modern monasteries live in just such a way. Their lives – a rule of work and meditation – are lived creatively. Work becomes the physical, creative actualization of the meditative experience, whose consciousness is carried into and practised in it. Work, for them, is the testing ground and form of spiritual development. Sweeping floors, gardening, carpentry, cooking, eating, maintaining the daily physical, clerical and administrative tasks of the monastery and the countless daily duties of life are all carried out without rational thought,[14] in the total mental stillness of Tao and its pure creative action. When this is possible, and it *is* possible, it is not us that guides and directs our lives, it is Tao – it is the spiritual power which is the foundation of all creativity. What would the implications be for human life if the whole world lived in such spiritual unity?

In experiencing the work of the fine arts the creative experiences provided by the artists are as much beneficial to our creative development as to theirs, and have the same ramifications of spiritual realization for us. We have already learned how the spiritual vibrations of a painting, its 'spirit resonance', is an actual part of aesthetic experience. This meditative type of experience in art is very like similar experiences in meditation. In meditation nothing comes to pass which can be concretely availed in pragmatic terms – one can't put it in one's pocket, so to speak. So it is in the experience of art, but it is nonetheless a valuable experience of spiritual integration and meaning for that cause. It is only when we are deeply moved by a work of art that its spiritual realization and

essential meaning come through with utter clarity, as it touches the chords of humanity and conjoins with the inner spirit of ourselves, and by this we know that it is experienced intuitively, even if not always understood rationally.

The Taoist masters left the key phrases 'mind control', and 'art of the mind', which refer to the practice of quieting the inner self and the overactive rational mentality, to make way for the non-verbal enlightenment which results in creativity and creative action. It was inner silence, sought as a goal for these and other spiritual purposes. It is what we call peace of mind, serenity, and calm. The description they preferred was 'stillness'.

In stillness of mind one could become the reflection of Tao. It led to communion with spirit and inner reality, with intuition and the creative power of *Te*; it led to spiritual realization and the fulfillment of the 'Real Self'; it led to integration and spiritual growth. It was one of the main methods and major requirements of the Way of cultivation, for it joined the meditative consciousness to daily life. So important was it considered that their transcendental meditation was directed entirely toward the attainment of this end, and it was from meditation explicitly that its importance came to be known.

It was Chuang Tzu who said: 'To a mind that is still the whole universe surrenders.'[16] This gives some idea, some hint of the mystical creative capacity that is available to the mind, alive and whole. To that mind which flows in the still, spiritual harmony of nature and Tao there is no resistance, no opposition. The ability to transform the objective, physical world which is creative art is without limit when the inner world is in harmony with the outer world. That harmony only takes place in non-verbal stillness, in the transcendent reality which is the spiritual being of all things. This Way is not easily attained. It can't be bought or held at any price. It must be practised, followed, lived, and the Way of cultivation and spiritual discipline can lead us to it.

A calm sea is troubled by some movement but still flows easily, a *still* sea can reflect the light of heaven. For all of us the practice of continual and unremittant calm is the most important precondition for creativity, spiritual reorientation and the reception of creative intuition. It is the most immediate way to translate some of the meditative and spiritual experience into daily life and gain better access to the creative principle. It is the way to self-mastery. For calm is most like the cessation of all rational activity known by the sage and the spiritual master, in which art becomes life, and life becomes art.

Chuang Tzu summarized the Way when he said:

When things are produced in accordance with the principle of life, there is physical form. When the physical form embodies and preserves the spirit so that all activities follow their own specific principles, that is nature. By cultivating one's nature one will return to virtue. When virtue is perfect, one will be one with the beginning.[17]

Returning to art, it would be difficult to imagine a more creative painting than Lu Chi's *Autumn Landscape With Herons and Ducks*, (Fig. 11), for the virtuoso mastery of his brushstrokes brings forth the spirit of everything they touch. What can we say of a painting which makes us *feel* and delight in the cool slabs of rock and precipice, the perfect reality of misty fog rising from water, the wet verdure of hanging trees and vines, the lofting flight of birds upon the wing?

This is not the vigorous dynamism of Li Shan or the *yin-yang* turbulence of Wen Cheng-ming, (Fig. 10). It doesn't have to be. Rather it is nature at peace, sufficient in itself, serene, flawless in balance, grace, and the splendour of inner poetry reflected in outer form. The technique is perfectly in keeping with its subject. While restrained by exquisite good taste and appropriateness to the subject, the bold and powerful strokes of the trees and the bravura brushwork on the rocks spring and bend with their own inner vitality, which so well expresses the spirit and life of these forms. Throughout, this painting technique has been so mastered that it is surely forgotten, serving only the spirit of the artist and the gentle spiritual presence of nature that he portrays. We see it in the smooth transitions between rock and mist, the subtle variations in tone and values as the rock forms are shaded by mist or lose themselves in it, as they come forward or recede in space, and as they rise, delicate and sure, out of it in the distance. It is this same mist which unifies the painting, beginning from within its depths and wafting along the barely suggested, but felt presence of the river. That surface, described only by a few, expert, horizontal washes that establish the mist-covered, wandering banks, the tilted bodies of the swimming ducks and the slight accents of current which flow around them, has its spirit well defined by these means and by the way it disappears into the lovely mist of the middle ground.

The painting is a dazzling display of realistic drawing in the ducks, herons and trees. This contrasts sharply with the soft, flat washes that effectively utilize the smooth surface of the silk ground,

a surface which also made the lucid realism possible. The same advantage brought about the tremendous realness of the foggy mist. And yet these technical tools are all put to work in a single direction – the expression of the essentials of form. It is from those essentials that we grasp their spirit.

It is when we come to the herons rising upon the misty morning air that we can learn how magnificently the art of Lu Chi transcends technique. Their technical execution is obvious – they were painted in opaque white and colour overlaid upon the fog wash behind them when the latter was dry. Their wings are suitably outstretching; they fly at a proper, steep angle in staccato spacing; they recede in space and contrast in direction. And yet there is something additional within them, something inexpressibly excellent, elegant and sublimely beautiful. They lift upon the air with a glorious lightness – they *fly*, and we can feel the air currents around them and their happy spirit as they take to the wind. The herons *float* upon the painting's surface and take us aloft with them, and it is in their naturalness and beauty that we can well perceive the indefinable essence which is spiritual reality. This is not technique, this is art.

From the tops of mountains to the depths of limpid pools the Chinese painters explored their universe and every part of it, waking up our consciousness with ever greater mastery of their art and its insights into reality. Such an extraordinary demonstration of the transcendent performance of art is found in *Fish At Play* by the Sung painter Chao K'o Hsiung, (Fig. 12).

Chao takes us into a new reality, the underwater life of nature, where five swirling carp swim in and out of the softly waving rhythms of a variety of aquatic plant life. Motion and the beauty of motion, as well as resonant harmony and delicate grace characterize this painting. Once again the spirit of reality, found in the essence and character of individual natural forms is evident, while in the *ch'i* vibrations of the several fish on the right the impression of a unifying spiritual dynamic becomes vivid, as vitality, as symmetry, as life. Was this, and the *yin-yang* opposition of the fish on the left an introduced symbolism, a planned contrivance of the painter, or was the tension and electric vigour of the negative spaces between the fish a design created out of an inner instinct for the natural? Obviously the latter, because true art is one with nature.

There is so much that is excellent in this painting that I can't hope to comment fully on its technique, but I should like to point out some outstanding features. These occur as follows: the tonal value of the lighter coloured fronds of the water plants have an absolute registry in relation to the amount of light which would be conveyed

under water, and thus contribute mightily to the intense sense of liquid translucence and softly filtered illumination; their curved, waving fragility and their pattern of motion as it ripples across the painting diagonally from top to bottom are also part of the overall charm and fluid reality; the same is true of the darting little pollywogs, the marvellously restrained spattered accents of bubbles, and the treelike variant plant forms which offset and punctuate the whole; a third type of spiny form, in its length and tonality, echoes the twisting, whirling shapes of the fish – it is nevertheless painted with an exquisite skill, brushstroke sewn upon needlelike brushstroke built up on the thinnest, most graceful of stems, to support them. Finally, it is the fish that most enchant us. Seldom has the world seen such perfection of gradated watercolour washes as they turn the sleek, serpentine forms, flash into tails and fins that in turn fan out into whispers of fragile, evanescent tone. Nor what masterful hand could draw such continuous, flowing contours without a flaw, as perfect in their curving and lost edges and symmetrical infinities as nature is in her forms.

Within the fresh beauty of this painting there is something magic, even miraculous in its artistic performance. Every artist would attest to the difficulty of painting such contours in watercolour, much less the achievement of the incomparably blended washes. There is an amazing command here which rises far above the usual possibilities available even to the most skillfully advanced, a matter of sheer brush mastery which many artists would find formidable, to say the least. Far beyond technique and surpassing it – it is Tao, the 'art' of creativity. It is the human being in possession of a transcendent spiritual power, its own creative spirit.

Notes

1 May, 40.
2 Waley, 58, 59.
3 Chang, 184.
4 Ibid., 229.
5 Ibid., 65.
6 Waley, Footnote, 48.
7 *Tao Te Ching*, LVII, Waley, Translator.
8 Waley, 46.
9 Deng, Ming Dao. *The Wandering Taoist*. San Francisco: Harper and Row, Publishers, 1983, 140, 141.

10 Herrigel, Eugen. *Zen In The Art of Archery*. New York: Pantheon Books, 1953, 66, 67.
11 Callahan, Steven. *Adrift: 76 Days Lost At Sea*. Boston: Houghton Mifflin Company, 1986, 146, 188, 199, 212.
12 Chang, 94.
13 Suzuki, D.T. in his Introduction to *Zen In The Art of Archery*, Ibid., vi. Herrigel, Introduction, Suzuki, vi.
14 Nishimura, Eshin. *Unsui: A Diary of Zen Monastic Life*. Honolulu: University Press of Hawaii, 1973, passim.
15 Waley, 49.
16 *Chuang Tzu*, XIII, 1. Waley, Translator.
17 Waley, 202.

Chapter VII
The Meditative Way: Integrity, Unity and Harmony

There is an oral legend from ancient China, related by Chuang Tzu,[1] in which Confucius came to visit Lao Tzu and found him in meditation. The latter is said to have appeared rapt, 'a mere lifeless block', and when questioned on this state by Confucius replied that he was 'wandering in the Beginning of Things'.[2]

It is heartening but not surprising to find the great master, the father of Taoism, in all his saintly mysticism and spiritual knowledge, practising the Way he had been privileged to perceive and bring into the world. Probably the development of such meditation had been preceded by a long mystical tradition with forerunners reaching as far back as the animistic shamanism of prehistoric China, as did many Taoist ideas, which were already ancient even as early as the Chou period in which Lao Tzu lived. These influences can be noticed in his remarks in the *Tao Te Ching* on the spiritual acuity of the ancients and his disenchantment with the civilized state: 'In primitive times, intelligent men had an intuitively penetrating grasp of reality which could not be stated in words.'[3] The Neolithic shaman, or *wu*, was a religious leader who used forms of art, trance and ritual to bring integration to his people, to unify their vision of the animistic spirit world with reality.[4] Taoist meditation, or *tso-wang*, however, is not trance nor any kind of self-hypnosis, even though its aim is definitely spiritual integration and the latter is achieved in it.

Tso-wang (literally, 'sitting with blank mind') was described by Chuang Tzu as: 'Slackening limbs and frame, blotting out the senses of hearing and sight, getting clear of outward forms, dismissing knowledge and being absorbed in That which Pervades Everything.'[5] It was practised by the Taoists as the portal to genuine spiritual experience, the training ground for learning the ways and

means of intuition, and the method through which psychic integration, the harmonization of being, and completion of the true self would eventually follow.

Chinese meditation in this form is simple, effective and undemanding in method and procedure. It differs considerably from Hindu yoga meditation, where mantras, verbal forms of individual invocation and concentration inducement, are mentally repeated or chanted. It differs also from some of the more involved techniques of Buddhism, such as the mental visualizations and repetitions of the Pure Land school and the directed contemplations and generalized mantras of Mahayana Buddhism. In the Buddhist forms of meditation, Ch'an (Japanese Zen) is the closest in practice to Taoist meditation in many respects, and this is because Ch'an Buddhism (and Zen) is a syncretism of Buddhist and Taoist ideas. All of these methods, however, have the same goals of self-cultivation, inner quietude, and the achievement of higher spiritual states.

There is no need whatever to approach the practice of transcendental meditation of this kind with any sort of fear or trepidation. The experience is one which is totally wholesome, natural and healthy in every way, and nothing occurs in meditation which can by any stretch of the imagination be said to be dangerous, frightening, or harmful. If it did, it certainly would not have continued to be a major religious practice in various parts of the world, including Christendom, for more than 2000 years, and would long since have vanished from human affairs. On the contrary, its effects are so salutary, physically and psychically, that they are experienced as welcome blessings from the outset, from the earliest stages of practising it. Those who know the experience will attest to this without reservation. It is especially noteworthy also that in recent years transcendental meditation as observed by the Taoists and other religions has received the wholehearted endorsement of psychiatry and psychology as a healthy and recommended exercise for optimal mental health, relief from the stress of modern living and the improvement of intelligence.[6]

The Taoist principle of meditation was based upon the underlying idea of soul or spirit indwelling in both man and nature, as opposed to something that came from without. Universal, both without and within, it was what made up the phenomenal base of reality, both subjectively and objectively. It was only in Tao that these fundamental oppositions of existence were united and thereby harmonized[7] as the integration of mind and body, of mind and spirit.

The purpose of meditation, then, was to bring about this union, this integration, to re-establish the soul in its proper relationship to the Tao, to nature, and to the reality of itself. In other words, to make the objective form of the physical being, the personality, the ego-self, one with its true nature within. Understood in this sense, it is not difficult to see why it was called a 'returning'.

Waley saw this meditative predisposition toward spiritual purification as arising out of 'the gradual inward-turning of Chinese thought', and as influenced by earlier traditions of sacrifice and ritual wherein 'a cleansing of the heart' was part of preparing the priest or sacrificer for the reception of a 'descending' external spirit. Such purificatory rites were closely related to Taoist ideas in their insistence on the 'stilling' of outward activities and desires, as well as on the sense of 'returning', of transcending the cares and confusions of daily living, which blocked and interfered with the pure state of man 'as he was meant to be'. The same process was sought in Taoist meditation, but in Taoism the spirit was not 'descending' or an outer entity, but within the human soul, and it was there that the primary, spiritual nature of man was to be found. Working the conscious, rational mind back through the succession of survival worries, distracting external stimuli, and its habit of pursuing personal interests, toward reunion with the Tao, was the Way of meditation, the 'Art of the Mind and the tending of the Vital Spirit',[8] where profound inner peace and intuitive self-direction would be found.

Various effects occur in meditation which are direct and unequivocal manifestations of God, the spiritual world, the Tao. What we expect to find there, what they might be, and in what manner they transpire, are usually not what we expect. It is unusual to experience the spiritual world, at least in the early and intermediate stages, through any likeness to the physical dimension, and verbal manifestations are unknown. Still less does it have anything to do with our hopes, wishes, or preconceptions of what it should be. What Lao Tzu described as the 'Uncarved Block' was a metaphor for the primary nature of life – spirit – experienced within in meditation without tangible reference to anything conceived by the rational side of the mind and the common state of usual consciousness. Thus he knew it as a pre-intellectual or supra-intellectual state which was prior and basic and could only be described in terms of the soul, fundamental reality, or the essential, 'Real Self'. The Taoist thinkers referred often to this inner perception as light, or 'The Heavenly Light'.[9] The reference to light

is, indeed, very common to Christian and Eastern mysticism alike. Chang suggests that the experience of light or inner radiance is identical to the intrinsic self, the soul.[10]

The spiritual dimension, what the Taoists call the domain of non-being (as opposed to the being of the physical world), manifests in integration, 'the great sympathy.' As integration occurs, so does Spiritual Being infuse the soul of the meditator, causing his consciousness to become identical with the primary consciousness of all spirit as it inheres in the multiplicities, the countless forms of the natural world.[11] This becoming one with the nature of Pure Being and the being-spirit of all things is the role of integration[12] and the ultimate aim of meditation. It is the returning to Tao, which is the One, the all-unifying source of spirit and origin of being.

It is certain that the experiences of meditation carry over into life with positive results and good effect. Nevertheless, the Taoists insisted that in addition it was part of the Way of cultivation to creatively translate the meaning and issue of meditation into living. Meditation was to 'personally realize the infinite to the highest degree and travel in the realm of which there is no sign',[13] and we should 'exercise fully what you have received from Nature (i.e. from meditation) without any subjective viewpoint', (without bias or partiality).[14] Transferring the analogues of meditation into living, they advocated renunciation of self-glorification, scheming, pushiness, manipulation and political manoeuvring,[15] the aggressive forcings of energy which are so ego-based and antithetical to the spiritual realization of meditation.

As we are empty and still in meditation, so should we be empty and still in life,[16] that is, filled only with natural truth and motivation and not the calculations customary to the conscious mind – what the Buddhists called the 'self-nature'. In life, if we think about it in nature's terms, we already have all the resources we need for happiness, survival and natural living. In the strictest terms, anything else is excess baggage. In actuality, simplicity is the natural state of man. Nature cares nothing for excess, for that which can't be used to promote or nurture life. And it is her Way that only real being or veracity, not illusion and non-existence, will triumph and survive. Every tendency of the meditative experience made the individual more whole and defined in character, more real, more natural, less artificial and contrived.

Related to this practice of conscious integrity as a means of staying in touch with the meditative disposition, was the guarding and preservation of serenity. Why so? Because for the mind to be serene and calm was the most beneficial and natural condition for it,

and the one state most amenable to receiving the intuitive spiritual impressions that would creatively solve problems of living. To live with serenity was also to live in the spiritual and natural Way, to live in the same kind of being-condition that characterized the essential spirit of nature, ourselves, and the Tao. Except in its turbulences, which are transient and which serve to remind man of his insignificance, nature is serene, as are animals. 'I think I could turn and live with the animals, they are so placid and self-contained', said Walt Whitman, one of the serenest of men. In the serene, calm state the mind would naturally 'return to its purity',[17] its spiritual base, its greatest efficiency and finest creativity. It would be ready to use the spiritual knowledge and power that came from within; it would be ready for *Te*. All of us desire to know, but the Taoists teach us that it is only by perfecting the 'means whereby we know', the art of intuition, that we *will* know.

This inner receptivity depended tremendously on the habitual keeping of inner dispositions that are quiet enough, calm enough and non-verbal enough to make such reception possible, and this as a constant practice of the mind. Conscious thought, conscious verbalizing effort, interferes with the inner correspondence, so a seasoned calm is necessary in accessing the unconscious, spiritual (creative) centres. A whisper can't be heard in a shouting, crowded room. It is well to recall here how the Taoists equate the rational mind with physical form and the intuitive mind with spiritual substance. The spiritual constitution was accordingly non-verbal, non-vocal, untroubled by activity, and quiet. The maintaining of a serene mind did not entail a strenuous grappling of the will with consciousness or circumstances, a contest or a stubborn 'mind over matter' exercise. Instead of any kind of strained forcing or extreme, the avoidance of all inner disturbance was advised by simply renouncing it. Worry, restlessness, agitation, the powerful emotions of fear and anger – all had to be mastered and brought under the creative influence of calm self-possession and a tranquil mind, which was more powerful, in the final analysis, than any emotion.

This is very much in agreement with what we know to be the natural, peak conditions for mental and creative work. The mind, a sensitive and finely tuned instrument, indeed can't operate effectively under disquieting or discordant conditions, especially if they are self-generated. We are bothered most in life by opposition, by that which runs counter to our wishes or purposes. It is the frustration of our intended actions or imagined wants which leads to excessive, and usually ineffective, reaction. Yet our wishes and wants may not be in harmony with the wishes and wants of others,

our needs may be imaginary or out of harmony with the creative, eternal purposes of Tao. Serenity teaches and gives acceptance of the inevitable, and neutrality in every sphere of life.

The Taoist meditative outlook, however, was not simply a passive acquiescence to the *yin* and *yang* of life, but a positive and creative response to it through moving with or balancing out opposition. All things had to accept the natural harmonies which adjusted the life of the universe, and the human mind was no exception to this. Regardless of what appeared to trouble or disquiet the mind it could be and should be countered by stoic calm, by the determined preservation of serenity and inner stillness, which would eventually lead to perspective and enlightenment.

This concept is difficult and foreign to the Western consciousness, for excited emotions and aggression have been programmed into our customs and thinking by the incessant din and false values of competitive materialism. The wisdom of our greatest thinkers, our temples of learning, our religions, our art, represent the strongest bulwark against this diseased consciousness, which has dragged every great civilization down to its ruin. Our red-faced shouting matches, our berating of others in response to some petty frustration, our willingness to unlease volcanic emotions in defense of ego and our trivial possessions, account for much of Western violence and much of its lagging spiritual and aesthetic progress. True pride is based on confidence, on the knowledge of internal strength. The imperturbable Taoists offered, long ago, the spiritual answer to frustrated illusions – serenity, also known as sanity.

Our helplessness before the unpleasant effects of stress, and our inability to know what to do about it, other than to resort to a variety of drugs (on which much profit is made), make the attainment of serenity seem like a herculean task to the modern mind. Yet it is not difficult, as the Taoists show us. Meditation definitely promotes and strengthens the ability to do this, and that through an easy practice and gentle self-discipline.

The meditative Way was also extended to include the practice of balancing the fluctuations of change, the challenges, hurdles, victories and inevitable defeats of life with the masterful presence, dignity, composure, poise and inner equanimity which the deepest spiritual resources were ready to supply and creatively handle, if we let them. A tranquil mind opens the doors to universal consciousness, where it meets the unfettered power of truth and spiritual means appropriate to the moment. Worry and anxiety are therefore fruitless and a demeaning of the tremendous powers available to us. Often we want guarantees, total security, but

sometimes blind faith is necessary. Nature is indifferent to the fears, partiality and self-interests of the limited conscious intellect because nature's way is first, and greater, and is the home of the spirit. Accordingly, we only live up to ourselves as we follow and accept the laws of spirit and the true creative power with which we are endowed.

The emphasis on tranquillity and mental calm was further extended to include all extreme emotion as harmful, since it wasted vital creative energy and interfered with intelligence. For the Taoist, even when the defence of life became necessary, and then only when there was no other choice, victory depended on being in touch with one's spiritual centre, which was always on the side of right: 'He who gets angry, loses', states an old Chinese maxim, for he has lost the Tao, the Way of peace.

Questions of good and evil in Taoism centre on the balance of nature, because nothing that is natural can be wrong. A great martial arts master said, 'Tao is balance. But balance can be lost; the fragile equilibrium can be destroyed by evil. Evil must sometimes be met head on'.[18] Taoist ascetics were very concerned with what is unnatural as detrimental to spirituality and to life itself, and this usually meant the excessive or immoderate pursuit of anything, including sensual pleasure or ego arrogance. Excessive involvement in the senses leads one away from the spiritual world through externalization of the consciousness. The mind, the repository of spirit, should be the master and controller of life, not the other way around, where men were led by the strings of illusion, like so many marionettes, toward possessing sensual objects, and being aggressive and vicious toward others in order to do so. The spirit was the master of life, and the spirit was a calm, self-directed, unturmoiled power.

Man is special in the universe because he alone has the power of choice, of creating his own destiny. In the simplest terms of living the path lies up, toward self-perfection and spiritual fulfillment, or down, toward self-degradation and self-destruction. The turbulent forces of nature, the fluctuating energies of change, the polarities of yin and yang, need not be, for us, the blind tossing about of our lives as on a hurricane sea. It is true that we are all swept along, all caught up in the tide of life, but we will not be affected, we will not be afraid if our lives are in harmony with those natural forces, for we will be on their side and they will serve us. We are microcosms of the universe. Within our bodies all of the natural elements, energy fluctuations and rhythms exist as much as in the rest of nature. We can harmonize them, flow with them, master nature in ourselves

105

and direct it to creativity and intelligence through the guiding spiritual centre of the storm. Or we can let our lives be like helpless bamboo leaves that flutter wildly according to the winds of change and are blown away in autumn. It is, perhaps, the difference between strength and weakness, between life-success and life-failure. Success in the truest sense has nothing to do with fame and fortune, but only with what we are within. The Taoist Way sought, through meditation among other things, the harmonization of man's mind with the powers of nature.

Meditation was precisely such a harmony, because it integrated the inner and outer worlds. It was the spiritual union the Taoists sought, uniting the physical and spiritual selves and making them one. It was joining man to the creative heart of life, and making him, too, its master to the degree that spiritual integration, the divine unity, was achieved. The Taoist mystic therefore aspired to penetrate beyond the natural world, beyond what we consider 'reality' to the state of real and original being itself that was identical with Tao, with what we call the soul, the true self. Doing so, he would perhaps achieve a small bit of the creative power of *Te*, and attain that sublime peace and calm which is the still centre of nature, 'beyond time and change'.[19] He would become one with Spirit. Entering the Great Wholeness, so would he become whole, one in body and mind, a natural man in command of nature within and without.

Paradoxically, to become natural he had to strip away the unnatural, the acquired, the learned, so that only the pure state of nature and spiritual consciousness was left, by 'losing and losing' as Lao Tzu put it. The conscious mind, with its accumulation of experiences and their often limiting biases, its analytical and critical propensities, its base in objectivity and calculation, was left behind by this new consciousness, for it was simply representative of physical life and the physical dimension in all that it is. It could not, of itself, arrive at spiritual awareness by the nature of its own limitations, which, while they are good in themselves, are incapable of the spiritual understanding which is above and beyond the boundaries of rational thought. That we have the capacity for transcending the ordinary intellect to reach an extraordinary level of intelligence and spiritual grace was the reason why the Taoists practised meditation. Because they knew that meditation was a necessary and disciplining spiritual exercise, and that in seeking to gain creative intelligence and spiritual unity the rational mind and its logical method was no help at all, and was even a hindrance. Could it be that what we call unconscious instinct is the gateway to

another, greater dimension of consciousness, that contrary to what we have always believed, intellect serves instinct, rather than vice versa?

The repose, peace and calm that are found in meditation are what the Taoists believed were the effects of spiritual encounter, the direct experience of God. We wonder why, perhaps, the Divine Creative Intelligence can be so identified, why peace seems to be associated with its intrinsic nature, and how stillness can be productive of so much power. Yet the miniscule microcosm of our minds seems to confirm this as we observe how well the peaceful mind, the calm, still, rested mind works in normal consciousness, in creative activity and in natural regeneration. Of course it relates to the whole mystery of energy and what it is, and we remain hardly able to define it except in terms of natural phenomena, its least appropriate description, yet the way we can best perceive it.

The power of a magnet to attract lies not in either of its poles but in their electromagnetic union. That power is greatest not at either polar end of its activity, but in its centre, where its magnetic activity accumulates and culminates. There it is most balanced and derives its greatest energy from the interaction between the two poles. This still centre is peaceful and inactive, yet it is the real source of energy. To describe spiritual energy in such terms is woefully inadequate, and such comparisons merely help us to understand something of the Divine Nature and its creative effects on human life. That the human mind is a tiny pool reflecting this immense and infinite spiritual dimension is to know we can reflect it better still, and grow far beyond our most advanced imaginings and expectations. 'The still mind of the sage is the mirror of heaven and earth, the speculum of creation',[20] said Chuang Tzu, and we mirror it the better when the mind is most like it.

Nature is action, and spirit is quiescence. The rational mind corresponds to the active, generative and physical; the intuitive mind corresponds to the inactive, creative/regenerative, the spiritual. Bound to physical form, we are also bound by its limitations, its *doingness*, its duties to necessity, its compulsions – even as the spiritual dimension of being is non-material, uncompelled, eternal, and absolutely free. Spiritual life, therefore, is stillness, is peace itself, and at peace. It is the perfect balance of all forces, actions and opposites, nay, perfection itself. It is the Divine Harmony, the one Great Chord of creation. Its Harmony is symmetrical, a single unified tone, the tone of the spirit of consciousness, of life itself, and harmony is energy.

The practice of meditation is, then, the practice of a higher,

spiritual consciousness by infusion with it, with the sources of life and being. By union with the vital stream of reality as it flows toward life from the spiritual centre of the universe we are activated, transformed, and renewed by it. Intuition, as the spiritual correspondence and spiritual principle of the mind, becomes the instrument and magnetic receptor here, the balancing agent, the bridge to the spiritual world, for the intuitive mind works in non-verbal stillness. As stilling of the rational thought process is practised, the intuitive mode is freed to become aware, to know, to perceive with greater clarity than conscious deliberation could ever do – to 'know' surely and completely, the truth, in an instant. For such knowledge does spiritual union, the source of all truth, produce. Fulfilled in this kind of peak and liberated intelligence, consciousness can become the direct knowledge of life as it is in itself, in its principles and essences, uninterrupted by the need for rational thinking. For the intuitive mind is the temple of spirit and the means of all true and creative knowledge as known by the experiencing of spirit, the basis of all reality.

In this state the false perceptions of reality, the loss of perspective, the sense of distinctions, the rational proclivity to differentiate and externalize, the illusion of our physical form as the self – all melt away into the greater unity of spiritual reality, the *only* reality. And this is the same spiritual reality which pervades all of nature, man and the universe, and unites all. This undifferentiated oneness does not mean the loss of personality, but is its fulfillment and replenishment, precisely because it is the base of natural being.

This sense of unity with the universe is characteristic of the higher meditative states. To experience this condition, to become one with the spiritual realm, with the Tao, with God, with the Creative Intelligence, is to become in some way purified and sanctified by it, and to participate in and absorb its energy, which is, beyond all doubt, creative energy. To find this state and know it, this sublime union with spirit, is not merely pleasurable, it is 'absolute joy, utterly transcending any form of earthly enjoyment'.[21]

The spirit, which gives happiness and creates through peace, can only be known through peace:

According to the Taoist, when a state of perfect quiescence is achieved all the signs of action of the outside world and one's own will cease and every trace and mark of limitations and conditions will vanish. No thought will disturb. One becomes aware of a Heavenly radiance within. It is the light in darkness. When this radiance comes it is said that the golden flower opens. The

blossoming of the golden flower purifies the heart and the body as well. One gains an illuminating insight into the pure nature of his own. Here then is the real self, the inmost being. Chuang Tzu says: 'When one is extremely tranquil then the Heavenly Light is given forth. He who emits this Heavenly Light sees his Real Self. He who cultivates his Real Self achieves the Absolute.' (Ch. xxiii).[22]

The Taoist method of meditation is practised in a very simple procedure. One sits cross-legged on the floor, on a light mat or cushion, with the back supported against a wall or some solid object so that an erect sitting posture can be maintained comfortably. (It is well not to be *too* comfortable – the purpose is to meditate, not fall asleep). During the session the spine is kept straight but not stiff, relaxed and natural. Some teachers advocate the 'lotus' posture of the legs, which tends to be most uncomfortable and is not strictly necessary in this type of meditation, as long as one does not sit with the legs extended, or in a chair. A natural, cross-legged position suffices. The head is kept erect, to the front, and aligned with the spine. The eyes are closed. The hands are settled relaxedly in the lap, the left clasping the right or vice versa, palms up, and the thumbs crossed. One should not face a window or other source of light as it will penetrate the eyelids and prove distracting. Optimal conditions would be in a semi-darkened room that is completely quiet and free from any potential interruption, although with practice one can meditate anywhere. With these conditions and postures met, the meditation is ready to begin. The first step is to relax completely and silence all thought. It is the whole purpose and practice of meditation to maintain complete stillness of mind, without any thoughts, throughout the session.

Taoist meditation is a concentration technique, as opposed to those which use mantras, some form of repetition, or the visual aid of mandalas, as in some Buddhist sects. Its most basic requirement, in fact, its only requirement, is concentration. This is much easier said than done, as the novice will soon find out. As an aid to concentration, the meditator is advised to concentrate on his breathing, which helps to mobilize the attention and foster inward consciousness. The desired mental state is absolute stillness and the cessation of thought, and when the mind strays (and it *will* stray), the concentration should be simply and gently returned to one's breathing. As noted above, the purpose and goal at all times is total stillness of the mind, and this requires continual and attentive concentration.

While the general concentration is on the breathing, the point of attention should be focused on one of the two main spiritual centres in the body – either on a point one inch below the navel, called the *tan t'ien* ('third eye'), or on the area of the forehead exactly between the eyes, the upper 'third eye'. The meditation period should not be longer than 15 or 20 minutes at the outset, either once or twice a day, preferably morning or midday, and/or evening. The meditator will know, according to his or her progress, when to extend the sessions to longer periods, and this will usually depend on the ability to keep the mind still for longer periods, which is an indication of advancement. It would not be unusual for this not to happen until after three or more years of meditation if ever, so there should be no effort made to lengthen the sessions. Taoist and Zen adepts in monasteries, under ideal conditions, are able to meditate for 12 hours or longer, but they are extreme ascetics and for most of us this is not advisable or even necessary. Good progress and excellent results can be obtained through consistent practice of a 15 minute meditation period, and longer periods should not be forced.

The beginner will learn at once that it is no easy matter to keep the busy conscious mind still, even for 15 minutes. He will be plagued by what the Taoist masters called 'rising thoughts',[23] i.e. the interfering activity of the conscious intellect and its habit of constant mental verbalization, self-interest, objectification and externalizing of the consciousness. If one is thinking one is definitely not meditating, for in meditation there is no conscious thought. Various mental images may also arise during meditation, sexual or otherwise, traces of memory and experience, etc., and these may or may not be conscious phenomena and the work of imagination. Images or symbols of any kind are only bona fide manifestations of meditation when they aren't the result of willing them, and when there are no expectations or desires of any sort present in the mind, and then only when the mind is perfectly still. The meditative attitude should always be one of not expecting to experience or receive anything; the will must lie dormant, the consciousness perfectly free and undirected. Spiritual symbols or insights have a 'flashing' or indistinct quality in the novice stages of meditation. They can be distinguished by a much greater reality and lucidity than usually occurs in willed imagination. They are perhaps different for every individual, nevertheless, and their nature should be carefully considered when the meditation period is over. Usually someone will know when they have had a spiritual insight, because the experience is always much more intense and arresting than when a mere memory or imagination has arisen.

Everyone who meditates will encounter this problem of conscious thought activity – it is the whole business of meditation to quiet it. Patience and sustained concentration are the best antidotes, and this involves only the simple and repeated returning of concentration to one's breathing. Another very effective method aid, perhaps the best, is to deploy what the Taoists called *hua t'ou*, 'looking into' a thought as it arises,[24] which practice has the immediate effect of instantly dispelling it. The conscious, rational mind is externally directed and works in a chainlike fashion, linking one thought to another in order to build a concept of whatever it is thinking about. This process is interrupted by introverting, by 'looking into' it, so that the next step in the chain, the next thought, will not follow. If it does, it is simply looked into again, and it will then cease. This method is excellent for sustaining and prolonging the mind in a quiet state, and is of great assistance in maintaining concentration in that state.

The practice of breath control during meditation was considered very important by the religious Taoists, who were deeply interested in the relationship between health and spirituality. In this method, the breathing is always through the diaphragm, each intaken breath being drawn deeply to the point where the belly is stretched tight. It is then exhaled very completely until the diaphragm sinks down fully. Lao Tzu does not seem to have placed any undue emphasis on such breath control, however, merely advocating that it should be 'as soft and light as that of an infant',[25] i.e. completely natural and unforced, unlaboured. I have tried both methods with good effect. If one uses the first method, the focus of concentration should be on the lower *tan t'ien* below the navel; if the second, it should be on the 'third eye' of the forehead between the eyes. Some of the more esoteric methods of monastic Taoism included the controlled circulation of the vital energy through the theoretical 'meridians' of the body, a theory which has been endorsed by acupuncture to some extent, in order to improve health and prolong life. While much of this remains to be explored by medical science, it seems certain that spiritual health also has a beneficial effect on the body, as well as on the mind and character.

Meditation unlocks creativity through the regeneration of character and the renewal of its integrity with itself, as well as through the improvement of intuition. The scale of values to which the artist and the person of principle adhere have a common base. They are equivalent to perception of the characterological meaning of things, and are known through the same inner identity which unifies them. Meditation disciplines, systematizes this inner

correspondence, inducing greater awareness of essence (which is spiritual meaning) through increased sensitivity to this inner concordance, and through learning to detect better any inharmonious deviations from it. This reinforces directly what untrained and untempered intuition picks up only by chance.

Real creativity thus follows the kind of inner integrity which places the spirit and character of things first in that value scale, exactly as the artist does when he seeks essential meaning and character, and is that which acts according to an inescapable conviction of rightness arising from the soul. To be creative simply means to act solely according to inner dictates, and in so doing to regenerate the principles of reality laid down by the spiritual source of life and its reflection in nature. This also corresponds to the meaning of integrity, which all men at all times do not act upon or perceive equally.

Integrity is therefore allied to honesty and strength of character, because to act according to inner values is often to confront the imbalances of one's time, environment or society. The soul is ever new, fresh and living, even as societies are locked into the mouldering and rigid structure of their own inevitable stagnation. The human willingness to be motivated only by those inner standards which intuition and the perception of spirit make known, and which is *not* idealism, are surely the finest attributes of humanity. It is as if nature had endowed us with an inner tuning fork by which to measure the pitch and tone of truth, to right ourselves as if by the magnetic needle of a compass, always pointing toward our spiritual north. Integrity and character are well known to go hand in hand, not only because at times great inner resources must be called upon to remain true to principle, but because they are reciprocal and mutually beneficial in strengthening and confirming individual identity, in promoting maturity and the Taoist 'Real Self'.

Now integration, the kind of integration which occurs in meditation, the blending of the inner and outer selves in a disciplined and repeated practice, is in effect the spiritual exercise of integrity. When we sit in meditation we are returning to the spiritual state or condition which is the sole and primary motivant of all reality. There we come to know ourselves and our inner being, there we hear the 'tuning fork' with greater acuity, and there we familiarize and reorient ourselves to an inner landscape where all the real sources and meanings of life become clear. Returning to the light, we become once more vehicles of the light, and so learn to follow it, which is what integrity is and does. Moreover, as we

exercise our integrity in this Way so does it grow into spiritual muscle. The Taoists knew that the Way of meditation would lead to the development of spiritual character.

If integrity is the quality of being undivided and complete, it is remarkably similar to unity, if not identical with it, and requires two important supports. First, the powers of the self must be mobilized into a whole, united against external distraction and internal confusion, able to find a recognizable and consistent character within, and to be true to it in each and every circumstance of life. Secondly, the character of the individual needs to know how to discern essence in order to apply creative action in life. Both of these conditions are provided by meditation. In the first case, meditation is in fact practice in quieting the environment, the body and the mind, and in the process of introversion, 'looking within', the focus of identity is shifted from the body and ego to the 'Real Self' within. As that real identity becomes stronger and better known, so is it more easily identified and followed. In the second case, it is highly likely that in continued practice in meeting the essence of ourselves within, (which, as we have noted repeatedly is the same unified field as all of reality), we become more adept in discerning other meanings, other essences, since their tone and feeling state, their 'resonance', is similar and thus becomes more easily identifiable – it 'feels right', or has the 'ring of truth'. As a practical example of this we can cite the artist who, through constant habit in his work in searching for meaning and expressing character essence, becomes very proficient at it, at identifying essences and in expressing them, far more than the average person. And he does this through inner means, through identification, precisely because the inner and outer worlds have the same identity:

> Only the truly intelligent understand this principle of identity. They do not view things as apprehended by themselves subjectively, but transfer themselves into the position of the things viewed. And viewing them thus they are able to comprehend them, nay, to master them; and he who can master them is near. So it is, that to place oneself in subjective relation with externals, without consciousness of their objectivity, this is Tao.[26]

From this it becomes clear that the same kind of self-identification transpires in meditation, and so we can agree that it can lead to the same discernment/perception process as art, the discernment of essence, of spiritual meaning.

Unity to the Taoists meant far-reaching and wonderful implications that were much more than an integration of the subjective and objective selves, for it did not end there, even though it prepared the way for a higher experience. What unity means in this regard can be observed with special significance in art. While working, the artist identifies with his subject and seeks to unify the whole of the work, to produce a oneness and singleness of total effect. Now this unifying process is the same subjective/objective integration which is the result of meditation, as we earlier suggested. This striking parallel extends further, to what is obtained – the experiential effect on the viewer – and this reduces to consistency of style and/or of the character expressed. The elegance of this attained whole comes from its innate symmetry, a form of perfection to which the soul responds with the fervour and joy elicited by the beauty of a true spiritual experience. The same symmetry occurs in meditation, and is why meditative unity produces oneness with the spiritual world. Man may rise up, but spirit can't go down; so to know spirit we must know it in the terms of its own aesthetic perfection.

The total effect of unifying objective and subjective, *yin* and *yang*, body and spirit, form and content, reason and intuition, is to become one with the Origin, the Whole, the Absolute, the Source of Life; and this is the experience of Tao in the degree to which it is achieved. As we have often observed, art and meditation achieve the same thing. Religious contemplatives of all times and countries have spoken of the highest degree of meditation with ecstasy, as the supreme experience, and as the attainment of 'truth, happiness, and power'.[27] They speak of a beautiful oneness with God, a mysterious, mystical experience in which the soul feels itself to be complete, and totally merged with the Divine Intelligence, as well as with all other creatures. It was this divine, ultimate unity that was the spiritual goal of the Taoist masters, which St. John of The Cross spoke of as 'Mystical Union', and of which Chuang Tzu said, 'Heaven and Earth and I live together, and all things and I are one.'

One of the most surprising things about meditation is that it gives such a complete and ineffable sense of *rest*. Fifteen minutes of it leaves one feeling more rested than a two-hour nap, and this leads me to believe that this sense of repose which has been so highly valued by all monks and contemplatives is not only part of the magnificent reward of spiritual reunion, but also amounts to the idea that it is a virtual recharging of the vital energy of the entire physical and mental system. And the Taoists confirm that this is exactly what does happen.

This brings us to the final point in the triune effects of meditation, perhaps the one on which all depend, and this is harmony. We can now recall that harmony was the fundamental nature of Tao, and that its issuance in the physical dimension was the vibrational generation of *ch'i*, the electric vitality of creative power and the spiritual world in the act of creative transformation. Harmony *is* energy, the highest octave of *ch'i*, just as the tonal waves of sound in harmony resonate and vibrate generationally upon the inner ear to stimulate or calm us. In meditation we are participating in, moving with, experiencing and being renewed by, the creative power of the spiritual world, the Vital Spirit which heals and rebuilds all life, and so are we vivified and made more special by its radiant harmony and restoration.

Thus the whole principle of meditation is to harmonize the human being with itself and nature, to reunite with the spiritual source from which we came, to return to the spiritual identity upon which the universe and our own lives depend, and to enjoy the happiness and creativity which that pure and natural state most surely brings. Natural humanity, left to freedom, leisure and solitude in a natural world, would perhaps not need meditation, for spiritual energy rebuilds naturally from within and restores our knowledge of self-worth. But survival in a physical world can seldom be without action of some kind, so we must learn to renew our creative spiritual energies in order to live creatively. In the world of responsibilities, the world of many demands upon our creative energy where most of us live, meditation is an oasis of peace, a refuge and an actual replenishment of the soul, a blessing for mankind.

The benefits and spiritual growth it brings to the individual are many and important, most of all, to the continued development of self-realization and character, and its outcome in creative intelligence, for the creative and intuitive faculties will be further developed by it.[27] The calm and serenity practised in meditation become further confirmed and strengthened by it, infused into the consciousness and carried into life, so that the mind is increasingly more in control of the body, and ever more receptive to the advanced intuitive enlightenment without which intellect will never be complete. Poise becomes deepened and consolidated, so that one is less and less disturbed by outward conditions and circumstances, more detached and more in command of them. This new, inner strength finds at its disposal an increasing, effortless creativity, and a power to attract what one needs, so that less effort is needed to obtain goals. The ability to concentrate one's *ch'i* can even result in amazing physical powers, as we learn from the martial arts and in

psychic abilities, and we are just now at a vast new threshold of these powers. One finds one's life being subtly and gently changed from within, filled with surprising benefits and spiritual riches, as if magically, when the self is in harmony with the cosmos and nature, and the spiritual self is one with the body. With the expansion of consciousness that meditation brings the world is seen in a new and fresh way – inexplicably, nature is felt to be like an intimate friend, and a supreme inner joy often comes in meditation which can only be described as bliss.

These are its miracles, the Mystical Way which is at once not so much hidden and recondite as it is creative and life-giving, the surest path toward the living reality of the spiritual world.

In ancient China a jade disc in the form of a circle, called a *pi*, was highly treasured as a symbol of the universe, because in that perfect symmetry all the powers, attributes and presence of the Godhead are symbolized – Infinite, Undivided, One. It is indeed in such divine symmetry that integrity, unity and harmony are epitomized, and become known as all of the same substance. The circle, for this reason, is a physical symbol of God. Some who meditate have seen the inner radiance and light of which the Taoists speak – in the form of a circle, a circle of light.

In *Scholar By A Waterfall,* (Fig 13), we have a deep meditative mood and another tour de force by the redoubtable Ma Yuan, whose superb masterpieces dot the history of Chinese art over a relatively short career of about 35 years.

An aged scholar gazes in contemplation down into a river chasm where coursing waters froth and bubble over rocks. His attendant serving lad, holding his master's staff, stands nearby. In the background, all is lost in the obscure mystery of dense clouds of fog and mist that arise from the river and are split only by the dashing arc of a waterfall that spills from some massive cleft in a barely perceptible, rounded mass of mountain wall. In the far distance we can make out a dim, soft horizontal shoreline, perhaps a lake, but we are not certain. All is quiet, verdant, moist, and man is one with nature which surrounds him.

Two main masses structure this composition and balance the misty mass of open space. These are the powerful form of the bent and angular old pine growing on a hillside on the left, and the rock mass which juts up dramatically from the centre foreground. Both of these large masses are sustained and balanced by the sharp rock in the river and the activity of the far right. Ma Yuan painted this picture from the inside out, as watercolour demands, first laying the fluid, wet, steaming washes of the background. These were overpainted

with the next darkest wash value, the vague, shadowy limbs looming behind the pine which create depth, with their charming little inverted triangles of leaves. Next came the feathery texture of the hill, composed of many, individual, hairlike strokes. When all of this was dry the springing vitality of the much darker pine was added, with its knotty trunk, angled, knobby limbs, and stiff needles, all done with the liberated dynamism of the painter's exciting brushwork. The unique shape and form of the foreground boulder was also painted at this time, the drybrush effects on its side establishing smooth, weathered surfaces and planes. The figures and guardrail were painted in last, with touches of opaque colour, and accented with line.

Integrity, unity and harmony are well represented here and well captured. Integrity, in the character and understanding of the old sage, in the bent angles of his frame, which reflect the aging majesty of the pine tree, in the droop of his shoulders and thin, ascetic figure, in the simple essentials of brush lines which are the essence of his robe. The unity of the whole is also well taken with the silvery tonality of the mist, the same value which penetrates everywhere in the painting, and which underlies and unites everything in it. This is also its harmonizing agent, and this well-unified whole is its own harmony, bringing with it a deep sense of the harmony of nature and the effect of spiritual reality which we call beauty.

Notes

1 *Chuang Tzu*, XXI, 4. Waley, 116.
2 Waley, 117.
3 *Tao Te Ching*, XV, Bahm, Translator.
4 The role of shamanism in prehistoric Chinese art and culture, and in prehistoric Western art, has been greatly overlooked by scholars.
5 Waley, 117.
6 Bloomfield, Harold H.; Cain, Michael Peter; and Jaffe, Dennis T. *Transcendental Meditation: Discovering Inner Energy and Overcoming Stress.* New York: Delacorte Press, 1975, passim.
7 Legeza, 7.
8 Waley, 49.
9 *Chuang Tzu*, XXIII, Chang, Translator.
10 Chang, 49.
11 Ibid., 50.
12 Waley, 48.

13 *Chuang Tzu*, VII, Chan, Translator.
14 Chan, 207.
15 Ibid.
16 Ibid.
17 Waley, 48.
18 Deng, 36.
19 Legeza, 8.
20 Siren, 51.
21 Waley, 46, citing Chapter 18 of *Chuang Tzu*.
22 Chang, 49.
23 Lu, K'uan Yu. *The Secrets of Chinese Meditation.* London: Rider and Company, 1964, 169.
24 Ibid.
25 Waley, 44.
26 *Chuang Tzu*, I, 20. Giles, Translator. Quoted by Siren, 24, 25.
27 Waley, 45.
28 Siren, 68, 69.

Chapter VIII
The Artistic Way:
The Realization of Spirit

The Way of art to the Taoists meant the outward expression of Tao in the world, the visible terms of meditation, the externalized action and expression of inner spiritual reality. It was performance, the 'art of doing', certainly not in any artificial sense, and not in the superficial sense of the mere display of technical expertise. It was, rather, the most effective and significant kind of action or effort in its deepest and widest sense, as the creative outcome, in the world, of the effects and benefits of the Way of meditation, of the growth and mastery of spiritual realization in the individual. It was 'art' only when these terms were present.

Furthermore, the discipline of art was seen in itself as a kind of meditation, and many artists practised meditation to improve their intuition and creativity.[1] It was from and through this cause that spirit manifested as outward and material expression for good, that it became known to society and the world at large, so the Way could be followed and achieved through the practice of art as well as through sitting meditation. And this was because the Tao, spirit, was creative in nature and in *its* nature. So in both of these forms the outcome was mutual. The performance of art generated the terms of spiritual development, and spiritual development produces a proportionate increase of creative power in all its forms. Art is *Te,* and *Te* is art.

In order to grasp this idea we must abandon our preconceptions and consider, on the one hand, that the meaning of art is permanently entwined with the meaning of spirit or essence, and on the other, that the action or effect of spirit or essence is art, i.e. the expression of individual spirit. Not only art, but all creativity had this basis in absolute being, in the spiritual character of the individual. The expression of this inward character of things was

119

not typified by technique or skill, but rather by the full utilization of the divine creative energy which was omnipresent in all things. This was why the Taoists and Zen Buddhists spoke of 'artless art',[2] i.e. art which grew entirely out of the unconscious spiritual centre and was not the result of any contrivance, artifice, or deliberate application of cleverness. It was a childlike innocence, a purity of mind, a lack of self-conscious action, a self-forgetfulness that transcended all technique or intellectual reasoning. It was art by virtue of harmonious contact with one's Tao or spiritual source, and this integrity, this *virtue*, was what released the tremendous creative power that was *Te*. Art, therefore, was an unconsciously concentrated form of spiritual energy, the virtue and power of *Te*; and *Te* was the creativity of Tao which could be fulfilled in the individual through the Way of self-discipline, meditation, and spiritual cultivation.

This does not mean that everything that passes for art is the result of spiritual power, nor that all art works bring spiritual realization to society equally. Just as art is a spiritual discipline, so are there times when discipline fails, and art declines under human weakness. Then there is the art which, while not fraudulent, nevertheless represents confusion in its philosophy, as when it falls under the spell of conflicting intellectual conceits about art and produces pretentious ostentation, of technique, or of exhibitionism. Such art may enjoy temporary popularity and even extensive contemporary success, but it will lack power and inner truth, will seldom last past the artist's lifetime, and may be classed among the transient entertainments of his time. Finally there is the 'art' which is outright fraud, that shabby arena which supports a host of poseurs and the topheavy political manoeuvres of mercenary galleries and specious critics, which panders to credulous collectors, which is produced to sell like production-line knicknacks at absurd prices, which prostitutes itself to commerce or which slowly erodes its integrity with each passing fad of the art world as it depletes its energies in catering to the latest fluctuating changes in taste, fashion and sensation. It is yet another strange and horrible corruption of civilization that it sometimes succeeds even in corrupting art, the one thing that might have saved it from itself.

Earlier we mentioned the Taoist belief that art was immeasurably beneficial to society and civilization. Everything we know about culture confirms that this is true. Given the qualities of art demonstrated by Taoism – its ability to unite spirit and matter, its transformative tendencies, its profound penetration of essence, its realization and expression of the cosmic harmony which restores the

human soul to peace, repose and integration, its power to 'transmit the spirit' and the spirit of Tao in nature as living realities to be perceived socially in objective form – we can hardly deny such a priceless influence has a regenerative, elevating effect on human life and society, and that as a major contributor and instrument for human refinement and the highest good. Most importantly, such benefits occur on an intimate personal level with the individual, and can be expected to spread to society at large from there, rather than as some vague tendency or societal imprint. We have already noted how the beholder or audience of art benefits from it as much as does the artist,[3] and numerous other benefits could be enumerated. The pursuit of meaning is a perpetual, never-ending human need. Art fills this spiritual hunger, adding something infinitely precious to human life which can come to it no other way – the making real of spiritual truth and beauty in the material world.

In this way, the artist becomes a minute reflection of the Universal Mind, or, as the Taoists preferred, a mirror of Tao. With his powerful intuitional capacity he stands as a bridge between the personal, objective intelligence of human rational consciousness and the universal intelligence of spiritual life. What the artist sees and knows, others will soon know and see, and he makes that human union and spiritual reunion possible for non-artists, for the beholders of his work. The silent participation of the audience in a work of art engages the same forms of meditation and intuitional creativity which produced it. It grows through the perception of essence and the experience of spiritual reality; that in turn expands the consciousness and generates character development and spiritual and intellectual growth. The individual who pays attention to the work must meditate on its meaning and grasp its strength, its power, its spiritual significance. He is either being drawn into it or infused with it unconsciously, for it is literally hurled at him as its spiritual qualities arrest a response in his own soul. I recall an occasion when I sat before Albert Bierstadt's *The Rocky Mountains* in the Metropolitan Museum of Art in New York. While studying the painting I suddenly became aware, in a flash of intuition, that here was not only a work of marvellous grandeur and exquisite beauty – it was also something which actually revealed and made real the living spirit and essence of nature, and with it a sense of the divinely human spiritual character which pervades it. It is in this kind of experience that participation in art becomes a positive good for civilization, in its effect on individual human beings, for they are its elements and cornerstones.

Art is a path to spiritual realization because it can't be divided

from the meditative modus operandi which is normal and intrinsic to it. Everything the artist does while executing the work joins it directly to the same disposition and effects as meditation, allying it to the Taoist Way and Spiritual realization with sure and certain bonds. From this unprecedented circumstance we learn that art and creativity are clearly not the result of reason or logic or education and are in fact superior to those functions. From it comes a most welcome increase in religious sustenance, in faith, in hope, finding that the spiritual is not only a mere word, concept or ideal, but a living reality, reflected and active in every principle of life and nature. And that spirit is unmistakably creative is a fact that brings its real nature home with a deeply understandable, deeply human immediacy. The parallels between art and the Taoist Way are as mutually supportive as they are mutually endorsing, as they prove the truth of each other and reveal with a brilliant clarity the spiritual heart of life and the life around us.

Many things have been said of art and artists, but art as a form of spiritual development and knowledge has been recognized least of all. Perhaps this is not entirely by accident; there are evil elements in the world which seek to suppress faith and spiritual growth as much as they do other forms of truth. Yet we have seen how these terms are apparent and are driven home again and again. The artist (in all of the arts) is in his work consciously or unconsciously practising the Taoist Way when he stills his mind and heart, when his ego is quieted and he 'sheds the thoughts and emotions of his personal life'.[4] This tranquillity, calmness, presence, 'emptiness' of mind becomes like the great, still harmony of Tao in which so much power is latent, becomes clear and reflects the infinite clarity of the Universal Mind in which all truth inheres. This inner quietness of a mind empty of all distracting inner and outer disturbances is like the 'purity of the space that was the Great Void of Tao'.[5] The analogy to meditation continues even further, for 'Tao abides in the emptiness',[6] the stillness, the receptive state. But the Void 'does not signify vacuity or the absence of life and consciousness, but rather the contrary, as it is the very source out of which all forms of conscious life emerge'.[7] In effect, the attitude of the artist that was required for creative work was identical to that of meditation, as we have often observed. Being so, it achieved the same thing, took its life and power from a spiritual source and became able to give form to it and to express it, to conceive it in the physical world – as a work of art.

Professionals in every art form find and demonstrate, whether they are aware of it or not, the likeness of creativity and its

expression to a true spiritual mode of consciousness and action. All work from a base of mind control and self-discipline, and all are firmly situated in intuitive response and profound identification.

The actor of stage and film, for example, does not merely memorize his lines and mechanically repeat them. By rehearsal, and by going over them again and again in his mind and practice he actually imbues and saturates his own mind with the character he is playing until he achieves unity with it, becomes one with it, *lives* the part until it is a part of him and permeates his entire being. His identification is so complete, his personal life so transcended, that by the time he steps on the stage he has *become* the character he is playing, for its meaning and essence are firmly his. Spontaneity is also engendered between actors during the performance, and each is thrown upon his own intuition to react to this interplay, thus arousing inner resources in each actor which further vivify the overall play or film. The actor's art is one of the most difficult. His canvas is himself, and it is total performance, total doing, and that under the watchful eye of an audience waiting to be convinced, a terrifying prospect. A steely self-mastery and superb control of mind and body are therefore a vitally necessary part of the actor's repertoire. Were he to think of himself he would be lost, for the strength of his performance depends on him alone and his composure, proving how self-consciousness and personal thoughts can make creative performance impossible. Art is an act of faith – everything comes from within, and the beautiful calm, presence and poise of the actor is part of his art, that which sustains him and makes it possible and enjoyable to us, his audience. His intuitive command of his part during the performance arises solely from sternly disciplined inner stillness. In this way, the character, the spiritual meaning and essence of the part, are transmitted and made real.

The above terms hold consistently true for the other performing arts as well. Dance is, like the martial arts and other athletics, the art of movement. The dancer works from a base of self-discipline, concentrates energy in the body's spiritual centres, and moves in a spontaneous, intuitive response to a purely intuitive medium, music. The dancer identifies with, becomes one with the music in much the same way as does the musician, and so swims in the pure river of *ch'i*, of spirit. The rhythm of movement both arises out of this intuitive awareness and evokes it. Conscious verbal thought is entirely excluded from the dancer's performance. Not only does the dancer not have time to think, but such thought is redundant, because the liberated motor centres of the body are completely

natural and involuntary, and because the grace and flow of harmonious movement generates its own vitality and deep inner tranquillity. Like the musician and the athlete, the dancer's practice consists of constant training to ready the physical instrument for maximum intuitive/spiritual response. Co-ordination, agility, balance, muscle strength, all of the other disciplines of physical preparedness are but roads to inner integrity and organization once the performance begins. The beauty of harmony awakens a natural human response for expressive movement in rhythm with it, and the flowing symmetry of the human body in natural movement is itself a kind of music and a living meditation, as it generates a mysterious electricity and a truly powerful form of action.

Much like the dancer, the musician has an added advantage in his art, for the performance precludes and shuts out any and all mentation. Thus music is situated in pure intuition and pure spiritual consciousness and elicits these in its performance and expression. A sheer purity of aesthetic and form contributes to this efficacy. It is the least of all the arts encumbered by media – the musical instrument, even of the finest quality, is a mere object without the music it gives and the intuitive sensitivity of the performer, and written musical notes are only symbols of sound. Having some experience as an amateur musician (trumpet), I don't believe it is an outlandish statement to say that harmony is a major part of music. As such, its relationship to a spiritual dimension of being whose essential nature is Pure Harmony can scarcely be imagined. As Taoism so well explains, the vital spiritual capacity of harmony, with its ground in fundamental being, its regenerative energies and consequent spiritual realization resulting from its being the centre of life and the Tao nature, surely must ally music very closely to that aesthetic correspondence through which we view and come to know spiritual life and meaning, and that in perhaps a more direct relation than other art forms.

The creative writer, like the painter, can never be anything but unavoidably committed to the search for essential meaning, for truth, and this by the nature of his art and the integrity which produces it. It is in the nature of literature to strip things down to their most basic meaning, if only to expound more clearly the writer's ideas and not bore the reader into a catatonic state, and because this is so the literary form already has the quality of art, almost before it begins. But a more noble principle motivates the literary artist who, again, like the painter and the person of principle, perceives essence through purely intuitive means and acts, out of integrity and creativity, to give form and expression to what

can be known and seen, and can do nothing else. The intense curiosity and inquiring mind of the writer strives to *know*, and once knowing must speak honestly and with the truth to it such knowledge demands.

Added to this is that rigorous intellectual exercise, practice and self-discipline which hammers again and again at the subject, turns it over and over in the mind until unity and self-identification with it are so complete that the saturated consciousness serves intuition and intuition alone. Then the *yang* of rational consciousness and the form of the book must yield to the *yin* of the receptive intuitive mind, to become one with it and its truth. When that superb creative flow begins, it is almost as if the book were writing itself, as if the writer were listening to an inner dictation. It is then Tao that writes, hitting the target with every arrow.

The work of literature is a prolonged meditation on a single subject. Nothing else demands so much from the human mind, and yet the same intense intellectual concentration draws forth from the mind its best and finest state. This can only be characterized as a near ideal blend of intellect and intuition, that creative intelligence which we insisted earlier was peak intelligence. The conscious and the unconscious, the rational and intuitive minds working together as one surely constitute the best and most balanced condition of mental harmony. Such a state has the same outcome as the meditative disposition, is the reflection of Tao, and is, best of all perhaps, the mind 'as it was meant to be'. A literary work of any merit whatever has to be something far above what transpires in the superficial stream of daily thought and in the mostly silly cares of personal life. For at its finest hour it is the human mind in touch with Universal Mind, and has the same transcendent power.

The creativity of men of literary genius is something titan-like, larger than life, endowed with the highest power of spirit, replete with an awesome authority which seems to come from on high and by which its audience perceives that this can't be anything but sublimely pure truth and its realization. It is mind risen above itself, or rather, finding itself within its own innate spiritual forces, and using that power to know, to explore, to discern and discover knowledge of the life essence in every aspect of life. It is the mind fulfilled, the hint of a vast consciousness universal in scope and spiritually fed; it is the genius every one of us could be.

Words are mere tools of medium to the writer, as paints and brushes are to the painter. The Taoists called writing 'mind painting',[8] which I think is rather significant. Like every art form, the technical framework of literature, its problems and requirements

– research, space, economy, length, monitoring of style, editing, the meaning of words and the way they are used – are only make-up and costume for that which takes place on the stage of meaning. Words to the creative writer are not the calculating verbalisms and endlessly linking speculations of the ordinary conscious thought process. They are precision instruments, symbols, musical notes to give form to essence. He fashions them, not so much according to a verbal process in his mind and thoughts, as to a professional awareness of the modes of meaning which underlie them and which they represent. He is, nevertheless, well aware of their limitations.

The writer's work is ideas, not words, and ideas arise in consciousness fresh and alive and without the least hint of their origin, without any effort at conception, and these are intuitive, spontaneous, evanescent suggestions and sudden insights coming from within which he learns to heed, respond to, put into words. Upon them concepts can be built or elaborated, and to them the tests of analysis and critical thinking can be applied. This very creative thought process has been dumped into that large vat of clichés we call inspiration. It is, however, something rather deeper, for it arises out of profound calm, detachment and concentration, rather than mental activity. It becomes a dialogue of the mind with itself, where word forms are but the formal rhythm of an inner correspondence. It is the still voice of intuition, of spirit, which calls forth timeless universal realities to the conscious mind, and these essences translate with great rapidity into their formal meaning, into the words and concepts for them which lie at the writer's fingertips by reason of his discipline.

Thus it is that every kind of literary work – fiction, drama, poetry, non-fiction – no matter what its subject, can elicit and put into concrete form the essence of that subject. This is surely knowledge of the spirit of things, in a word, of their Tao, their real meaning and fundamental character, and it has as many forms, degrees and shades of meaning as there are things in the world. Within this universal diversity there is universal cohesion, and so there is no question of levels of importance – all spirit, all expression of essence are important, and some aspect of the mind of God, as important and vital as it is for the human mind to know. To bring the spirit of anything into real and formal existence is art, and so is it also spiritual realization.

A great deal has been said about artistic conception, and here again we can refer to those delightfully succinct and accurate Taoist insights, to which I can attest out of my own experience as a painter. Tung Yu, a poet and connoisseur of painting who lived during the

Sung dynasty, remarked that the birth of an artistic idea revolves on two things. First, on the inner integrity and spiritual character of the artist – 'Those who do not differ from the truth will obtain it.'[9] – and, second, that such conception is 'naturalness', i.e. that the creative life spirit that unifies all reality is the same 'moving power' which transforms and characterizes all things and gives them their 'mysterious fitness'.[10] According to Siren, this is analogous to a 'sudden realization of the fundamental naturalness or truth of a motif, the inherent vitality which is produced by the all-pervading spirit of life'.[11] Certainly these are true. Artistic perception is almost one with its conception, and at some point this is a flashing and complete image of the picture, its idea, in the artist's mind. This image arises spontaneously and involuntarily and hence is not the willed work of imagination, but rather the intuitive realization of an essential reality with which the artist has identified and which can be turned into artistic form. The artist works unconsciously toward this original vision, toward making his audience feel the same identification with the object depicted as he perceived at the moment of this spontaneous conception.[12] This self-arising image is, then, not a concept at all, but rather the symbolic intuition of an artistic and ontological reality.

Inseparable from the creative Way, from art as a form of spiritual realization in the world, is the question of beauty – what it is, and how and why we know it. Curiously enough, artists seldom speak of it to the public, although they do discuss it with other artists. Perhaps to them it is a felt intimacy, something sacred that extensive airing can only degrade or turn into a banal travesty. Perhaps they are intimidated by the reams of critical literature on the subject and those scholars who know far more about it than we do, at least that is what they tell us. Yet every artist has experienced beauty many times, even if he can't verbalize about it as endlessly as the pundits, for it is that which moves him to paint.

The Taoists say little about beauty per se, but much is implied. Western culture thinks of it mostly in sensual terms – it can be seen, heard, touched, smelled, even eaten. There is really nothing wrong with this sensual approach, yet only a handful of our aesthetic philosophers have understood what it is in its basic nature – Croce, perhaps, Ficino, Schiller, certainly Plotinus. The Taoists and most Eastern philosophies would not hesitate to view it transcendentally and to say that beauty is a perception of spirit, of Tao, of the spiritual character of reality of which the sensual world is a reflection, and that it is from this spiritual reflection that beauty is derived. I could not disagree, having known Taoism, nor would

most artists. The question is why, for if we were to know why we would perhaps understand even better the great universal truths upon which Taoism is based.

What moves me, as an artist, as I walk among nature and the natural world, are first of all correspondences. By this I mean those visual or perceptive experiences which somehow meet with something I know within myself, something that speaks to me out of the recognitive relation of an outer essence with my own inward being. Next, I am moved by the unusual, the rare, the very essential form which seems to have the clear imprint of its own character upon it. Finally, I am moved by that which can only be described as a perfection of form, and generally this perfection has within it not only an exquisite sense of 'rightness', of 'fitness', (which, again, is perfection) – it has also throughout a dynamic sense of bursting vitality, of life. Its rightness, proportion, line, colour, rhythm, spatial reality, etc., have all added up to a 'mysterious' fitness, i.e. one imbued with some indefinable spirit of its own. And the more I think about these things, the more I become convinced that the quality of form which most strikes us as beautiful, which most arrests us, is that form which is of perfect symmetry.

Reduced to its simplest terms, the best example of this kind of perfect symmetry is found in two geometric forms, the circle and the cylinder, and in their principles and variations. Add to this as a combinant the natural rhythm and centrifugal movement of the circle, and consider that the circle is the inner spatial centre of the cylinder. Now if we study nature closely we will see that much natural form seems to be derived from, or is built upon, these two principles – circle and cylinder. The human body, especially the female face and figure, in both form and movement, is a demonstrable example of this circular principle. As an artist constructs the human figure in a drawing he uses circular or cylindrical forms to describe that figure, for these forms underlie the constructive principles of the human body – they are precisely those which are the basis of nearly every part of its construction. The same is true of animals. The formal base of their bodies, limbs and joints is circular and cylindrical. The limbs of a tree and its trunk construction are cylinders in principle and in general, as are the bodies of birds, flowers, the motion of hills and mountains and the waves of the sea. The sun, moon, and planets are circular – one could go on and on, for the natural examples are endless and apparent. What we see in nature is symmetry, the purest form of perfection, and nature everywhere speaks to us in symmetrical forms. Are these forms the visual basis of the beautiful? If so, they may be at least part

of the means by which we perceive and know beauty, and knowing it, also experience the spiritual world through it.

So, too, there are other forms, other ways by which spiritual meaning is perceived in terms of beauty. We have already considered many of these: harmony, unity, character, essence – all are aesthetic qualities involving the beautiful, and all, strangely enough, embody some aspect of symmetry. If the beautiful, or what we call aesthetic perfection, is not identical with the spiritual level of reality, it is certainly an important means by which we experience it. Through the beautiful, we come to realize some small part of that glorious beauty which is the spiritual dimension, that which lies beyond the physical at the heart of the universe, that which is life itself.

Yet nature is something too vast, too grand, too uncontainable to reduce to any single premise. All we can know is but a remote radiance of it, its spiritual effect. All we can know is what it represents, what moving spirit lights its forms with life, but that is a great deal to human beings. Nature is endlessly healing to us, endlessly interesting, endlessly inspiring. Each and every part of it, from the smallest cell and atom to the highest clouds and mountains is aesthetically and physically perfect, and will always be so. If anything, it is from this that its great beauty, its sublimity, is derived.

The artist is the interpreter, the translator of this sublime physical perfection of the divine, the Tao, in an almost exact parallel with the way the intuitive mind stands as an avenue to Universal Mind, to spiritual consciousness. He is the reader of essence, the voice of those powerful spiritual truths and realities by which we live. Whether he puts beauty into artistic form through knowing it better, whether his intuition is more lively than ours, or whether he perceives the character, essence and reality of nature with a sharper vision, he makes it possible for us to know what we might not have known, to see what we might not have seen. He opens nature for us to see its beauty, and to see in that beauty the spirit made real.

The spiritual world can only be known through the terms of aesthetic perfection because it is not a physical world. That it can be known by us at all, that its imprint is upon nature and in our hearts, that its spirit pervades all things, is, in itself, the miracle of the universe. That we can know it and understand it, that we can see this dimension through its aesthetic perfection, in that reflection of its reality we call beauty, is a major part of the wonderful heritage of human beings, and perhaps all of our dignity, for we, too, are reflections of that eternal beauty and reality. It is our being, our intelligence, our creativity. When we can become one with that

perfect harmony, when we can but catch a glimpse of the universal and timeless significance it conveys to us, it inspires us to the peak of ecstasy, of passion, of love and devotion, overwhelmed by its goodness, truth, and most tender rapture. The artistic Way, the creative Way, is the receiving and giving of ourselves of this good, and for the greater good, and as the creative life power of spirit is given form and realization in the world, so is that good accomplished.

The beautiful spirit of nature and its God-given perfection is surely immortalized by Chu Lu's *Bamboo*, (Fig. 14), a hanging scroll painted on satin by the hand of a master. If we compare this work to Wu Chen, (Fig. 3), we will find a distinct individuality and an individual personal style are evident in each of these paintings, even as the rich spiritual content and its presence is the same in each, an interesting consistency of insightful perception on the part of these painters and of the 'all-pervading' spirit of reality.

Chu Lu's work also gives us *yin-yang* in the twin, slender stalks of bamboo. Dark and light, strong and weak, forceful and quiet, they stand together in the wind and are united by two brief cuts of the brush in the upper third to become one. Balanced by each other, complementary in form and juxtaposition, they create a harmony, a symmetry of the whole, opening our eyes and hearts to spiritual perception.

This painting is so clear, crisp and precise in its brilliant realism that it gives an impression of 'tight', highly controlled handling. We're surprised, therefore, to find upon closer study that the opposite is true, that it is in fact a work of the freest, most direct kind of spontaneity. There is no rigidity, no passion for exactitude which licks the life into these wind-springing leaves; there is only a gift of the spiritual depth of the artist and its fulfillment in creative intuition and the *Te* of creative expression. Through the spirit of the artist, through his Tao, the Tao of life, of living nature charged with spiritual energy, is made manifest.

We can see this masterfully liberated spontaneity in the way the painting was carried out. Before the horizontal washes of the background were quite dry, at the exact moment when blending would be optimal and very soft, the top of the left trunk of bamboo was dropped into the half-wet background to fuse imperceptibly with it and become invisible. Then, quite magnificently, the succeeding tension of each section of stalk was added, stopping at each joint, and the luminosity and impeccable registry of this wash, done in single stroke brushwork, contributes finely to an overall sense of light. The right trunk was painted in a similar way,

somewhat more slenderly, beginning a little lower, and dragging slightly near the bottom, where its solid, unconnected terminal implants itself firmly in the rich earth by the tiny break of space just before the frame edge. The delicate stems and leaves of the left bamboo were painted in next, in a slightly darker wash than the trunk. It is in these that we can observe most clearly, as in its sister stalk on the right, the 'signature' quality of extremely spontaneous brushwork. Looping back on itself, dashing, arching, curving with dynamic springiness and fragile tensility, it is inner creative power released to bring life to the painting as nothing else could.

The artist qualifies the tone, harmony and curving grace of the left bamboo still further by accents of other, still slightly darker leaves superimposed, but as our eye falls on the right bamboo, the painting comes to its climax. Both in the upper leaves and in the playing pattern of shoots and grasses at the base, the dark drama of vivid brushwork strikes an intense contrast against the pearl grey background which is exciting and unique. Nor can we overlook the brilliant little accents at the bamboo joints on both trunks, the clean purity of the calligraphy balancing the left side of the picture. It is in the character of the dark leaves – that which is one with the character of the energy which painted them, and which for that reason gives them life – that we can experience the reality of their spirit, and in experiencing it know the spirit of reality itself, in all things and everywhere.

The source of that spirit is also implicit there. We can sense it, feel it, in the sweeping symmetry, the graceful flow of the bamboo, in the *yin-yang* integration and the harmony which is its balance, in the rush of wind and the fresh, unseen air currents bathing the leaves with poetic motion, as real here as in the nature we know so well. Resonant and alive, the fountain of life, it is harmony and Tao – it is God in beauty.

A book on the Tao of art would not be complete without the irrepressible Tao Chi, *Peach Blossoms At My Window*, (Fig. 15), the chuckling individualist much of whose work seems playful or punning on the viewer (and sometimes is), but which nevertheless had a very serious basis in his attitudes toward method and execution. Notwithstanding this, Tao Chi had a sense of humour and evidently did not take himself very seriously, as we can note by his inscription on one of his paintings of 1703: ('Tao Chi presents this to Hsiao-Weng that he may laugh at my work.'[13]

It is a serious, if happy Tao Chi that we encounter, however, in *Peach Blossoms At My Window* as he follows his 'method of no-method',[14] i.e. completely spontaneous creative painting. Done in

131

fresh, luminous colours that fairly sing with life, this painting is atypical of muted Chinese colour for the most part (but typical of Tao Chi's originality), and a monochrome reproduction permits us to study better the magical power of the artist's facility, which is replete with an effortless, startling command of performance.

Earlier we remarked on the almost miraculous ability of the Chinese painters to perform amazing feats of the brush which would seem well-nigh impossible to many artists. This quality is derived wholly from the artist's mastery of *Te*, of the creative faculty, his inner liberation and inner direction of *ch'i*, the spiritual power of creativity which can transcend and master all physical form. Directed alone by intuitive forces and their natural spiritual energy, this is more evident when we learn that this painting was executed entirely without any kind of underdrawing or preliminary sketch. The artist simply started painting at the top, and using three or four different brushes charged with colour, spontaneously painted his way down the composition. This is all very well until we consider the utter complexity of execution involved. Given the technical difficulties of watercolour, attempting to achieve a realistic work of this kind without an underlying drawing structure could very well result in disaster or nonsense. The artist has abandoned all technical controls and yet has achieved a high quality of art, in fact a masterpiece. Not only is the single stroke brushwork an accurate, flawless rendition of nature, but the space between the branches, leaves and flowers has the same unerring placement, even as they also are spontaneous judgment, creating everywhere a highly varied, natural pattern and a balanced design as well. Every flower petal is but a single stroke of the brush also, added on top of half-wet leaves and branches at the moment of maximum blend or transparency. The darker line accents at the flower centres and leaf divisions were added last, also done singly and placed with complete economy and accuracy.

The whole painting was done very quickly, and to accomplish this remarkable work in the few minutes it took – to let the turn of the brush create the shape of a leaf or a flower, and to come up with a realistic essence of natural forms in so doing – is truly a masterwork of performance. Indeed, it is far above what we call skill; it requires the utilization of true creative power, the power of the transcendent inner spirit.

Although Tao Chi lived at a comparatively late period in dynastic history, he had a far better grasp of the principles of art as they related to Taoism than many of his contemporaries. He left a body

of writings on aesthetics called the *Hua Yu Lu* (*Notes on Painting*), which were important in their influence and insights. The following are some excerpts at random:

> Thus mountains and streams and the innumerable things of the world all reveal their spirit to men.

> The first thing to be established in the sea of ink is the divine essence; then life must be brought in at the point of a brush.

> Painting may be done by anybody, but 'all-inclusive creative painting' is not done by anyone. It is not done without penetrating thought, only when the thought reaches the origin (or meaning) of things, the heart is inspired, and the painter's work can then penetrate into the very essence of the smallest things; it becomes inscrutable.[15]

A Chinese garden was often thought of as a miniature universe where one could look down on shrubs, grasses, rocks and even pebbles and see in them trees, valleys, mountains and boulders. Such a universe in microcosm is the Sung master Hsia Kuei's *Twelve Views From A Thatched Cottage*, a detail of which we see in Figure 16.

The painting is nothing, really. A mass of open space, a line of mountains, an outcropping of shoreline, a few figures in boats. But what a sublime nothing! What sheer good taste in the symmetrically 'fit' placement of these relations, what elegance and delicious restraint of brushwork, what artistry of performance! Here is pure poetry, and in that poetry the 'transmitting of the spirit', the artistic making real of an essence, that which carries its own spiritual substance and import.

The carrying out of a handscroll such as this was particularly difficult, since the scenes overlap without any definite division between them. This required that they be somehow unified and made into a continuous running whole, even as each view was self-contained and independent of the others. Hsia Kuei started this section by an undetectable blending of wash with the preceding section. This same tonality was then extended entirely across the whole surface of this view in a very wet continuation of it. As this began to dry, he watched and waited. At exactly the right moment of 'wetness' his intuition told him to drop into this base wash the slightly darker tone of the central land mass with its tree line, which

was feathered to left and right with a soft brush to blend into the background. Still wet, this same value was carried along the sweeping vitality of the shoreline, where sharper edges show a drier surface, perhaps aided in its drying by the swift stroke of a finger. Next, he returned to the centre area of the shore mass, and added darker touches – the splaying pine, the village rooftops, a few darker, soft trees, which happily blended well. Then he spread the background wash, now nearly dry, farther to the right, and upon it added the line of mountains in the same value as the primary land mass. Waiting again now, for everything to dry completely, he composed himself and then added the boats, figures, and dark little touches of water plants on the sandbar of the foreground, to the now dry silk surface. This part of the handscroll was finished.

From all this quiet inner energy came a simple morning in summer. Ferrymen in boats, carrying passengers, make their way silently across the flat stillness of a serene river. All along the disappearing shoreline toward which they move soft, thick mists drift up from the banks. They flow into a wooded line of trees and pines surrounding a small village, melt into the same mists rising from among the trees, then roll into a cavernous valley and an infinite open space beyond. In the distance the expressive spiritual form of a mountain reaches high and away, and above the mountain a flight of wild geese make their way toward a far-off goal. It is the Yangtze delta of 700 years ago, but it could be Surrey or the Mississippi of today. It is all times and all places – it is unity.

Notes

1 Siren, 69. See also Chang, 205.
2 Suzuki, vi.
3 Chang, 205.
4 Sze, 96.
5 Ibid., 103
6 Siren, 27.
7 Ibid.
8 Siren, 215, 216.
9 Ibid., 64.
10 Ibid., 26, 64.
11 Ibid., 64.
12 Cf. Siren, 76.

13 Lee, 149.
14 Siren, 183.
15 Ibid., 189, 190, 191.

Chapter IX
Spontaneity and Creative Intuition in Art and Life

If Lao Tzu were today to walk the streets of any modern city, especially in the Western world, he would not be surprised to find that the great civilizations we have built were declining in spirituality and the life-giving effects of natural creative happiness.

He would see that once more man had traded his peace of mind, creativity and inner freedom for the illusion of security. He would see that the things that moved him and directed him did not fulfill nor complete him, did not come from within himself, but instead that he was the pawn and slave of increasingly meaningless utilitarianism and dehumanized, pragmatic social formulas. Far from being free, he was rather the pawn and slave of intellectual or physical drudgery, of hapless circumstance, conventional conformity, and grossly materialistic social systems which were shaking the aesthetic foundations of those civilizations and eroding them from within.

Modern man's frantic answer to this perverse and unnatural trade-off was economic competition, a dog-eat-dog race with his brother to get free of his self-created trap. For this he needs ever more money, ever more activity, ever more exhaustion of his creative life-energy. He is on a treadmill, deluding himself that he is happy with this madness, a tired workhorse, a nervous squirrel endlessly running a circular cage, a desperate rabbit chasing a carrot he will never obtain. Lao Tzu would say that this man could only become free by returning to himself, to his own inner power, to a natural life within and without, by living only according to the dictates of his spiritual self.

Yet how to do this? How can we revitalize the stagnant social structures we have made which now have become our prison? When does society and civilization go wrong, as Lao Tzu saw it? Why are

his observations still so applicable to us today, perhaps even more so? Have we made the same mistakes as ancient Chinese civilization?

In the Western educational system we have laboured tirelessly under some originally puritanical ideas and murky misconceptions that can be traced to the formalized rise of Christianity and the mauling of that beautiful religion by the zealously heavy paws of an atrocious Church government. Man was simply an animal, a beast, a devil. All his 'base' desires, motives and spirit had to be eradicated so that the new ideal man could somehow limpingly emerge out of all this hopeless smothering and repression. He was the clay upon whom the scholars and religionists could beat without mercy, until he took a satisfactorily unnatural and unrecognizable shape. The fear of instinct, the hatred of nature, the burial of intuition was implicit here. What did mystics like St. Francis, Thomas à Kempis, and a few penniless philosophers have to say about the matter, and what chance did they have?

Yet the Church was not all to blame. We have an intellectual element which has always loathed intuitionism for its own reasons, and which has always agreed that natural man was 'a threat to navigation and good manners'. Even Plato was suspicious of poets and their intuition, although he used it to create his philosophy. Except for a handful of great lights who pop up here and there in the history of art and literature, this state of affairs lumbered along merrily, lost in the vanity of scholarly playing with words and the worship of rational consciousness, which at last proved to be a very dry religion.

And then, lo and behold, along came the Industrial Revolution and the brave new world which has been so successful at destroying every good of the old world. Along with peace and quiet, man's individual spirit was swept away, his spontaneity and creativeness destroyed as he was trained and educated to be the servant or tool of industry, the mighty godless giant which has filled the world with such ugliness on every side. In this world creativity was redundant. The machine mentality required a mass man, quite like his fellow in every way, a drone who could think in only the most mechanical and superficial way. Creativity was even dangerous – it could be a threat to the totally functional, totally practical, totally material world of production and consumption which would make millions for a few. Man was served up to Mammon, and Mammon found him delicious.

The kind of mentality which best served the industrial age was a strictly left-brain, wholly rational, verbal consciousness whose analytical, logical, objective qualities were apt fuel for the science

and technology which was the basis of that age – and its profits. The entire Western educational system was revamped to that end and aim, geared to spawning such a hugely one-sided scientific mentality. Seen in its creative and spiritual ramifications, I do not think that it is an exaggeration to say that such a system is slowly destroying the human soul. If a truly creative person emerges from the modern educational mill it is strictly by chance and his or her own individual efforts, for the whole system is oriented toward producing a very scientific, verbal, coldly analytical mind, where real creativity must struggle to exist.

This shocking imbalance becomes even more dreadful when we can observe its effects (and its vast failures) on human life and society, and I wonder how much of the psychopathic personality, the criminal mind, and our endless array of neuroses and patterns of social unrest have come from just such an educational overemphasis on left-brain specialization. Without its delicate balance in the tender-hearted intuitive spirit, the rational consciousness alone can become scientifically selfish, a stalking, unfeeling monster mostly bent on serving its own immediate superficial, childish, egoistic interests. It is not our fault if we have lost our creative intuition as a result of our unbalanced education, but it is our fault if we remain that way.

The time in which Lao Tzu lived was one of intense intellectual growth and activity, as well as one of war and violence. A sophisticated written language had emerged perhaps 1000 years before his birth which had changed the Chinese world from a simple farming economy into one of city-states which revolved around the wealth and power of an imperial family-ruling class, who provided a paternal protection. Scholars spent long years learning this language in its difficult written form, and even longer years in codifying, recording and structuring the complex rituals, laws, history and ancestral conventions upon which that world rested. Confucianism has arisen, with its strict emphasis on the perfectibility of the rational mind through prolonged studies and learning, as well as through the rigid moral conventions of filial piety. Duty, language, and the meaning of words also was the preoccupation of another branch of scholarly philosophers, the Realists. Confucianism had further aligned itself with the status quo, with the family and the structure of that society, a formidable combination, and it was against these forces that Lao Tzu stood, with his little book, probably quite alone.

It was a precise, highly structured and formal world that came into being, guarded by imperial and intellectual might, but to Lao

Tzu it was only half of life, half of reality. For in this new world of society man was becoming a regimented, formularized being, a social product rather than his own product or the product of nature. He was turning into a being that served everything except himself, every convention, every ritual, every law, every social demand, and was losing his natural character in the process. It was this that the great philosopher couldn't swallow. For where was *natural* life, where had nature gone, with its beauty and the beauty within man that made him what he was and human life so rich? Where was the way of spirit in the way of the world? There was a great disparity between the inner and outer worlds that man was making, saw Lao Tzu, and only something born in the individual soul, something called art, seemed to be holding it together. When it should be the business of people to bring those worlds together, the inner real man and the outer society, to live as one and as nature intended, it was an artificial, transient world dictating to that which was natural and eternal.

Instead of harmony and spiritual naturalness Lao Tzu now saw a world petrified into appearances and externals, a world out of touch with life and nature, a world where natural man himself was becoming extinct, superficial, unfinished, artificial, a shadow of what he could be and should be. He saw a mankind which, having lost its spiritual freedom and identity, lived in a world of illusion and conventional substitutes for being alive. He saw a harsh contrast between the beautiful wholeness possible within him and the external world that was without, as a child sees the world with pure eyes before he is taught to fear and flee. He saw reality being traded into names, into mere words – he saw the death of meaning through materialism and the loss of a whole and universal intelligence. Does not his civilization sound much like ours?

We have come very far, without a doubt. But the advent of our rational consciousness has only taken place in the last 4000 years. For countless thousands of years man did not live by such a consciousness. And he not only survived, he prospered. He lived by his wits, by his instinct, by his creativity, by his natural intuitive intelligence, happily hunting the woolly mammoth and drawing masterpieces on cave walls. Was he an animal? I think not. I think he was the same human being we are today – he was simpler and more ignorant perhaps, but he was also natural and free.

We are educated; we understand the why of things; we are not tormented by superstition nor too many fears of the unknown. The step of education was a necessary one for man, who was born to master the world. It gave new meaning to his spiritual nature; it gave

him conscious understanding; it brought him out of the cave toward a fuller and more complete intelligence. Just as the rational mind is not whole without its creative/intuitive complement, so do intuition and instinct remain unconscious and mute without their logical-verbal counterpart. Education was a further development of the human mind but it was never meant to imprison or improve on nature, which was there first. It was never meant to be anything more than the window-dressing of nature, the clerk and doorman of creativity, the lantern on the great spirituality which is our heritage. How could it be anything else without distortion, over-intensification, *imbalance*?

Education which is not directed to the whole mind – analytical *and* creative – is a dangerous failure. In our zeal for socializing man and improving his knowledge, we have been rapidly educating out of him the natural means for complete intelligence and further development. We are 'shaping' a being unknown to nature, eroding his natural spontaneity and repressing his creativity through freezing his consciousness in the rational mode, the most superficial level of intelligence. To have been satisfied with educated knowledge and reason as the balanced complement of a natural creative mentality would have been sufficient and perfect. Instead, there was an educational system created which resembled a spiritual prison, which saw that mentality as some kind of vague threat and which actually sought to minimize it or to brainwash it out of existence. To say that such a system has become unbalanced[1] and has gone much too far the other way in instilling an entirely verbal mentality is kind understatement. Priding itself on its imagined modernity (it makes a great show of exterior trappings and plastic appearances), it is in fact a system which is repressive, hideously overstructured, hidebound, and based on ignorance. The Taoists have shown us very clearly how balance is the law of life and the very roots of the flourishing human mind and psyche. What can the effect be on students when we have an unbalanced educational system which produces an unbalanced consciousness?

Now Western education has become a prestige game, losing its meaning, serving itself, forgetting its purposes, fostering in our children and college students a mind that is both ego-situated and uncreative, not to mention unspiritual. Joyce Cary and Blakeslee have both pointed out how a child's spontaneity and the free play of his or her creative intuition have already been seriously impaired[2] by age six by the lopsided verbal consciousness of that system. That truncated creativity may or may not be recovered much later in life, by sheer accident or individual struggle and sacrifice, and then only

in the most haphazard and fortuitous way. The same system points with hypocritical pride at its art teachers, but they also are its hapless product, instilling a lifeless verbal approach to art, and handicapped hopelessly by the unspoken prejudices of an administration which regards art as unimportant and makes it the least supported feature of any curriculum. It is a system seriously burdened by lack of imagination and doubtful motives, and it must be made whole if we are not to witness the eventual decline of Western civilization. Education must restore itself and get a new grip on reality; it must grow with the new intuitive and spiritual consciousness that is on mankind's horizon.

During the historical period of China there were also authorities and administrators upon whom education depended. These were the scholars, and they were of two kinds, the Confucian and the Taoist. In many ways they sound like some of our modern scholars. The Confucians occupied bureaucratic posts and busied themselves with dry scholarly learning, with examinations, the imposition of degrees and formal requirements, with the construction of a rigid social and educational structure, the protection of the status quo, and with the endless reiteration of the ideas of the past. To them education meant preservation, mummification, crystallization, the continuation of tradition. Anything else was decay and erosion, a menace to Chinese society and to the enormous prestige they enjoyed, and this included the Taoists, whose freedom and creativity they hated and feared. They did not see that such continual hardening and repetition of the past was the real decadence, could only lead to intellectual callousness, limitation and stagnation, and they forgot that the past and the traditions they revered had been brought about by pioneering creativity. Their comfortable scholarly tradition became ossified, ingrown, fearful of change. Instead of being pliant, living ready for new growth, yielding to the winds of time and change (as traditions can be), they became stiff, rocklike, and like rocks could crack and fall apart.

The Taoist scholars, on the other hand, represented the true meaning of that word. They, too, were learned, but their learning was carefully balanced by creativity and the lifelong pursuit of truth. They wrote poetry, painted, were master calligraphers and musicians, didn't confuse their rational minds and their learning with the end of education or the only kind of intelligence, practised meditation and faith, and lived out wise, creative principled, intuitive spiritual lives as well. They were the literati, Renaissance men in every sense of the word, well-rounded gentlemen of refinement and character, in touch with life and the real world and

fulfilled in their intellectual and spiritual development.

It is amazing how like the Confucians our modern scholars seem to have become, but it is distressing to characterize our higher education, as Blakeslee has done, as decadent. Yet the shoe seems to fit:

> There is a decadence in the field of higher education that is the natural result of an ignorance of the 'unconscious' side of the brain, a sort of academic dream world has been created in which purely left-brain thinkers admire each other's 'scholariness'.[3]

It has been said that the scholar's purpose is the advancement of knowledge. Does knowledge consist only of the perpetual inspection of what has already been done, or is it an ever new, ever growing potential to know what is yet unknown? How strange it is, then, that there are scholars, and they are legion, who will accept no new idea, who are little interested in the advancement of knowledge and far more interested in the advancement of their careers and the good opinion of their colleagues, who pathetically regard reams of footnotes and prestige credentials as paths to divinity and omniscience, and whose closed minds are literally impeding the course of that knowledge they purport to advance. Unable to see beyond the narrowly analytical box in which their overbalanced verbal education has placed them, they know only the sleepy reproduction of the creativeness of an established past, only criticism and pretentious jargon, never progress, never fresh insight. Where there is so much repression and structure, where is there room for creativity? It is no coincidence that nothing new, no innovation, no creative or groundbreaking discovery ever proceeds from our scholarly world, or that no one reads scholarly books, not even scholars. For it is a world that has suppressed its own creative vitality through its own methods, has become divorced from life, perhaps even from its integrity. It is a world where many of our finest minds must languish in a kind of sick regimentation, watching their creative powers decline because they are ignored or muzzled.

Yet education is not all of life. Our lives are always in our own hands, for better or worse. We live inside ourselves, in our minds, and we can overcome the deficits of a verbal education. Human intuition, with its wonderful creativity and spiritually powered energy, can never be entirely destroyed. It slumbers within, waiting to be awakened.

We have observed throughout this book the many ways creative intuition can become real in our lives. Meditation is the first and

best key to it, since meditation promotes its growth, vitality and further development. We also need to more extensively study the inner lives of great artists beyond the biographical facts, the history of art as well as its meaning, and actively participate in art and art forms, whether as practitioners or as an interested, involved and receptive audience, for from art we can absorb the tone and feeling of intuition, in addition to the free spontaneity which gives rise to it. In art too, we can encounter spiritual consciousness in the forms of essence, meaning, harmony and spiritual vibrations, all of which make the inner self more receptive and educated in spirit and truth and which quicken our creative readiness and integrity.

We need, desperately, to catch up with the spiritual levels of the Eastern world. There is no study so worthy as that of those Eastern philosophies, such as Taoism and Zen, who have for so long before us been on intimate terms with spiritual reality. Their understanding of the import of a non-verbal consciousness permeates every aspect of their society because they have accepted it as not only important but as central to life.

In the West we tend to doubt we have such a consciousness.[4] In so doing we have placed serious strictures on our spiritual, intellectual and emotional growth. Perhaps we will take more notice of the intuitive faculty when we realize it represents the foundation of our real being and the voice of spirituality, perhaps not. Perhaps we will flee from it out of mental laziness and egotism, but like the Appointment in Samarra, we can't flee from ourselves.

Our verbal intellect resists, opposes the very modes of spirituality and naturalness which could bring us more happiness and fulfillment and take us to greater heights. Modification, moderation of our thinking, our ways of living are becoming more and more incumbent upon us as narcissism, violence and greed continue to dominate Western society. We need to learn the techniques of non-verbal thinking and the reduction of conscious verbal thought to a minimum so that our creative intuition can awaken and become a real part of our lives. We can renew the spiritual beauty and reverence of ceremony and ritual, revitalize feeling through being in touch with our bodies and inner selves, approach craft and profession with a new integrity, discipline and diligence until our Tao takes over and is no longer directed by limited conscious thought, but by the spirit and its creative and intellectual perfection. How wonderful the world could become if all of us reached for higher spirituality, and how changed it would be!

The intellect is largely an artificial, acquired consciousness that inhibits the creative process by its own habit and superficiality.[5]

143

Only intuition can liberate man from this jailhouse of artifice. We have to learn to suspend logic, to trust the inexplicable, to break past the obvious and the accepted, to transcend habitual form in every way, to push consciousness to farther limits. If people did not live in the illusion of distinctions and a separate ego consciousness no integration would be necessary, for the world and the individual would be one. There would be no Way, only natural, spiritually harmonious life. But a Way of life became necessary for us when we distanced ourselves from spirit[6] and the natural purity of life, when we believed that our verbal consciousness was all that we are.

We have determined also how intellect and intuition reflect the *yin-yang* polarities of nature, and of how the creative action and harmonization of spirit bring their completion to pass. One of our greatest scholars and rational philosophers has described that opposition and its saving resolution in excellent terms that amount to a scientific endorsement of all the Taoists tell us:

Consciousness, in man, is pre-eminently intellect. It might have been, it ought, so it seems, to have been also intuition. Intuition and intellect represent two opposite directions of the work of consciousness: intuition goes in the very direction of life, intellect goes in the inverse direction, and thus finds itself naturally in accordance with the movement of matter. A complete and perfect humanity would be that in which these two forms of conscious activity should attain their full development.[7]

In the humanity of which we are a part, intuition is, in fact, almost completely sacrificed to intellect. It seems that to conquer matter and to reconquer its own self, consciousness has had to exhaust the best part of its own power. This conquest, in the particular conditions in which it is accomplished, has required that consciousness should adapt itself to the habits of matter and concentrate all its attention on them, in fact determine itself more especially as intellect. Intuition is there, however, but vague and above all discontinuous. It is a lamp almost extinguished, which only glimmers now and then, for a few moments at most. But it glimmers wherever a vital interest is at stake. On our personality, on our liberty, on the place we occupy in the whole of nature, on our origin and perhaps also on our destiny, it throws a light feeble and vacillating, but which none the less pierces the darkness of the night in which the intellect leaves us.[8]

In art intuition is, however, much more than 'a light feeble and

vacillating'. There it is alive and vital as nature and God intended, manifesting as the mediator between the universal consciousness of the spiritual dimension and the intellectual rational mind. By learning to still the heart and mind, the artist is defined as 'shedding the thoughts and emotions of his personal life'.[9] This is one key to intuition, and we can do the same. Following the artist's lead in this and other methods, we can achieve the same creative levels, and can apply it wherever we choose, for it is undifferentiated.

Our creative energy *is* art when we transcend technique and intellectual deliberation. Creative intuition comes from mental stillness first of all, and out of such inner consolidation and unity arises of itself. Intuition is that which breaks into conscious thought or comes about spontaneously in tranquillity. When this occurs the artist's hand and brush reflect the very power of the spiritual world (*ch'i*), and such expression is not merely his, but rather the reflected expression and power of the heavenly and cosmic harmony of the Tao.[10]

Translated into life, into the life of the non-artist, there are the parallels and examples of the Zen, Taoist and even Christian mystic monks, who lived out their creativeness in a living meditation, in their every act and work, through the same practice of inner silence. Body and mind blended into such harmonious oneness are already spiritually integrated, practising creativity, and on the way to further growth. Chuang Tzu thought of the artist's special consciousness as he works or prepares to work not as indifference or even detachment so much as spontaneous liberation, i.e. an impartial quality in addressing things and an open naturalness in response to them.[11] Above all, artists learn to trust their feelings and to obey their intuition, which is never a reasoned or calculated response, but rather habitually intuitive. Since intelligence is not verbal, it is possible to live in a wholly spontaneous consciousness without any loss of mental acuity, and is in fact more creative and natural. Moreover, intuition can guide our lives better than reason.

The mind, once in touch with essence, never forgets to measure all things by it. This is why the term 'mysterious fitness' or 'eternal fitness' came into use among the Taoist artists. A reflection of essence is also a reflection of its spiritual unity, both for the painter and the perfect person.[12] Such measurement, by reflection, by innate knowing and not by deduction, comes to be the highest form of right action and the perfection of art. Illumination depends upon freedom from attachment as well as preconception. It is a natural response to things without anticipation, a part of spontaneity.

We could even say that the spontaneity of the brush leads and

inspires the painter as much as *his* spontaneity liberates the brush. When man and brush become one mysterious things happen, great creativity takes over without explanation. Whether we unify ourselves within, or unify or identify with our materials or forms of expression, the same natural harmony and creative miracle takes place, and it is new, ever growing, ever unlimited. Regardless if this happens through repetitive practice or through effortless mastery the results are the same – in some way the universality of intuition has gained ascendancy over the limited vision and conscious control of the intellect, which it then liberates and fills with its spontaneous flow and natural creative freedom. Matter is transcended and vivified in the natural realm just as it is in the cosmic realm. Trying to do this ourselves through willpower, through forcing or straining comes to nothing – The Way must be followed on its own terms, and these are the terms of nature.

Intuition is thought of as difficult and elusive to identify, and this shows how completely out of touch we are with this very natural faculty. If we were more natural, and had more integrity, it should be as easy to identify the voice of the inner self as we do the voice of a friend. Since the experience is individual, each individual must learn to make this identification in his own way, but there are indications that a system is possible. The least we can do at the outset is to put nothing in its way, to not fight it with analytical thought, to be receptive, to be still within and open our hearts to spiritual life, for without that we shall never have intuition.

We can clearly narrow it down much more than we have done, sketch broad outlines and compare experiences. We may never have a precise science of intuition, nor should we seek one, for it is an art, and that would be attempting to limit and constrain its nature, which is impossible, and would be self-defeating, which is a waste of time. Its effectiveness depends on the fact that it is the spiritual complement of the material side of the mind and so is its integrator and harmonizer, the completion of the whole intelligence, which is indeed an illimitable spiritual factor, a first principle. In meditation we will discover that there are no verbal terms or conceptions for the spiritual world possible – so it is with intuition. It involves being and knowing, not defining, and we simply experience it, *know* it as surely as we know ourselves.

Once known, we can become familiar with its movements, learn to be alert to its ways and indications, and can test it rationally to our intellect's content, which the latter will hasten to do. The beautiful thing about an intuitive insight, however, is that it convinces intellect immediately and fully by virtue of its power,

authority and conclusiveness. Intuition is that which supervenes conscious thought or arises of itself, spontaneously, just as a tree grows the way it will, as a flower blossoms or as a child is born at the moment of readiness. It is an act of nature and its spiritual flow of creative transformation. We do not need to identify it so much as to be ready for it and willing to listen, for it makes itself known, but only once. It will never insist or repeat itself.

Just as nature is spontaneous, beyond intellection and inexplicable in its coming, so then is spontaneity a primary characteristic of intuition. Because it is, we can be more alert to its appearance through noticing spontaneous ideas, and through a serene, receptive mind. The Taoists clearly believed that naturalness was a predisposition to the spontaneity of creative intuition. What is a 'natural' frame of mind? Obviously this refers to the state of nature or tranquil emptiness, rather than artificial verbal fullness and busyness. Again this indicates a predisposition which is without inner manipulation or contrivance, one unaffected also by external pressures, repressions, stimuli or influence, one self-directed and arising totally from within, free of all self-interest and inhibition. In less complex guidelines it delivers us once more to the calm mind and the unaffected simplicity of all we know as being perfectly natural and at ease. So naturalness prepares the ground for intuition, and this makes sense because intuition is the most natural part of the mind.

Of course, we know the classical definitions of intuition, which are essentially its effects: it is the direct apprehension of knowledge, accompanied by an ineffable sense of rightness, of conviction; the attainment of such direct cognition takes place without any kind of inferential thinking or rational reasoning; and it is an instant insight into the inner meaning of things. The Christian mystics called this power of intuitive penetration 'the discernment of spirits'. Certainly profound depth of discernment is characteristic of true intuitive insight, and what is discerned is the essence of things, their spirit. It confers, quite naturally but quite mysteriously, the ability to see into things, situations and problems, and gives uncanny accuracy in reading the motives and character of people and ideas. It is this kind of spiritual discernment which is so important in art, for on the artists' talent for revealing the essence of their subject depends the success of their work. Well may we be impressed with this, our most natural of gifts, one which belongs to all of us, and well advised are we to regain touch with it. For in intuition lies not only the answer to creativeness, to fulfilled intelligence and spirituality, but also the largely unused potential for the mastery of material life and forms of

spiritual power as yet undreamed.

In learning ways to be sensitive to intuition I can only speak from my own experience and perhaps the experience of other artists. Spontaneity and receptivity are vitally important, in every way already noted, as well as the cultivable ability to recognize a spontaneous idea. To be aware of higher levels of feeling, and to understand their difference from ordinary emotion also implies that not every impulse is to be acted upon, nor that self-discipline is not necessary. On the contrary, the voluntary mental stillness and the physical moderation of *wu wei* are essential to the fertile ground which makes the spontaneous action of intuition more possible. Balance is always essential, in both thought and action. This can be thought of as a form of mental and physical restraint, a waiting on the moment of certainty. So spontaneity does not necessarily involve swimming nude in the moonlight (although that is not precluded on occasion), so much as cultivating a masterful poise and calm, where intuition can arise and effectively direct the life and life situations. And this is not regimen but liberation – inner peace is pleasurable, and a spontaneous awareness comes to know rather free currents of deep energy which seem to arise out of nowhere to refresh and brighten the mind with a delicious freedom and naturalness.

These can only come without forcing, but I believe that spontaneous intuitive flow can be nurtured, or at least prepared for. One of the ways to do this is first of all through calming the mind and reducing conscious thought to a minimum, and second through some kind of ritual, some means of activating the intuitive, creative centres of body and mind. I have a habit of writing first drafts in longhand, and to start the day's creative flow going I merely copy over the last page I wrote. The poet Maya Angelou follows a similar practice, as she recently remarked during a television interview. Siren makes mention of Chinese painters who lit incense on both sides of their worktable, or cleaned it meticulously and reverently before beginning work, as though preparing for an honoured guest. An artist I know simply doodles before starting work, letting his hand move freely in endless circular rhythms with a pencil on paper. Eugen Herrigel 'danced' his archery preparation with elaborate ritual movements before the actual practice ensued. We are physical vehicles of spirit, with an intimate relationship between mind and body, and ritual may be an important way to connect the physical body with the spiritual mind – or the rational mind with intuition.

Furthermore, all of these little rituals seem to indicate that physical acts of form and rhythm can set the mind working in the intuitive mode and the creative disposition. And is not the practice

of form and rhythm the practice of art? Above all, the idea of flow, and not deliberation and inhibitory caution, confirms the Taoist idea of *ch'i* – the perpetual stream of spiritual energy which activates, creates, and recreates all of life. This energy is internal and quiescent until activated, and once expended, in human beings needs renewal. In tapping this life-giving spiritual dynamo we are flowing with it and are empowered by it. What we call intuition is its effect, and this is why intuition is creative inner energy brought into concentration and pinpoint focus.

The kind of environment in which we work or live has an important bearing on intuition. We can't be natural or free or even normal without a large helping of privacy and solitude where our spiritual energy can rebuild. Solitude, being with ourselves and learning to know ourselves within, getting acquainted with our inner rhythms and deepest consciousness is vital to intuitive sensitivity and mental and spiritual health, yet there are people who flee from it as from the plague. New growth, new stages of development, new things grow quietly within us directly through intuition, and need a quiet time of being alone to ripen and mature. Spiritual reception takes time, unhurriedness, freedom from interruption by the exterior world. When we become spiritually advanced we want to flee to solitude, rather than from it. The creative process, the waiting on intuitive enlightenment requires reverent nurturing, unpressured freedom, *gestation*.[13] Nature is in no hurry – why should we be? Nature is *easy*, sure of herself and what she is about, cultivating life with quiet power and gentle renewal. The birthing of a work of art or the birthing of a soul is just that – birthing. It has all the time of eternity and will not be rushed or produced in clumsy panic. We can *feel* our inner lives, learn to flow with our leisurely natural forces, put away our work when interrupted by the world, return to it when the time is free and rich and not activity-filled, so that we may re-find our intuition and ourselves more easily. We must learn to pace ourselves, to rest, to let our spiritual energy restore itself from within, to be less busy. In repose the soul grows stronger, clearer, more easily heard.

Feelings seem to be a way we characterize intuition, but such feelings are not necessarily *emotions*. They are rather the apperception of essences which have a particular feel or weight to the mind. We can *feel* the nature or texture of something without an accompanying emotion. Emotion is such a dramatic, regurgitative kind of thing. Emotion refers to teary or violent extremes of outrage or passion, to unrest, fear, anger, frustration, jealousy, all those excesses to which a vulnerable physical organism is subject – a

reaction to pain or pleasure, surely, but this is not aesthetic or spiritual feeling. If the spiritual nature is in command such emotion is quickly transcended by sensitivity to the higher octaves of feeling and the nuances of meaning, and the emotions that move us then are sublime and spiritually beautiful and we are moved because they are so.

The positive discharge of the psyche is toward the spiritual or the aesthetic; the negative discharge is toward the possessive or material. The negative side of energy is its backflow – what is left after immoderation or exhaustion, and is not the natural condition. The word 'feelings' describes the perception of spiritual vibrations, the echoes and reverberations of essences which appear everywhere in human life and the universe. Feeling also defines the experience of a harmonious consonance in relation to a particular problem, in its resolution or in part of it, and intuitive perception is this kind of felt harmony, a release from limitation, and so is viewed or felt as enlightenment.

When I am beset by too many cares and desires, when I permit external conditions to rob me of peace, it is because my mind is not calm. When that happens not I, but the world is in control of my life, and instead of being the director of my life I am being directed by it. Externals have no power of themselves to affect me except as I acquiesce to them, as I want something in relation to them, or as I let them, but my love of freedom tells me to defy my passions and to keep my self-command. A mind habitually calm, habitually composed, will be a mind empowered and in control of itself and every life situation as it arises. As it masters and controls itself, it seeks less to control others. Such mind control is necessary if we want to have ordered, peaceful lives and the spiritual help of intuition. For that mind will be exactly as the Taoists tell us – the mirror of Tao, the reflection of Universal Mind, which only acts out of its own still centre, out of its own harmonic power. It is the calm mind which has intuition and which is intuitive; it is the calm mind which directs life, for in its full intuitional creativeness it will only act as perfectly as nature acts, and even as God would have in the same situation:

All that matters to a Taoist is that one is in harmony with nature. In one's character, one is like Heaven and Earth, as bright as the sun and the moon, as orderly as the four seasons.

When one has attained Tao, one can even precede Heaven, but

Heaven will not act in opposition, for one will act only as Heaven would have at the time.[14]

Intuitive ideas can be recognized by a self-evident quality and an appropriate identification with the subject's essence. Typically non-verbal, such insight seems like a dawning, a flash of light, and leads to the opening of new vistas of thought. We need not be concerned with connectedness, for reason will automatically make the necessary continuity and confirmation. Response is so important. An intuitive idea, once lost, seldom returns – spirit doesn't choose to be ignored. We can pay attention to our perceptions more closely and even our bodily movements. Sometimes a physical reaction, however slight – a hand already on the way to writing or painting an idea – may be the intuitive process taking over in reflex, even before our awareness. Such reactions should not be checked, it goes without saying. Go with your feelings, have a little fun with them, don't resist the inexplicable, see what happens or what will happen next. Questioning of intuitions and doubting their valid existence or presence leads only to their loss and the pain of indecision and confusion. Trusting intuition and all it means is the best way to receive more of it. If we can't help it arrive the least we can do is not stand in its way. An intuitive idea has the same sure and steady satisfaction to it of an arrow perfectly hitting its mark, an elegance, a symmetry. It is never disquieting, anxiety-provoking or nonsensical, and such negatives are sure indications of straying from it. Intuition is gentle, never violent, defends only when attacked, and only then when there is no other choice. Intuition is peaceful, tender, understanding, tranquil. Intuition is honest, truthful, meaningful. Finally, intuition is harmony and balance, the union of God and man, the reflection of the universe in human character. Intuition is light.

The rational mind discriminates because it operates in the realm of the externalized senses. It sees itself as a separate entity in this sensual relation, and so tends to be attached to external objects out of the habit of its own material consciousness. Such habit force is limiting to the Universal Intelligence upon which intuition depends and which is its cause. This opposition is resolved because the intuitive mind acts as a contact between Universal Intelligence and the personal rational consciousness, and has relations with both.[15] The intuitive mind, in this way, unites spiritual intelligence with the discriminating rational mind, breaks its attachment to sense perception and objective phenomena and restores its balance, its

151

harmony with universal reality and the spiritual dimension.

Intuition depends directly on the Universal Intelligence but does not give concrete or verbal information; rather, it gives something of far more value which can be translated into any expressive form – direct identification with essence. This is self-realization through identificatory unity with the nature of things and their meaning, and in reinforcing being, makes unrestricted perception and enlightment possible. Intuition is therefore man's most superior faculty of perception, but it appears only when the personal life, with its endless speculative thoughts and stimuli-induced impressions, has been silenced.[16]

Chuang Tzu and others saw also the essence of the human mind is identical with Universal Mind, with the Tao.[17] The person who finds their Tao brings everything to fruition through internal energy, with minimal mental activity and effort, by knowing their proper natures and the Way of their being and essence, their right principle, the intuition of their 'fitness' by which all creative action takes place. This is the true self realized and fulfilled, because in acting in harmony with the essence of mind which is Universal Intelligence, with the *source* of all essence, the mind can *know* all essence.

Some of the marvellous creativity of concentrated spontaneity and the magical, lyric beauty it gives in art can be seen in a section of a handscroll by Hsu Wei of the Ming dynasty, *Bamboo and Flowers*, (Fig. 17).

Delightfully fresh, dynamically balanced, this painting could be the work of one of our contemporary watercolourists, so modern is it in style and execution. More than is usually evident in Chinese painting, Hsu Wei shows a deep feeling for light and shade, for the turning and contours of natural cylindrical forms, for the play of patterns of light over and through the bamboo leaves. Done in an effortless, wet, loose, spontaneous manner, the free spontaneity of the brush is altogether masterful. It has expressed and captured the essence of the two main trunk stalks, leaf shapes and patterns so successfully that their spirit and character are there in all their living vitality in a way that a more thought out rendition never could convey.

Here is the very soul of spontaneity. The inner spirit and intuition of the artist are what moved the brush, without a thought, without verbalisms, as he unified himself with the subject, as he became one with Tao and with nature, and as the internal creative energy surged through his being to transcend form, time and space. At that moment creative energy became art, was art, and from it came the

reflection of spirit which is creative power. It is the same power which can always be fulfilled and utilized in every human intuition. It is fitting that as we near the close of this book, we end as we began, with our good friend Wu Chen, the master of spontaneity. In his little *Bamboo*, (Fig. 18), there is a finality, an elegant and crowning symmetry of all that Chinese art signifies.

Strong, upthrusting, a small clump of young bamboo springs to life from the earth between a cleft of rock formation, the curving grace of its stalks, shoots and leaves filled with life energy and the vital life spirit, the dynamic vitality which is *ch'i yun*. Studying this painting, there is an actual optical vibration felt in the eyes – spirit resonance – which is the visual counterpart of a fluttering vibration sometimes seen in the mind's eye during meditation, the infusion of spiritual energy, of spiritual realization.

Wu Chen was happy when he painted this picture, gloriously free, one with nature and the universe, knowing that he was the master of his brush and reality, the master of spiritual art. The ink was right, spring was in the air, the single big bamboo brush in his hand felt strong and good in its heft and as it dragged the paper tooth. The bold, swinging strokes following their own inner rhythm, the breaks of the leaf strokes in powerful suggestion, the confident command of the bamboo joints, the slashing forms of the leaves, their eternal flow and truth to nature and their deep, harmonious mystery against the rich and meaningful open space upon which they lie – all are created by the spirit of the brush, which has become one with the spirit of the artist.

And in the work we feel the inner life of nature and the spirit of reality as it becomes unified with our own spiritual reality within, and we are fulfilled and replenished by it. And this is the Tao of art.

Notes

1 Blakeslee, 74.
2 Ibid.
3 Ibid., 56.
4 Ibid., 72, 74.
5 Chang, 107, 108.
6 Deng, Introduction, xviii, xix.
7 Bergson, 291.
8 Ibid., 291, 292.
9 Sze, 96.

10 Ibid., 104.
11 Waley, 196. Siren, 51.
12 Siren, 28.
13 Rilke, Rainer Maria. *Letters To A Young Poet,* Translated by Stephen
 Spender, New York: Random House, 1984, 23.
14 Deng, 232.
15 Siren, 98.
16 Ibid.
17 Cf. Siren, 98, 99.

Chapter X
Toward a Universal Philosophy

Humanity now stands at the doorway of a vast new spiritual consciousness and forms of spiritual power which will be far in advance of anything we have ever conceived possible. Already a new spiritual awakening, a new need is evident and spreading among all the peoples of the world, and this is only the beginning. The work and achievement of the future will be to take human mental and spiritual development farther than it has ever been, indeed, perhaps to the uttermost limits of consciousness, intelligence and spirituality. It will rise above every religious and intellectual level of the past, introduce a new and amazing turning point in history, and mark the epoch in human progress when man came into his own as a perfect spiritual being, the master of the physical world.

This spiritual rebirth is already in progress, and it can mean peace and fulfillment for mankind as never before. Yet the work required may be herculean, the changes staggering. To do it, these creative changes must come first through enlightened individuals and spiritual masters whose leadership will in turn influence every world institution toward universal spirituality and an incorruptible integrity, unity and harmony. This will not foster a theocracy nor any form of church or political government, but will generate a worldwide agreement in kind based on certain knowledge of the fundamental principles of life. It will be a universal philosophy, with which all men, seeing its truth and unavoidable reality, will be in accord.

Because we have machines, because we have technology, because we ride about in automobiles and aircraft does not mean that we have yet mastered ourselves or the physical world. Yet there are those, the materialists, who still delude themselves that possessing things is living, that our civilizations are perfect merely because they are oiled. They are far from perfect. Our institutions are collapsing, our religions venal, our governments irrational, our science

dehumanizing, our plodding education unenlightened, our commerce debasing. We can look to our youth – they who are so close to freshness and the clear sources of life – and see the plain truth of our failure as they try to escape from a disappointing, meaningless and ugly, unnatural life through drugs and senseless rebellion. What is needed is what is now arising – an acceptance of the reality of more profound values and a new understanding of what they are.

A universal philosophy of life would inevitably result in a new and deeper faith in God and His Creative Intelligence and could well transform the religions of the world as they are presently known. A universal religion may someday evolve – a single world religion for all peoples – and this would be one based on direct knowledge of the spiritual laws of the universe and immediate communication with the Universal Mind through increased mastery of intuition and other spiritual powers. Our ability to use this now barely realized creative power can be multiplied one hundredfold, can be developed into an art, the highest art ever known, as the mind of man becomes one with the mind of God in more and more advanced ways.

We are at present as those who wander in the dark night of a moonless landscape, weary of the past, uncertain of the future, groping, seeking knowledge of higher forms of life and a higher consciousness without knowing what it is for which we search. But we *will* know. New scientific breakthroughs in physics and elsewhere will endorse the reality of spiritual laws and the presence of Higher Intelligence in the cosmos. And new guides, new spiritual leaders will come to us in increasing numbers, men and women advanced in spirituality and the Way, who will have discovered spiritual wisdom and light and the use of remarkable spiritual powers, and who will lead us to know as they know. These directions will eventually integrate all knowledge, through explicating the fundamental laws, physical and spiritual, of the universe, of nature, reality and spiritual life, and will teach us how to use those same powers for spiritual and human betterment. And the philosophy which evolves out of this totality will be one of the natural universe, of the way of God in nature, and of the utilization by man of its spiritual power and reality.

We have observed repeatedly the striking similarity of Taoist insights to other, unrelated areas of human thought and to the fundamental principles of reality as they have been observed by artists, mystics, scientists, philosophers and other thinkers. We have seen the pragmatic outcome of these insights, their universal, effective applicability to human life, the unlimited potential for mental and creative growth they offer. These many correspondences,

points of phenomenal agreement and confirmation, their dove-
tailing with other disciplines, experiences and ideas, elicit a
consistency too cogent and too extensive to be ignored. They agree
with physics and the natural sciences, with observation, with the
phenomena of the natural world as we know them. They agree with
the most advanced studies of psychology and the nature of the mind,
with the spiritual enlightenment of many religions and philosophies,
and finally with aesthetics, art, the nature of creativity and the
expressions of these as ultimate proof of validity. All of this adds up
to an astonishing cohesiveness, even as it contains the embryo of a
fundamentally sweeping revelation of the major principles of life.
We most surely could not, in good sense or conscience, ever consider
so many universal correspondences to be accidental or coincidence,
nor should we dismiss them lightly except to our own very great
peril. For there is in them the possibility of a grand synthesis, the
foundation of a new future for mankind.

What would be the result of such a synthesis? Perhaps a universal
philosophy, one that would unify and integrate all the peoples and
nations of the world under a single banner, an all-encompassing
form of knowledge based on spiritual laws and the promotion of
human creativity and fulfillment in every spiritual and material
form.

Why do we need such a philosophy? Perhaps we don't. The petty,
warring factions of nations, societies and individuals may tire
themselves out; our religions may stop sneering at each other; our
education may cease to reinforce an artificial, selfish mind; our
science may find a path to religion; our commerce may learn it can't
exploit humanity and rape the environment for the sake of money;
our governments may replace hypocrisy and self-interest with
integrity; our individuals may stop destroying their spiritual
character through drugs and materialism – *maybe*, and maybe not.
Moreover, even if millions of individuals the world over began to
follow a spiritual way of life *now* it could make no difference to the
proliferating corruption, stagnation and decline of our civilization
for hundreds of years. No doubt about it – we need to integrate all
our institutions and all of our spiritual life under a single workable
philosophy of life which, if it is not the entire direction for humanity
and its future, will at least point the way toward it with the unerring
accuracy of first principles.

To begin to actualize our spiritual and creative progress we need
to learn to live naturally again and to develop a unified base for
human growth and happiness. And for further individual
development we need something to learn from, a standard. Well,

someone may argue, we already have numerous standards. Yes, numerous indeed, and they are clamouring for attention from every quarter of the world, like hundreds of people shouting in a stadium with none hearing anything. Our so-called unity in diversity is nothing more than hit-or-miss pandemonium, a chaos of conflicting world elements and values without any internal order or any recognition of the factors which could make them one. What we need most of all are universal *spiritual* values on which we can rely, which we know to be true and enduring. Such a world philosophy of life can definitely come about in the future and usher in the new age consciousness. We can move toward it now, today. There can be a joining of East and West, a synthesis of the best in every religion and philosophy, and this can and should incorporate the spiritual miracle of creativity as the single most important department of human life, and be guided and guarded by spiritual leaders, by science, and by nature.

We need to learn the important truth that aesthetic meaning is the symbolic counterpart of spiritual reality, and that it constitutes the deepest inspiration and drive of the human mind and spirit. Modern Western civilization has imprisoned this spirit by surrounding it with an entirely functional, ugly, unnatural way of life, and by debarring man from nature and *his* nature, his own creative ability, expression and self-realization. Expecting society to fulfill man, we express offended disdain that it has not done so, and even more distaste that man keeps trying to break out of the obnoxious boxes in which society tries to lock him. It is not surprising the Taoists were disappointed in civilization because of its penchant for altering and corrupting creative human energies and putting nothing of natural value in their place, thereby interrupting and perverting the natural harmony and natural developmental process that could lead to the spiritual integration, mental growth and creative fulfillment of the individual.

The societies we have made have issued in large part from reason and our fascination with rational development. This is but half of what we can do, and the world of the future must be built by the whole mind and by the utilization of intuitive creative power. Since creativity comes directly from the spiritual 'Real Self', it is that part in human beings which is most expressive of their basic being and existence. For this reason it is the voice or action of true identity and the real person, as opposed to the individual as a social cog or social unit. Still, our one-sided societies persist as if this were not so, as if human life were identical with its social form or owed its origin to it, as if the individual was part of a dumb mass which must be

comfortable and mass-directed. This is the very antithesis of creativity and the failure of society, and our social systems, to recognize the inner reality of its own life. This strange dilemma must surely seem irrational to the perceptive onlooker, but it merely points out the monolithic clanking of fixed, stagnant social forms and institutions and their typical unwillingness to accept change and to adapt to the nature of human life. Instead, they expect the opposite. Even so, this defect is at the bottom of much of our social unrest, which tends to be cylical as the creative energies of humanity break forth to throw off the bonds that contain and repress them. Far better it would be, as the Taoists suggest, to work with nature rather than against it, to adapt society to the human spirit rather than trying to nail it into a social coffin.

The reality of human life is surely not in the form or social function of people – it is in their inner, individual selves, their souls. Through the illusion (or delusion) of expediency, which is a perverse way of equating wealth or mass conformity with power and order, the real creative potential of society is literally turned against it, being fed up to an obsessive *learned* materialism which has no meaning whatever in terms of spiritual progress. Frightened of nature, weakened by luxury, taught to compete with his brother and accept the state as his saviour, smothering his inner self and creative freedom, modern man still sometimes finds his soul, but many do not, and this is the great tragedy and crisis of our totally technological age and all it has brought us to. Lao Tzu would have thought these corruptions and dismal confusions to be typical, for he believed that civilizational failure was the natural consequence of unnatural and anti-spiritual living. He wanted something better, and loving nature, he finally came to discover that the natural Way, the road of a single human being toward God, was the final power in human affairs, and were all men but to use that power the world would be a vastly different place.

Society, however, is not all to blame for man's attraction for possessing things. Materialism finds ready ground in the ego and the curious propensity of the rational mind for feathering its own nest. Conventional pressure and artificial survival anxieties are also at work here, but more importantly the misdirection of creative energy and the warping of spiritual perception. It is typical of the rational mind to exert itself toward outer physical form, for it is the physical world that it deals with, but when that mind becomes obsessed with externals, and blind to their spirit, material things tend to become an extension of the ego, adding to an illusory consciousness. As such, they reinforce a half-developed psyche and separate it further from

the reality of ourselves and the reality of the natural world. The repression and frustration of the spiritual/creative nature are also instrumental in obsessive materialism, for the latter provides a false, substitute satisfaction and gives the self-deluding illusion of valid creativity. Conditioned toward form, superficial appearances and physical action as substitutes for creativity, the rational mind stubbornly seeks tangible evidence of its importance, and so preoccupies itself with material toys and the illusions of progress, even as it is informed by instinct and intuition that they are meaningless in spiritual terms and constitute no evidence of inner worth.

The upper side of materialism is sensuality, even though it is also based on illusion. This involves a ready tendency to fix on sensual or aesthetic pleasure as the equivalent of aesthetic meaning. This can deteriorate into the seeking of pleasure for its own sake, for the physical exaltation it provides, and is therefore a negative or lower aspect of what may be at least a spiritual insight to begin with. The sense of the beautiful is but a lamp to lead us to the realization of spirit. It is associated with pleasure because the experience of spirit is a joyful one. To equate all pleasure with the beautiful, however, is misleading, for only those pleasures which are associated with nature or essence can ever be beautiful in the spiritual sense. As sensate beings the whole physical world is open to us as potential spiritual experience and spiritual growth, through joy and every other form of happiness. It is only when we forget that beauty is what is given to us of the spiritual world so that we may know it, and that the beautiful is but the radiance of a greater reality, that we may fall into the imbalance of sensuality and hence lose our spiritual autonomy. Aesthetic perception is a way we have of understanding spiritual reality, but in order to grow strong in spirit we should not mistake spirit in its material manifestation, which is transient and changing, for its reality, which is eternal and enduring.

Even a slight perception of the beauty of spiritual reality can elicit the passion for its repetition, so wonderful is that world. Life sometimes involves passion because we can espy in some material forms a similarity to the aesthetic found in spiritual essence, hurling us with spiritual desire to become one with it. The man or woman we love and are attracted to draw us to them out of such a magnetism, out of the spiritual essence inherent in their physical form, which again is but the reflection of an inner beauty of spirit. This fervour for beauty is natural, for its hint of the sublime perfection of the spiritual dimension found in human form can inspire us, exalt us. It can lift us to sheer poetry of being, to true

creativity and self-realization in its higher spiritual form, or can equally exalt us to sexual ecstasy in its lower physical form. It has been said with surprising perspicacity that if God can't reach us through spirit He will settle for reaching us through sex, and sex in its highest form of love can be spiritual. The relationship between the physical, mental and spiritual is profound and far-reaching, affecting us unconsciously and working changes of development that we still know little about.

Nevertheless, to attain the higher levels of spirituality the inner self must be in command and free, not forever lured by the senses toward physical attachment, even when those senses admit the beauty of spiritual perfection. The danger of excessive materialism or sensuality is always of an imbalance of consciousness through a shallow, all-consuming orientation toward external objects which will abnormally intensify concentration on form, reinforce the artificial ego consciousness and ultimately, through such imbalance, smother creativity and the further spiritual and mental growth possible through intuition and an expanding spiritual awareness.

If the Taoists have set anything down clearly before us it is that man is inseparable from nature and his own fundamental nature. A glaring error of Western civilization seems to have been in separating spiritual life from its presence in nature, somehow inculcating a vast divisiveness of consciousness which causes us to war against ourselves and each other. A philosophy of nature and natural life does not corrupt spirituality; on the contrary, it restores it through purity, harmony and fulfillment. Taoism shows us, furthermore, that unity and harmony are the very sources of life and energy, that to be in harmony with nature is to be in harmony with, and to unify, ourselves. Such unity, of man with himself and with all other living things, is the desirable and natural way of life and the very essence of spiritual life. We need to become much more aware of the unavoidable reality of this spiritual law, this unity of spirit in all life and nature, for it can bring together the world and unite the human family as never before.

A child is born without any prejudice or partiality, without discrimination or distinction between any and all forms of life. Nothing is unclean, unwanted or undesirable to a child – all things to him or her are equally pure and good. He or she *learns* to make distinctions, and how they learn to do this should be the subject of our most intense future scrutiny. A child is *natural*, and somehow in the indoctrination of civilization and the conditioning of social consciousness becomes more and more separated from the attainment of an equal right-brain development, more and more

separated from his inner being, and less and less in touch with creativity and the spiritual sources of life. It almost seems that nearly everything we are doing in modern culture, in social growth, education, and a conditioning environment leads us not toward greater unity of personality and the integration of a whole intelligence, but away from it, toward fragmentation, division, and a schizoid consciousness.

Consider the facts. The very fabric of our social order is implicit with the enforcing of boundaries – of kin, class, territory and ownership, implicit with building walls between other people and ourselves. We are part of a clan, family, team, profession, business or nation; we compete with others for money or prestige; we extend the fences of this self-perpetuating enclosure to exclude not just rivals but potential rivals, to exclude not just the other family or the other person but whole races, religions and nations. We don't harmonize or co-operate – we isolate and oppose. We don't unify – we make distinctions, which is the typical and exact work of rationalism. We *learn* to separate ourselves from nature and humanity; we *learn* to distrust and not know ourselves; we *learn* to turn away from God and our inner life and follow the way of the world. We *shrink*, and we teach shrinkage. We fail to grow, and growth is the law of life.

Our religions are fine and beautiful in their basis, yet we turn them to the cause of making distinctions, of fanaticism, of sects and cults, of enforcing the walls of our narrow rational consciousness. We turn them to that greatest of all evils, nationalism. We put our religions in the service of war, violence, and international and political competition, where they have no business to be, and we wonder despite this why their spiritual influence has declined, their integrity is questioned. Had we listened to our religions, or had our religions listened to the great spiritual leaders who founded them, we would have seen the thread of oneness which runs throughout every religion of the world, and we could have loved and revered the nature and spiritual life that makes us all one. Here again our inclination to let social structure, the unchecked spread of a rigid, materialistic/scientific type of mentality, and the failure to know and heed our own creative heart, dictate to nature and even to common sense, has resulted in a world of armed camps where man is a stranger to himself and his kind.

The same discriminating verbal mind was at work in industrialism and technology, our great benefactors. Nature wasn't good enough – we had to improve upon it. Nature resembled the wild animal our medieval religions thought we were; nature

represented the uncertain, the inexplicable; nature was something to be hammered into shape or mowed down with a bulldozer, the same way our children had to be made over to fit our social requirements. 'Man is something to be overcome', shouted the madman Nietzsche, and our behaviouralists hummed 'Yea, verily'.

We watched a sterile, soulless world arising and we turned our eyes away or rationalized it as 'progress', or hired clever spokesmen to make it seem like the public was to blame for the ugly destructiveness of industry. Nature was something vicious and primitive lurking in our hearts and had to be cleaned up and sanitized by science and technology. Surely nature had nothing to do with God, who sat like a good businessman somewhere distant and removed in a far-off front office and who we only consulted on Sunday in His proper department. Industry would mechanize nature for us and make everything easy, make work and thought a thing of the past, would create a scientific paradise where the rational mind would not be prodded by the creative and the human, where everything would be practical, precise, comfy and secure. So great is our ignorance.

Here are the ways industry and technology have contributed to our happiness:

1 The invention and proliferation worldwide of dangerous modern weapons. The invention of the atom bomb and the spread of radiation which can never be dispersed.
2 The pollution, directly through industrial wastes and chemicals, of the soil, the air, the water, which are the sole resources of life.
3 The killing of wildlife in lakes, rivers, and streams; the poisoning of crops and domestic animals.
4 The more efficient killing of human beings through machine warfare.
5 The killing of humans through chemical-caused diseases, industrial occupations and air pollution.
6 The uglification of cities and landscapes.
7 The destruction of initiative and individuality.
8 The dehumanization of man and the brutalizing of human sensitivities.
9 The destruction of craftsmanship and creativity.
10 The development of a mass mentality and the levelling of large numbers of people to a common character.
11 The usurpation of governmental authority by worldwide, powerful industrial corporations.

163

12 The loss of beauty and meaning in human life.

Need I go on? As industry made science its bell-captain and turned its resources to ever more irresponsible uses, no intelligent person could fail to recognize that its negatives have far outweighed its positive benefits for humanity. Our work of the future must now include the rebuilding of the world to a tolerably human aesthetic level, the restoration and nurturing of nature and the natural balance, the elimination of the destructive effects of industry, and the changing of the wholly scientific/rational consciousness which has so far removed us from our souls and which made such destruction possible.

Our technology is not going to go away. We can only go forward, not back. But we can turn it to the service of the whole human being and the whole human mind, incorporate the aesthetic/spiritual side of human life into our technology and our awareness, make it fill those needs which are primarily human and natural, not merely social or commercial. The present expansion of worldwide communciations is the most hopeful sign we have of a new, less narrow and stagnant future. For where there are clear communications, often at an instant, and universal, the chances for the deception and manipulation of mankind grow much narrower, the opportunities for comparison of knowledge and spiritual growth much greater.

Yet dangers are incipient here also, of ideas losing power and truth through being tailored to mass audiences, of conformity and mass thinking which can smother individuality, originality and creative growth[1] and engender perverse, warped values as well. For example, the lurid and constant portrayal of violence as heroism on television and film can make it seem like violence is heroic, which it is not; the constant sensationalistic coverage of crime, anomaly, disaster and suffering can make it seem like these are normal and all that happens in life, can impair serenity and sensitivity to suffering, can spread despair or apathy and can create a very false impression of reality. Art made to sell is no art at all, and has lost its integrity.

We can see this mechanical warping of values to fit a mass mentality affecting drama and fiction very negatively, causing it to lose its creative and aesthetic power and meaning through pandering to what is imagined as a mass mind, and thereby creating one. The public can think, can perceive, can decide issues for themselves; no one has to decide it or digest it for them for the sake of profit or any other reason; no one has to coddle the human mind with thoughtless mental chewing gum. The advertising media are the worst offenders

of this toying with values and human consciousness; believing they are brainwashing the public, they are actually earning its contempt. New frontiers, new values and ideas can and will be accepted by the public if we let the mind assume its natural pliability and freedom, and we should never be afraid to jog the intellect, to shake up complacency and comfortableness, nor especially to expand the human vision and consciousness. Its depth and potential are always there to be reached as long as our media are original, fearless, creative – and keep their integrity.

The more we encourage and foster a mass mentality the more we are destroying human creativity. The consequences of that for society in the long run should be obvious. Our television and publishing, our communications expansion to world proportions can make the education of millions possible, can unite and enlighten every part of the globe with the latest findings of science as well as with the whole history of human culture, the exploration of nature, and the advances of spirituality and intelligence. But that education must transcend empty facts – it must explore and reveal meaning. It must include progressive human development in its aesthetic, creative and spiritual forms, must nurture spirituality, creative growth and religious confidence, must lead the mind to a whole, balanced and universal consciousness. It must blend into a new and constant education in truth, in essence, in spirit, in all the philosophical and spiritual principles of life and nature. All of this will require creative intuition and the study of how we can forward intuitive knowledge and the creative use of inner energy and its unlimited power. We must synthesize all knowledge, all philosophy, all religion. We must join science to art and religion; we must integrate the spiritual and the rational; we must follow the Way of cultivation.

We can and must explore and be aware of alternative intelligence, alternative consciousness and mystical phenomena much more comprehensively than we have been, learn to see God in the nucleus and under the sea, learn to see the good in every religion. Jesus was a great spiritual master; so also were Lao Tzu, Moses, Mohammed, and the Buddha. We can look more closely, more deeply at the signs of spiritual realization which transcend religion, at that which we do not yet fully understand. We can develop all the latent powers of the mind. We can, and should, look with new interest at the spiritual implications and possibilities of hyperkinesis, of faith healing, at acupuncture and the relation between mind and body, at the phenomena of energy and what they mean, at the universal phenomenon of astrology.

165

The latter is a case in point as an example of human perception and receptive intuition of the public as opposed to the narrow, limited consciousness found in our institutions. For at least 20 years valid and strong evidence for the truth of astrology has been perceived and observed by the public, together with a growing body of knowledge about it. What is called astrology is a demonstrable fact in life potential, character typology, and is well known as an important determinant in human relations and in understanding ourselves and the phenomena of personality. It has been accepted, used, and followed closely by millions of average people the world over, yet only a few years ago a select group of 200 scholars from as many American universities were unanimous in a 'scientific' denunciation of it. This is surely scholarly vanity at its most unenlightened hour. Astrology is as old as humanity. It was the discovery and knowledge of a biomagnetic, geomagnetic principle of magnetism and energy which effectively governs and guides human life, and which reflects the marvellous ordering of the universe by the Divine Creative Intelligence we call God, Allah, Yahweh, Brahma and the Tao. It was practised in China 2000 years ago, and is not incompatible with any religion, including Taoism. It has been endorsed by thinkers as diverse, learned and distinguished as Jung and Emerson, as well as by those same millions whose perceptivity exceeds their scholarly credentials. We would do very well to study it more closely and to introduce it into our universal philosophy, for like nature, spirit, and our own creative inner self we may not forever avoid confrontation with universal reality.

We need to confront and investigate also the sources of truth and power in authority and in ourselves. Not every public voice, not every person in authority is the voice of truth nor has intellectual infallibility or unquestionable motives merely by virtue of his position. Nazi Germany should have taught us that authority is not to be blindly obeyed. We need to learn to question the public spokesman and to discern his integrity and not be deterred by his credentials, his public facade or his inability to say yes or no. We need to be more vocal, to demand action, to demand integrity of leaders, to discern essence, to know the difference between propaganda and truth.

Spiritual power begins with fidelity to the inner principle of things. We can learn to search for the essence, the principle of any reality or idea and become sensitive to meaning, to real values in terms of their spiritual validity. Each one of us can become seers of truth as much as every wise man of the past. The inner voice, the intuition, is the only real standard for reality. With it we can see

through men and ideas as if they were glass. We alone are the regulators and guardians of nature and human life, because we alone are its essential fabric.

The Taoist Way, and the Tao of art, are about the principles of spiritual power and energy potentially available to all of us. The messages of Lao Tzu and Jesus Christ are the same. Jesus, one of the greatest spiritual mystics who ever lived, is an example, in the miracles, of what we are actually and literally capable of doing ourselves. Far above the plodding doctrinal and factual history of Christianity, Jesus was a spiritual master who followed and taught the Way of spiritual realization. He was able to transubstantiate and transform physical matter through internal spiritual energy, heal the sick, blind and crippled, read the minds and spirits of men, even restore dead tissue to life. In the end, his spiritual mastery was so complete he was able to restore the dead to life, and he did so with his own body. He was called the Great Healer but was also the greatest artist who ever lived, for Jesus manifested and used the power of spiritual creativity. He showed us the complete and real power of the human mind when it is perfected in spirituality.

We are presently using but a small part of the human brain. The Taoists have shown us the Way toward using all of it, the Way toward mastery of the physical dimension of existence through spiritual mastery and the use of the inner creative power and internal energy we already have. It was always a Way which is in our hands and depends on our will, and it was made for natural life in *this* world: 'You can only see the gods and Heaven by mastering this world, replied the Grand Master patiently, then you can see the next world.'[2]

The Grand Master looked at Saihung placidly. 'This, Saihung, is mastery of the world.' He pointed dramatically across the terrace at an unlit stick of incense. It lit immediately. Sandalwood fragrance drifted toward them. 'And it is also this', said the Grand Master. He pointed at a heavy brass teapot on a table six feet away. It floated up and moved slowly in the air to another table.[3]

These are not fables, but actual cases of spiritual power, and the history of world mysticism as well as Christianity is full of them. They show us what *we* can do, what someday we *will* do, allied to spiritual, creative, intuitive mental power.

The Tao of art shows us the creativity of the universe in specific human form, how that creativity is joined to the nature of

spirituality and the presence of the latter in nature and the human mind, and some of the ways we can achieve it. Using the 'art' of spiritual power, progressing in the Way of spiritual cultivation and development, there is no limit to how far each and every one of us can take it, both in ourselves and in the world. And it is written in our destiny that the world of the future will perfect this spiritual art.

Think of the possibilities! Think of the power to transcend and transform matter through thought, to have supernatural, even superhuman strength, to communicate at any distance through thought, to heal pain and illness through directing internal energy to it, to prolong life and youth through mastery of the sources of energy, to become physical sources of creative energy and power ourselves, to turn on electricity and magnetism at will, and in a scale beyond our wildest dreams, to be one with God and the creative powers of nature and the universe, to be participants in creation, to do with our minds what we presently do with machines or physical effort, to fill the world with beauty and meaning and light.

There are many instances in human history where all of these have already been accomplished by advanced individuals, by spiritual pioneers and forerunners of what we also can do. Only one thing is required – spiritual advancement, and the whole intelligence and life fulfillment it brings.

The Way lies open before us.

Notes

1 May, 73.
2 Deng, 140.
3 Ibid., 141.

Bibliography

Analects of Confucius, The. Arthur Waley, Translator. New York: Random House, 1938.

BARNHART, RICHARD M. *Peach Blossom Spring: Gardens and Flowers In Chinese Painting.* New York: The Metropolitan Museum of Art, 1983.

BERGSON, HENRI. *Creative Evolution.* New York: Henry Holt and Company, 1911.

BLAKESLEE, THOMAS R. *The Right Brain: A New Understanding of The Unconscious Mind and Its Creative Powers.* New York: Anchor Press/Doubleday, 1980.

BLOFELD, JOHN. *Taoism: The Road To Immortality.* Boulder, Colorado: Shambhala Publications, 1978.

BLOOMFIELD, HAROLD H.; CAIN, MICHAEL PETER; and JAFFE, DENNIS T. *Transcendental Meditation: Discovering Inner Energy and Overcoming Stress.* New York: Delacorte Press, 1975.

BYRD, RICHARD E. *Alone.* New York: G. P. Putnam's Sons, 1938.

CAPRA, FRITJOF. *The Tao of Physics.* Boulder, Colorado: Shambhala Publications, 1975.

CALLAHAN, STEVEN. *Adrift: 76 Days Lost At Sea.* Boston: Houghton Mifflin Company, 1986.

CARY, JOYCE. *Art and Reality: Ways of The Creative Process.* New York: Harper and Bros., Publishers, 1958.

CHAN, WING-TSIT. *A Source Book In Chinese Philosophy.* Princeton: Princeton University Press, 1963.

CHANG, CHUNG-YUAN. *Creativity and Taoism.* New York: The Julian Press, 1963.

COOPER, J. C. *Yin and Yang: The Taoist Harmony of Opposites.* Wellingborough, England: The Aquarian Press, 1981.

CREEL, H. G. *Chinese Thought From Confucius To Mao Tse-Tung.* Chicago: University of Chicago Press, 1953.

⸺⸺⸺⸺ *What Is Taoism?: And Other Studies In*

Chinese Cultural History. Chicago: University of Chicago Press, 1970.

DENG, MING DAO. *The Wandering Taoist*. San Francisco: Harper and Row, Publishers, 1983.

EDWARDS, BETTY. *Drawing On The Right Side of The Brain*. Los Angeles: J. P. Tarcher, Inc., 1979.

FRANKL, VICTOR E. *Man's Search For Meaning*. Boston: Beacon Press, 1959.

HERRIGEL, EUGEN. *Zen In The Art of Archery*. New York: Pantheon Books, 1953.

LEE, SHERMAN E. *Chinese Landscape Painting*. New York: Harper and Row, Publishers, 1954.
　　　　　　　A History of Far Eastern Art. New York: Harry N. Abrams Company, 1972.
LEGEZA, LASZLO. *Tao Magic*. New York: Pantheon Books, 1975.
LU, KUAN YU. *The Secrets of Chinese Meditation*. London: Rider and Company, 1964.

McNAUGHTON, WILLIAM. *The Taoist Vision*. Ann Arbor: University of Michigan Press, 1971.

MASLOW, ABRAHAM H. *The Farther Reaches of Human Nature*. New York: The Viking Press, 1971.
MAY, ROLLO. *The Courage To Create*. New York: W. W. Norton and Company, 1975.

NISHIMURA, ESHIN. *Unsui: A Diary of Zen Monastic Life*. Honolulu: University Press of Hawaii, 1973.

OSBORNE, HAROLD. *Aesthetics and Art Theory*. New York: E. P. Dutton Company, 1970.

PARDUE, PETER A. *Buddhism*. New York: Macmillan and Company, 1968.
POULAIN, AUGUSTIN F. *The Graces of Interior Prayer*. London: Paul, Trench, Trubner, 1910.

170

READ, HERBERT. *Art and Society.* New York: Schocken Books, 1966.

Education Through Art. New York: Pantheon Books, 1956.

RILKE, RAINER MARIA. *Letters To A Young Poet.* Stephen Spender, Translator. New York: Random House, 1984.

SASO, MICHAEL R. *Taoism and The Rite of Cosmic Renewal.* Tacoma: Washington State University Press, 1972.

SCHILLER, FRIEDRICH. *On The Aesthetic Education of Man.* New York: Frederick Ungar Publishing Company, 1954.

Secret of The Golden Flower, The. (T'ai I Chin Hia Tsung Chih). Richard Wilhelm, Translator. Introduction and Commentary by C. G. Jung. New York: Harcourt Brace and Company, 1931.

SICKMAN, LAURENCE, and SOPER, ALEXANDER. *The Art and Architecture of China.* London: Penguin Books, 1956.

SIREN, OSVALD. *The Chinese On The Art of Painting.* New York: Schocken Books, 1963.

SIREN, OSVALD. *Chinese Painting: Lead Masters and Principles.* New York: The Ronald Press Company, 1958.

A History of Early Chinese Art. New York: Hacker Art Books, 1970.

SUZUKI, D. T., FROMM, ERICH; and DE MARTINO, RICHARD. *Zen Buddhism and Psychoanalysis.* New York: Harper and Bros., Publishers 1960.

SZE, MAI-MAI. *The Tao of Painting: A Study of The Ritual Disposition of Chinese Painting.* New York: Pantheon Books, 1963.

Tao Te Ching: Interpreted As Nature and Intelligence. Archie J. Bahm, Translator. New York: Frederick Ungar Publishing Company, 1958.

Tao Te Ching. R. B. Blakney, Translator. New York: Mentor Books, 1955.

Tao Te Ching. Wing-Tsit Chan, Translator. Princeton: Princeton University Press, 1963.

Tao Te Ching. D. C. Lau, Translator. London: Penguin Books, 1963.

Texts of Taoism, The: Chuang Tzu, Lieh Tzu, Tao Te Ching. James Legge, Translator. New York: Dover Books, 1979.

WALEY, ARTHUR. *The Way and Its Power: A Study of the Tao Te*

Ching and Its Place In Chinese Thought. New York: Houghton Mifflin Company, 1935.

 Three Ways of Thought In Ancient China. New York: Doubleday and Company Inc., 1939.

WATTS, ALAN. *Tao: The Watercourse Way*. New York: Pantheon Books, 1975.

 The Way of Zen. New York: Pantheon Books, 1957.

WELCH, HOLMES. *The Parting of The Way: Lao Tzu and The Taoist Movement*. Boston: Beacon Press, 1957.

Index